500
POSES *for*
Photographing
Couples

A VISUAL
SOURCEBOOK FOR
DIGITAL PORTRAIT
PHOTOGRAPHERS

Michelle Perkins

AMHERST MEDIA, INC. ■ BUFFALO, NY

Front cover photographs by Damon Tucci.
Back cover photograph by Tracy Dorr.

Published by:
Amherst Media, Inc.
P.O. Box 586
Buffalo, N.Y. 14226
Fax: 716-874-4508
www.AmherstMedia.com

Publisher: Craig Alesse
Senior Editor/Production Manager: Michelle Perkins
Assistant Editor: Barbara A. Lynch-Johnt
Editorial assistance from: Chris Gallant, Sally Jarzab, John S. Loder

ISBN-13: 978-1-60895-310-3
Library of Congress Control Number: 2010916872
Printed in Korea.
10 9 8 7 6 5 4 3 2 1

Check out Amherst Media's blogs at: http://portrait-photographer.blogspot.com/
http://weddingphotographer-amherstmedia.blogspot.com/

About This Book

Posing one person for a portrait can be a challenge, but the possibilities—and potential problems—seem to more than double when photographing a couple. Not only must each of the individuals look good on their own, they must look good as a unit. Additionally, couples seeking portraits are looking for images that reflect the relationship they share, not just their likenesses. For some couples, this means capturing an intensely passionate romantic bond. For others it means finding a way to showcase how much fun they have together—or even a hobby or activity in which they share an interest.

An additional challenge is the fact that, more often than with individual portraits, images of couples tend to be created on location. This means the photographer will need to improvise to create poses that are harmonious with (or perhaps in wild contrast to) the environment around the couple. In many cases, the poses selected will also have to integrate the need to work with available lighting.

This collection is designed to address these problems. Filled with images by accomplished portrait, fashion, and wedding photographers, it provides a resource for photographers seeking inspiration for their own work. Stuck on what to do with a particular couple or unsure how to use a given location? Flip through the sample portraits, pick something you like, then adapt it as needed to suit your tastes. Looking to spice up your work with some new poses? Find a sample that appeals to you and look for ways to implement it (or some element of it) with your subjects.

For ease of use, the portraits are grouped according to how much of the subjects are shown in the frame. Thus, the book begins with head-and-shoulders portraits, followed by portraits that introduce one or both hands into the head-and-shoulders look. Next are waist-up portraits, featuring images that include the head and shoulders, arms and hands,

and at least some of the subjects' torsos. Moving on to three-quarter-length portraits, the examples feature couples shown from the head down to mid-thigh or mid-calf. The balance of the book features full-length images—the most complex couples' portraits to pose, because they include two entire bodies. Both the three-quarter- and full-length portraits are subdivided into poses designed for standing subjects and ones for seated or reclining subjects.

It can be difficult to remain creative day after day, year after year, but sometimes all you need to break through a slump is a little spark. In this book, you'll find a plethora of images designed to provide just that.

Contents

About This Book .3

Head-and-Shoulders Posesplates 1–66
Waist-Up Poses .plates 67–155
Three-Quarter-Length
 Seated/Reclining Posesplates 156–183
Three-Quarter-Length
 Standing Posesplates 184–277
Full-Length Seated/Reclining Posesplates 278–337
Full-Length Standing Posesplates 338–485
Detail Images. .plates 486–500

Appendix: Posing Fundamentals120
The Photographers .123
Bibliographical References125

PLATE 3. Photograph by Jeff Hawkins.

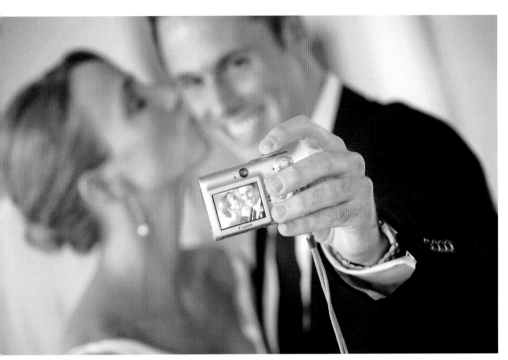

PLATE 1. Photograph by Kevin Kubota.

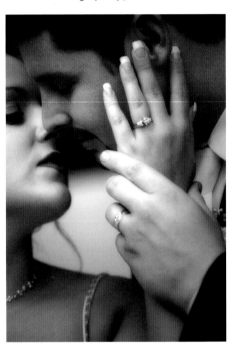

PLATE 4. Photograph by Jeff Hawkins.

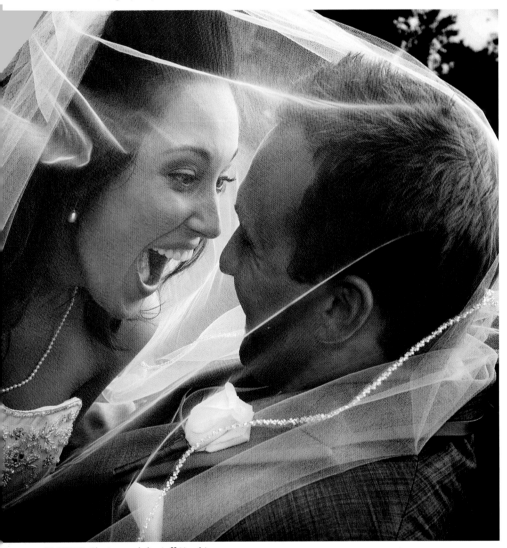

PLATE 2. Photograph by Jeff Hawkins.

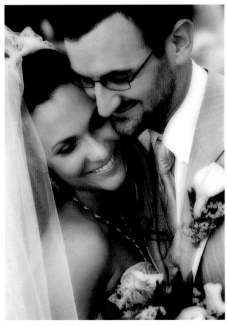

PLATE 5. Photograph by Jeff Hawkins.

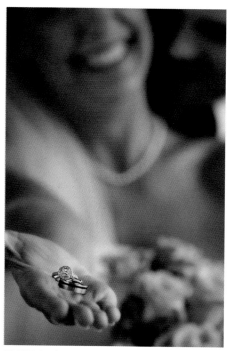

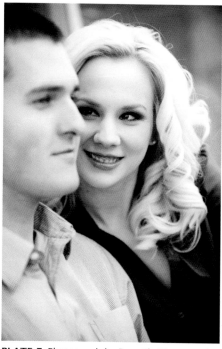

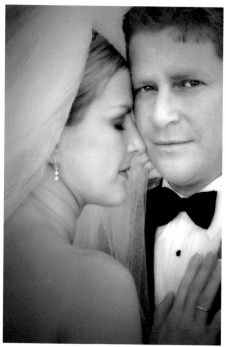

PLATE 6. Photograph by Kevin Kubota.

PLATE 7. Photograph by Regeti's Photography.

PLATE 8. Photograph by Jeff Hawkins.

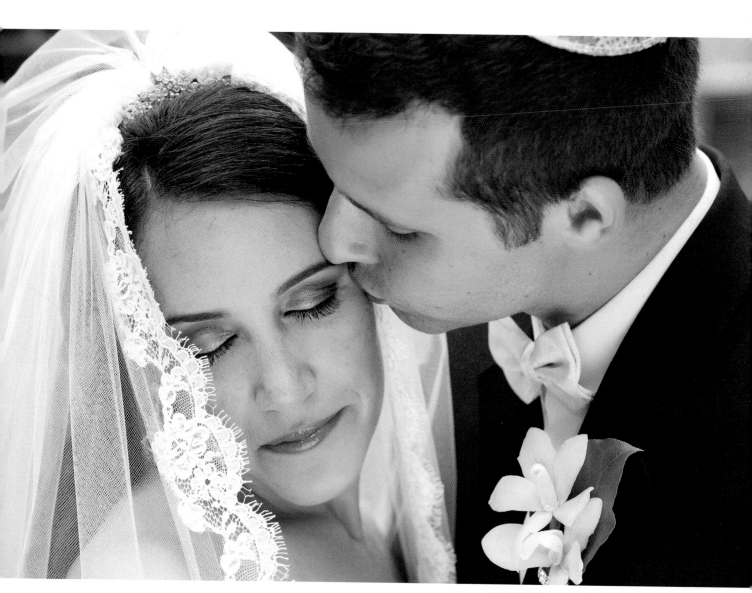

PLATE 9. Photograph by Regeti's Photography.

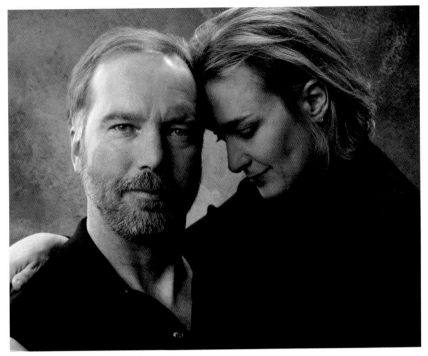

PLATE 10. Photograph by Christopher Grey.

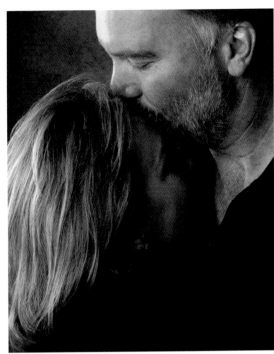

PLATE 11. Photograph by Christopher Grey.

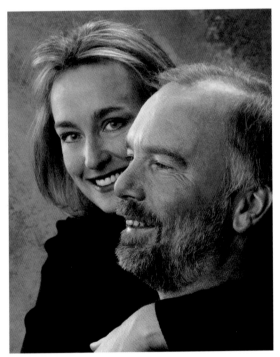

PLATE 12. Photograph by Christopher Grey.

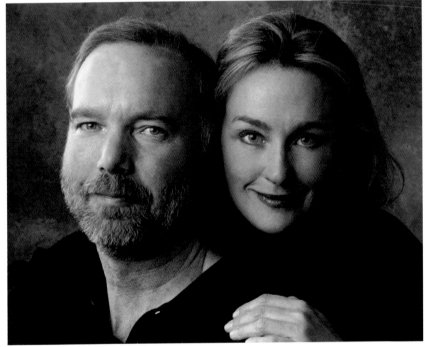

PLATE 13. Photograph by Christopher Grey.

"The camera typically adds a few pounds—something most clients won't appreciate. To compensate for this, we tend to use a higher camera angle. Upward angles may be good for supermodels, but for the normal person they exacerbate any facial flaws and make that double chin a quadruple chin.[1]" —Damon Tucci

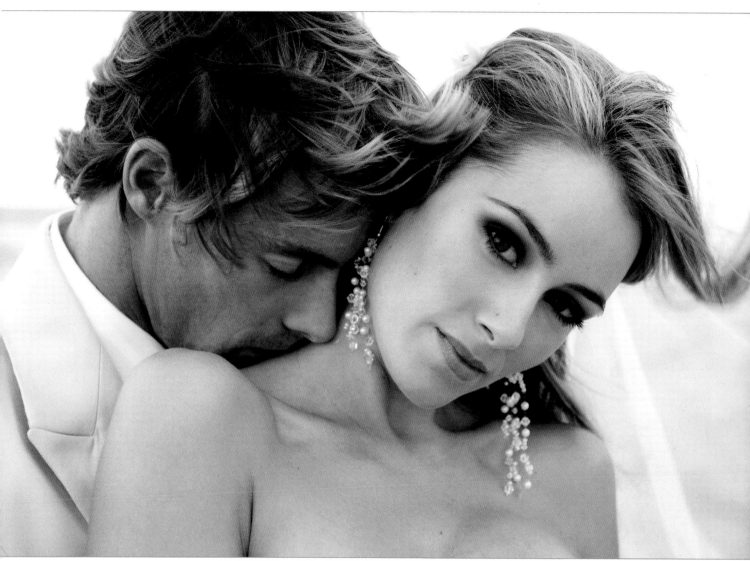

PLATE 14. Photograph by Brett Florens.

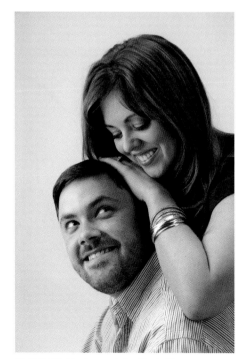

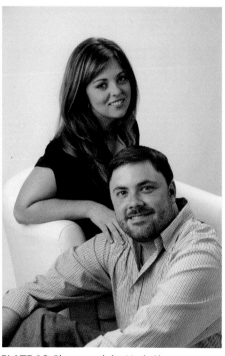

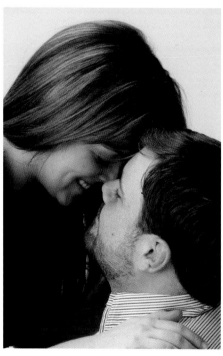

PLATE 15. Photograph by Mark Chen.

PLATE 16. Photograph by Mark Chen.

PLATE 17. Photograph by Mark Chen.

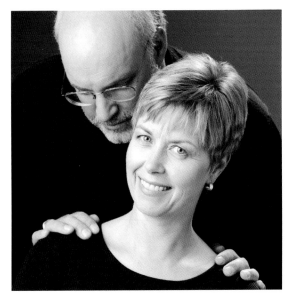

PLATE 18. Photograph by Christopher Grey.

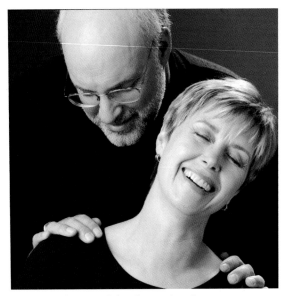

PLATE 19. Photograph by Christopher Grey.

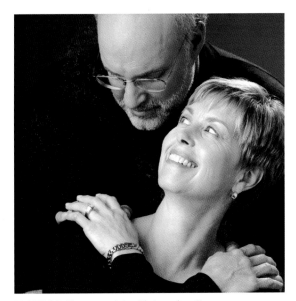

PLATE 20. Photograph by Christopher Grey.

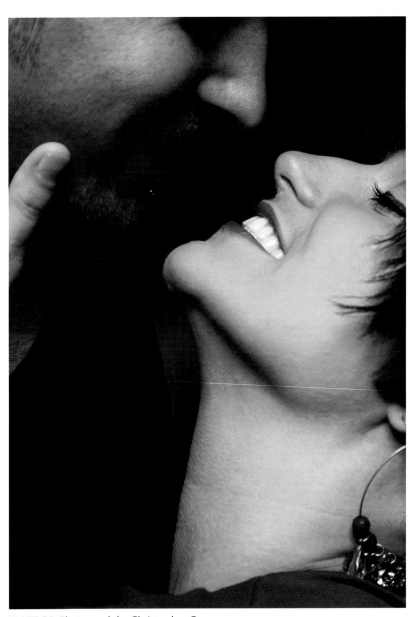

PLATE 21. Photograph by Christopher Grey.

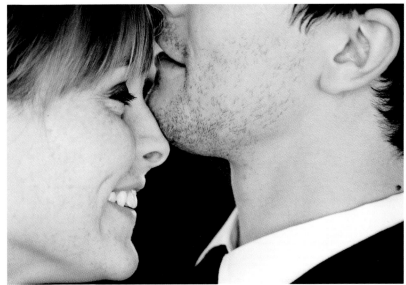

PLATE 22. Photograph by Tracy Dorr.

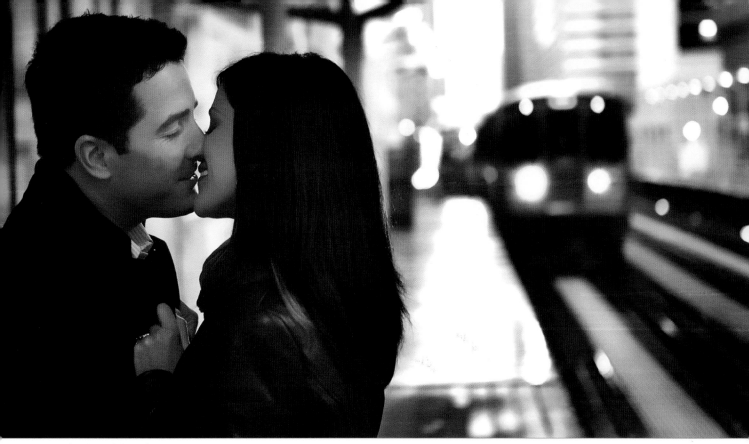

PLATE 23. Photograph by Salvatore Cincotta.

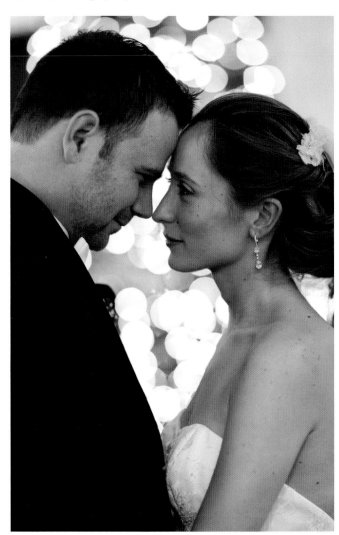

PLATE 24. Photograph by Neil van Niekerk.

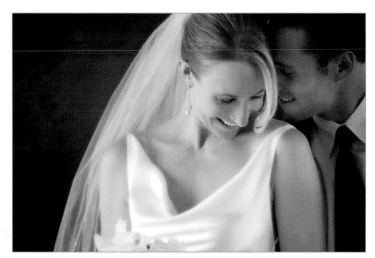

PLATE 25. Photograph by Kevin Kubota.

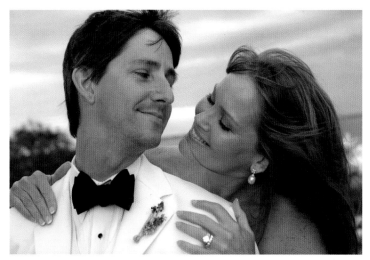

PLATE 26. Photograph by Cal Laundau.

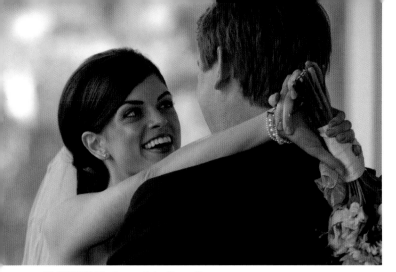

PLATE 27. Photograph by Doug Box.

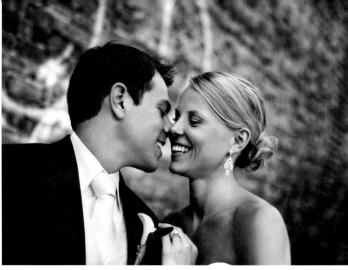

PLATE 28. Photograph by Tracy Dorr.

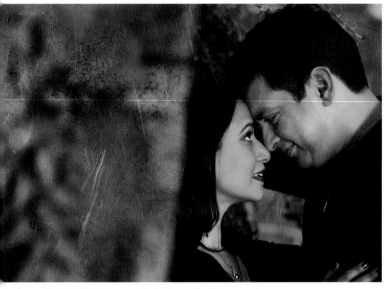

PLATE 29. Photograph by Regeti's Photography.

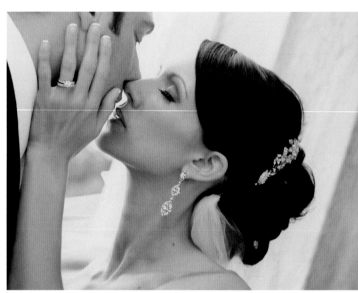

PLATE 30. Photograph by Tracy Dorr.

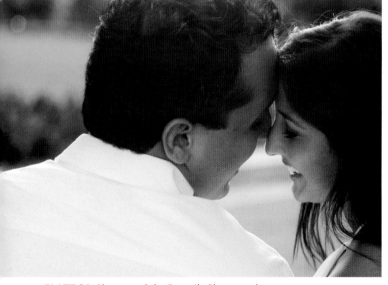

PLATE 31. Photograph by Regeti's Photography.

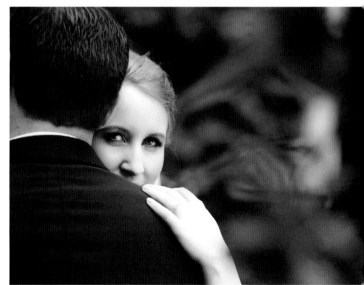

PLATE 32. Photograph by Regeti's Photography.

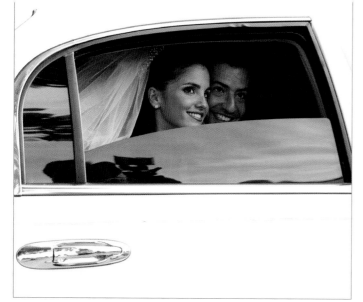

PLATE 33. Photograph by Jeff Hawkins.

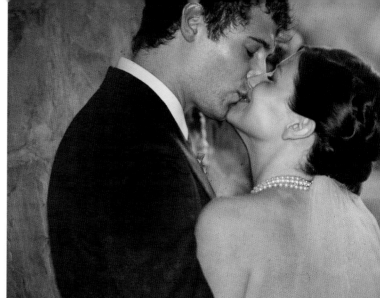

PLATE 34. Photograph by Cherie Steinberg Coté.

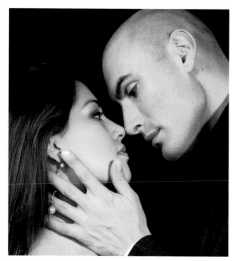

PLATE 35 (ABOVE).
Photograph by Hernan Rodriguez.

PLATE 36 (RIGHT).
Photograph by Hernan Rodriguez.

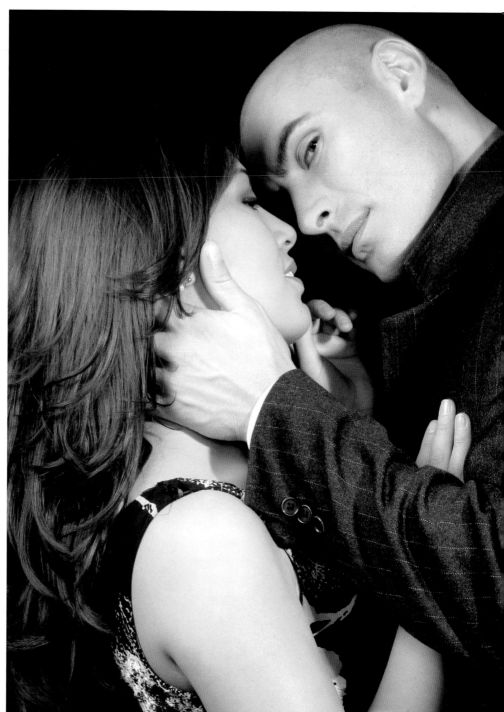

*"I start off with quite
conventional images, just
so that I am confident that I
have the 'money shots'
in the bag. Time permitting,
I then shoot more creative
images, taking into account
the bride and groom's per-
sonalities.[2]" —Brett Florens*

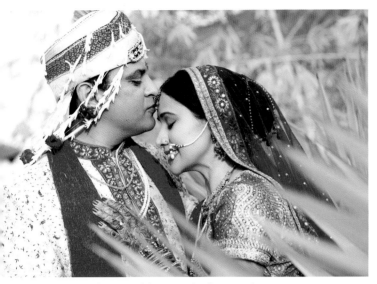

PLATE 37. Photograph by Regeti's Photography.

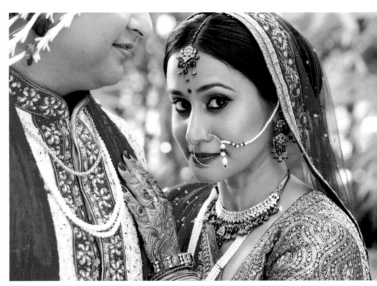

PLATE 38. Photograph by Regeti's Photography.

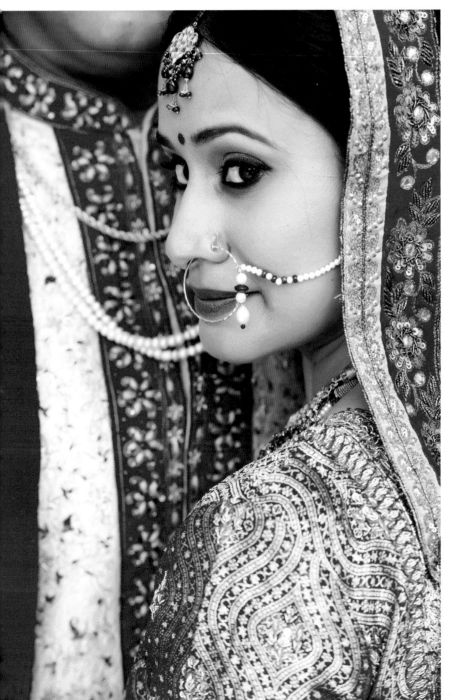

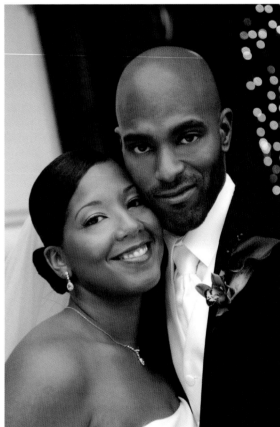

PLATE 39 (ABOVE). Photograph by Damon Tucci.

PLATE 40 (LEFT). Photograph by Regeti's Photography.

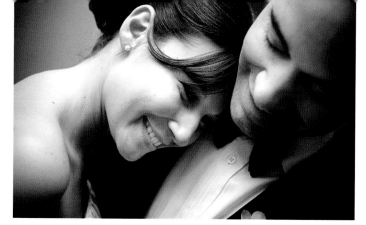

PLATE 41. Photograph by Paul D. Van Hoy II.

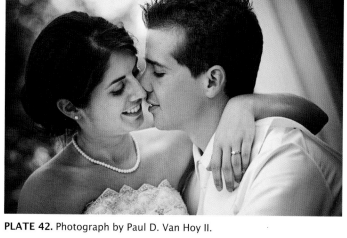

PLATE 42. Photograph by Paul D. Van Hoy II.

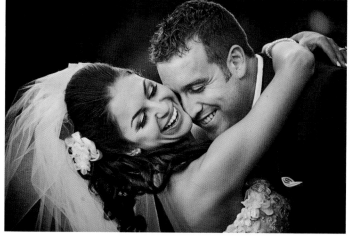

PLATE 43. Photograph by Paul D. Van Hoy II.

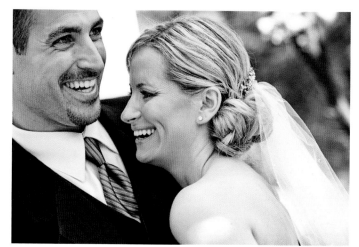

PLATE 44. Photograph by Paul D. Van Hoy II.

PLATE 45 (BELOW). Photograph by Paul D. Van Hoy II.

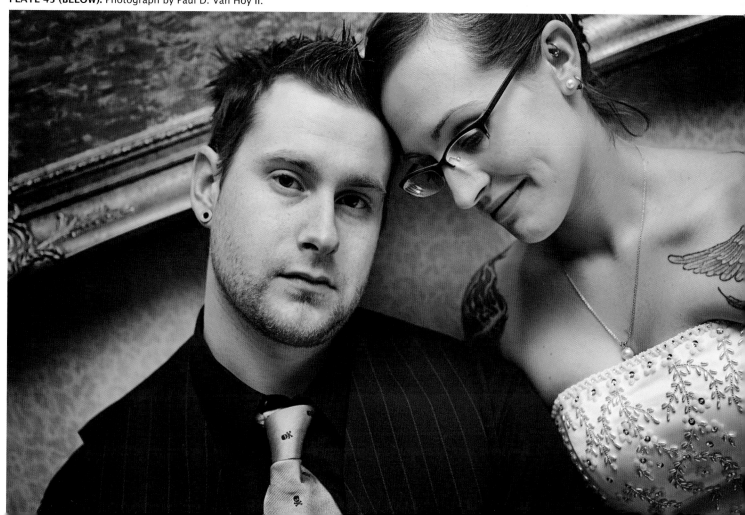

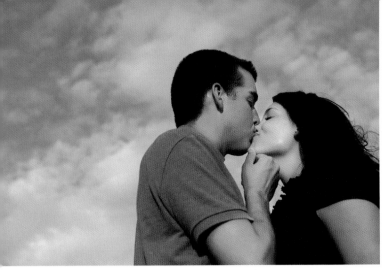

PLATE 46. Photograph by Regeti's Photography.

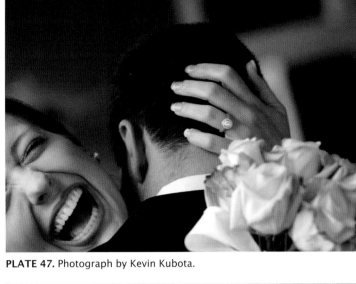

PLATE 47. Photograph by Kevin Kubota.

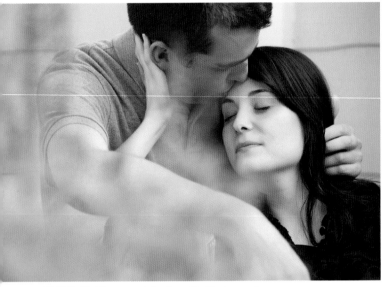

PLATE 48. Photograph by Regeti's Photography.

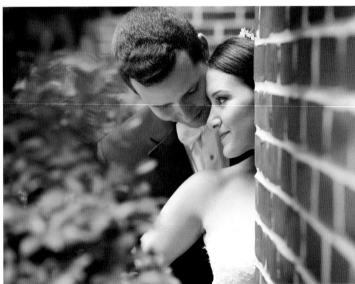

PLATE 49. Photograph by Regeti's Photography.

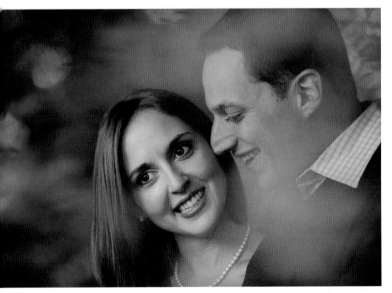

PLATE 50. Photograph by Neil van Niekerk.

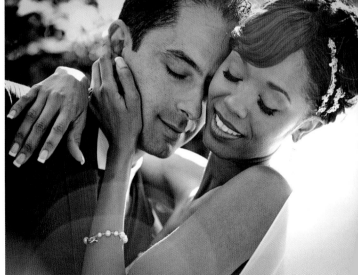

PLATE 51. Photograph by Paul D. Van Hoy II.

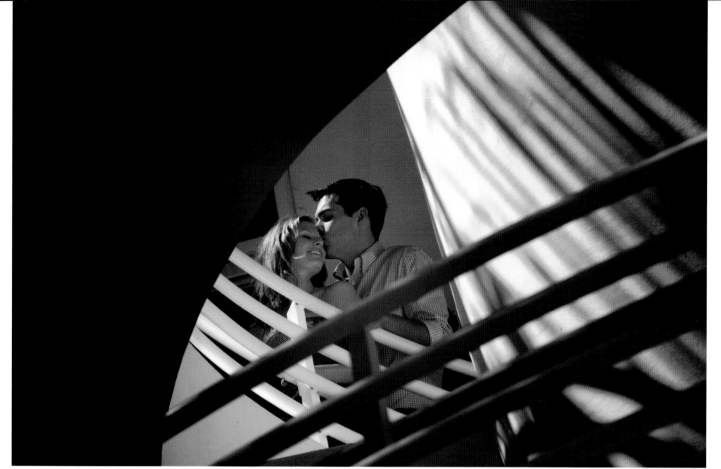

PLATE 52. Photograph by Cal Landau.

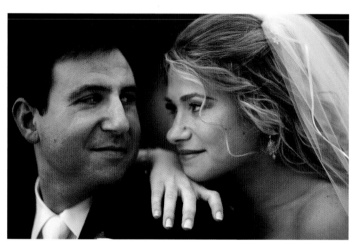

PLATE 53. Photograph by Neil van Niekerk.

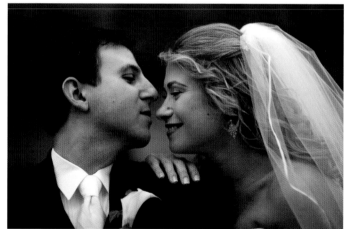

PLATE 54. Photograph by Neil van Niekerk.

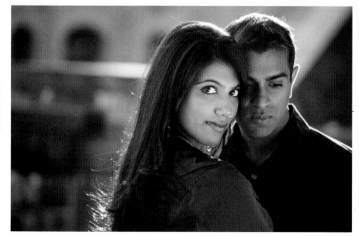

PLATE 55. Photograph by Regeti's Photography.

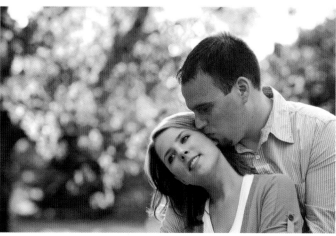

PLATE 56. Photograph by Neil van Niekerk.

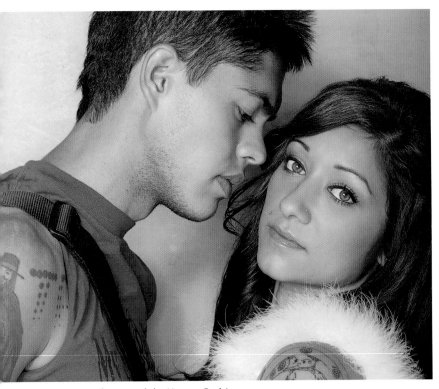

PLATE 57. Photograph by Hernan Rodriguez.

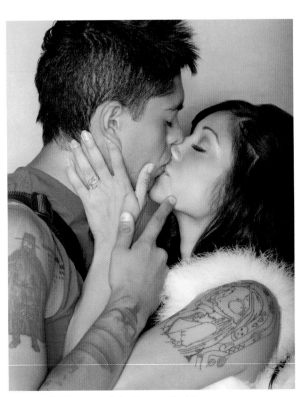

PLATE 58. Photograph by Hernan Rodriguez.

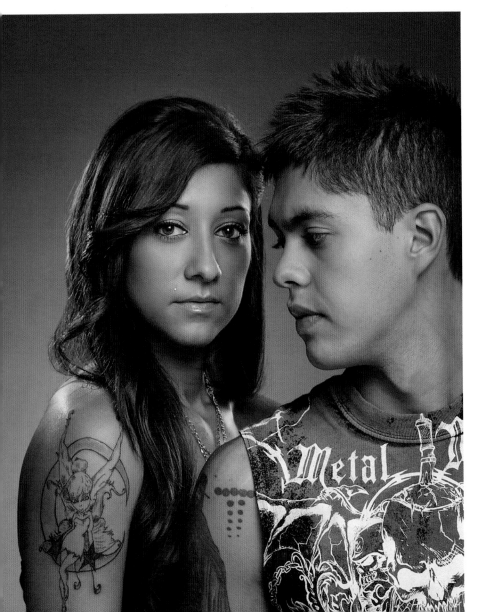

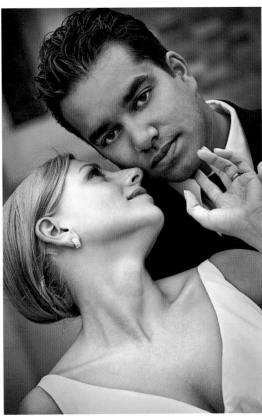

PLATE 59. Photograph by Paul D. Van Hoy II.

PLATE 60. Photograph by Hernan Rodriguez.

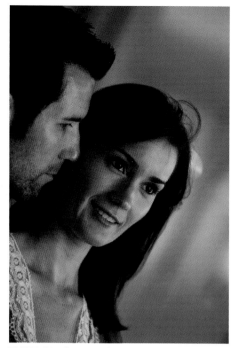

PLATE 61. Photograph by Neil van Niekerk.

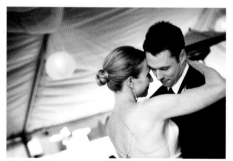

PLATE 63. Photograph by Jeff Hawkins.

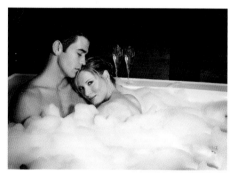

PLATE 64. Photograph by Kevin Kubota.

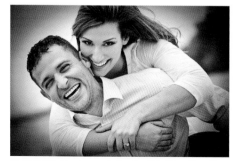

PLATE 66. Photograph by Paul D. Van Hoy II.

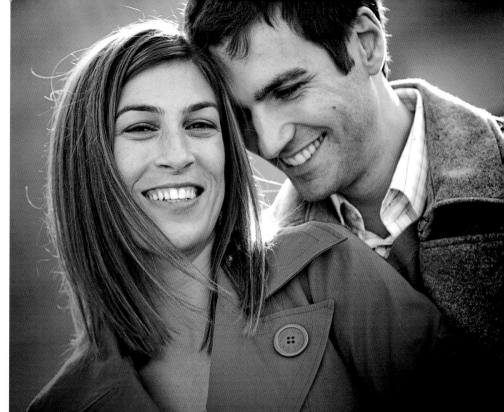

PLATE 62. Photograph by Paul D. Van Hoy II.

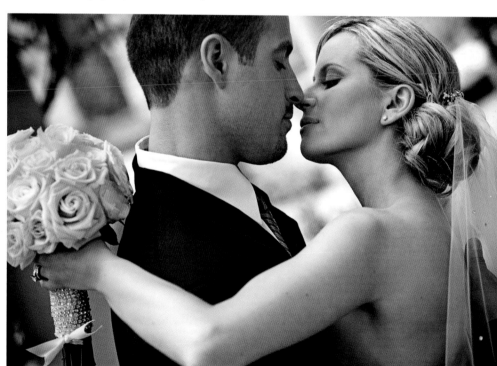

PLATE 65. Photograph by Paul D. Van Hoy II.

"A traditionally posed photo might serve as a record of what they looked like at that time. But if you can go one step further, if you can strike a chord with the perfect style of photography for that couple, then your product will be something they will treasure forever.³" —Tracy Dorr

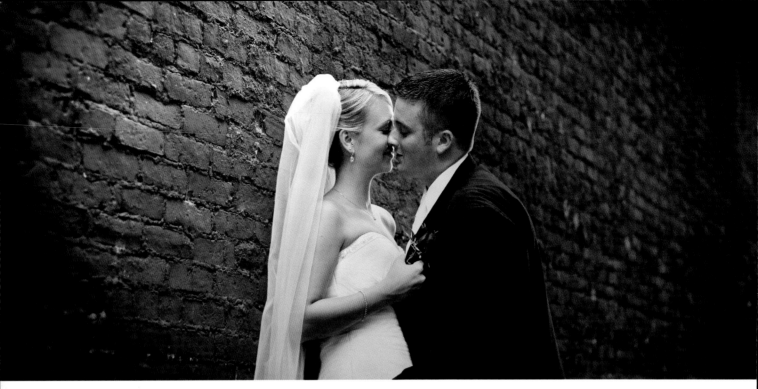

PLATE 67 (ABOVE). Photograph by Tracy Dorr.

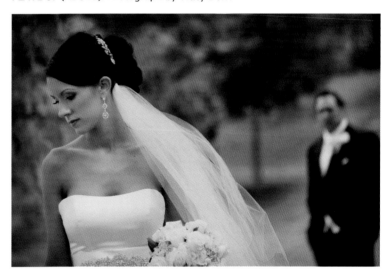

PLATE 68. Photograph by Tracy Dorr.

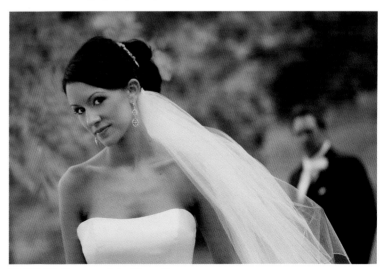

PLATE 69. Photograph by Tracy Dorr.

PLATE 70 (LEFT). Photograph by Tracy Dorr.

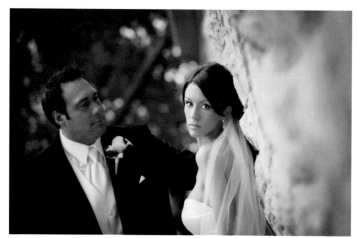

PLATE 71. Photograph by Tracy Dorr.

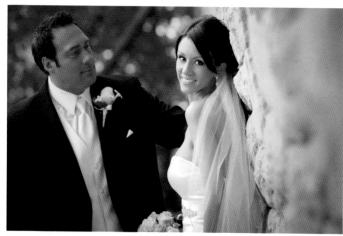

PLATE 72. Photograph by Tracy Dorr.

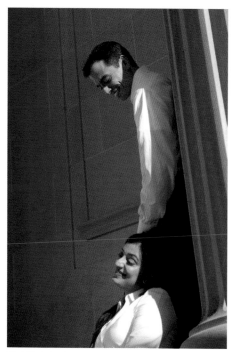

PLATE 73. Photograph by Mark Chen.

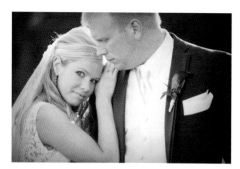

PLATE 74. Photograph by Salvatore Cincotta.

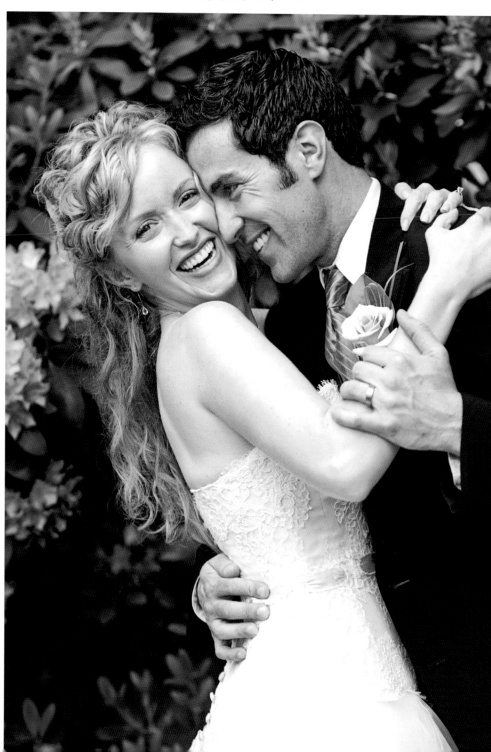

PLATE 75 (RIGHT).
Photograph by Paul D. Van Hoy II.

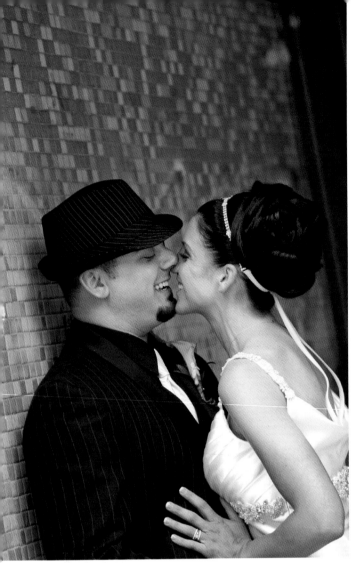

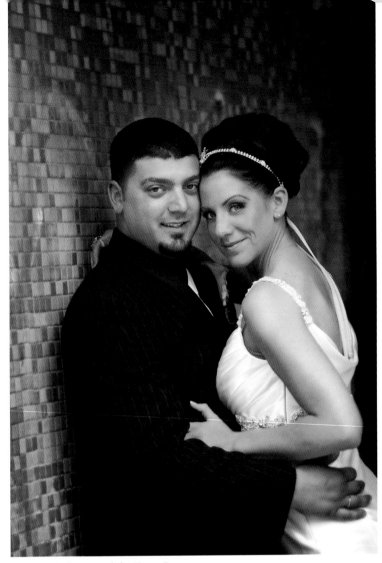

PLATE 76. Photograph by Tracy Dorr.

PLATE 77. Photograph by Tracy Dorr.

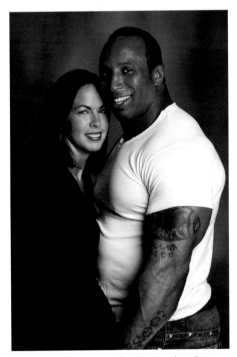

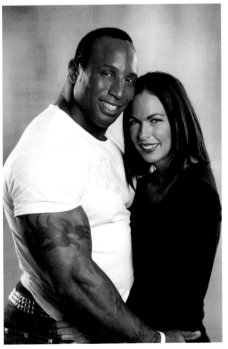

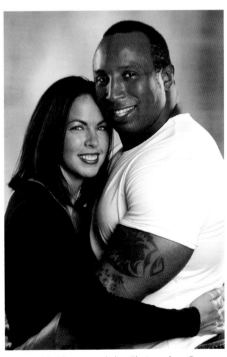

PLATE 78. Photograph by Christopher Grey.

PLATE 79. Photograph by Christopher Grey.

PLATE 80. Photograph by Christopher Grey.

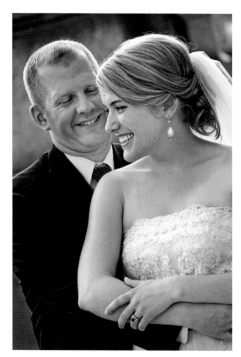

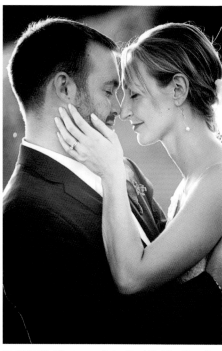

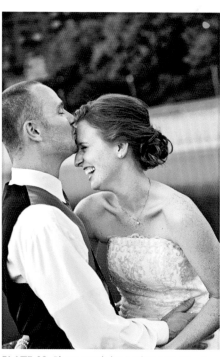

PLATE 81. Photograph by Paul D. Van Hoy II.

PLATE 82. Photograph by Paul D. Van Hoy II.

PLATE 83. Photograph by Paul D. Van Hoy II.

PLATE 84. Photograph by Kevin Kubota.

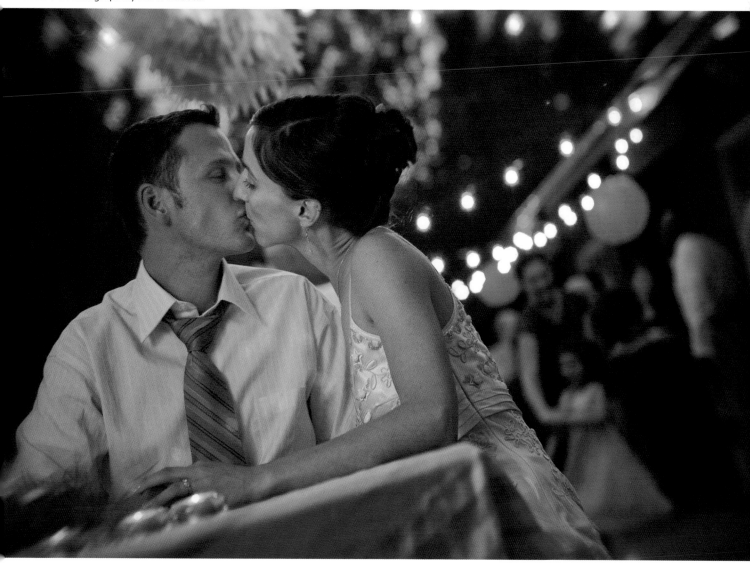

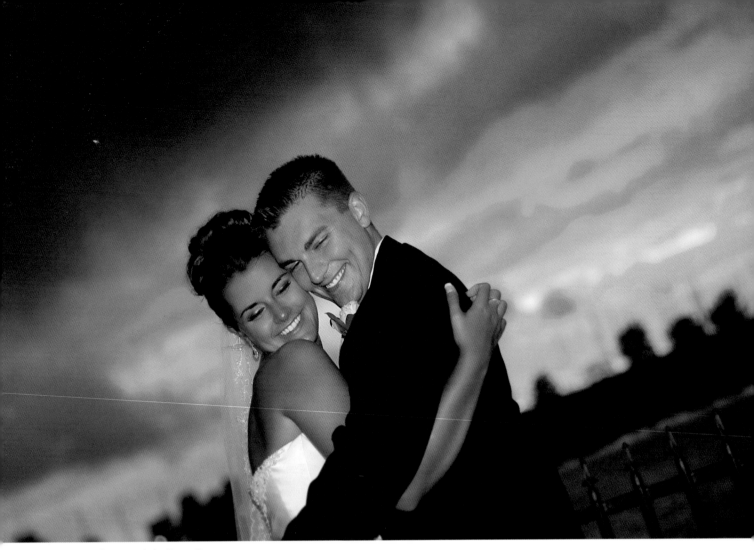

PLATE 85. Photograph by Tracy Dorr.

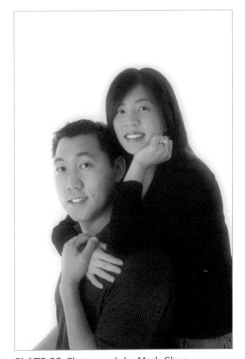

PLATE 86. Photograph by Mark Chen.

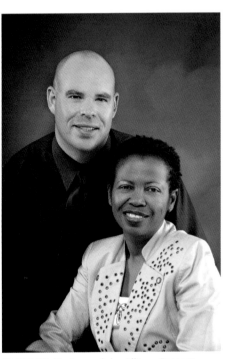

PLATE 87. Photograph by Allison Earnest.

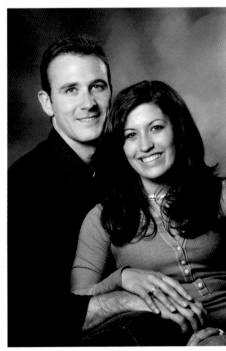

PLATE 88. Photograph by Allison Earnest.

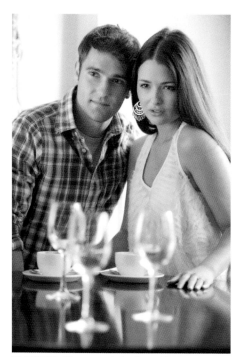

PLATE 89. Photograph by Brett Florens.

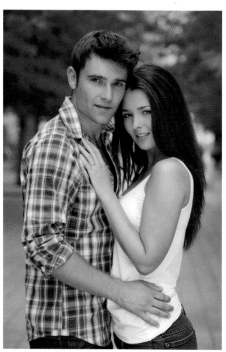

PLATE 90. Photograph by Brett Florens.

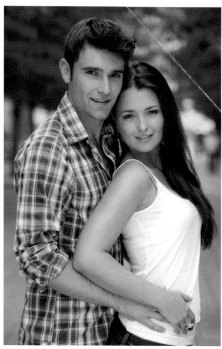

PLATE 91. Photograph by Brett Florens.

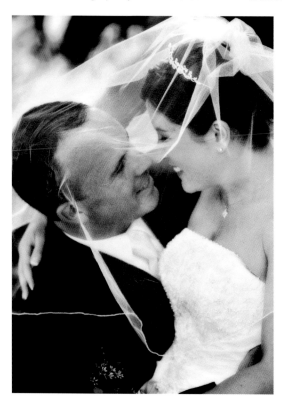

PLATE 92 (ABOVE). Photograph by Jeff Hawkins.

PLATE 93 (RIGHT). Photograph by Brett Florens.

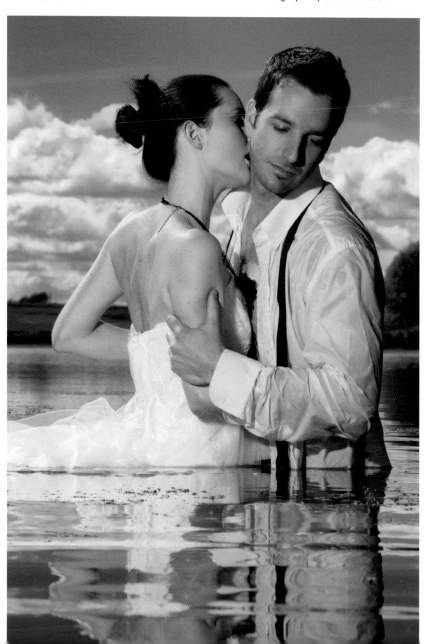

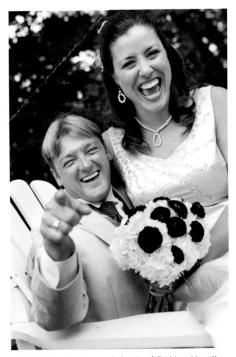

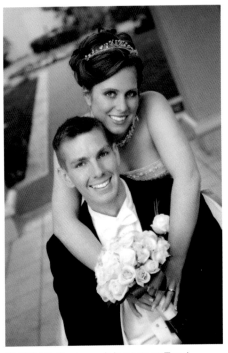

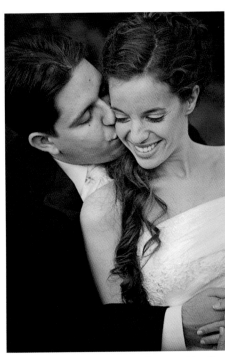

PLATE 94. Photograph by Paul D. Van Hoy II.

PLATE 95. Photograph by Damon Tucci.

PLATE 96. Photograph by Paul D. Van Hoy II.

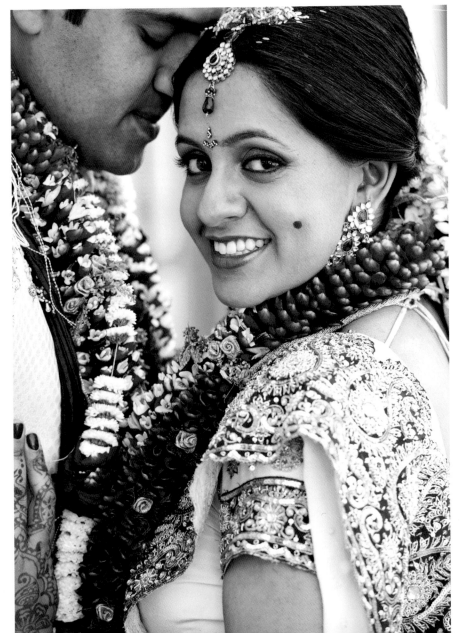

PLATE 97 (LEFT).
Photograph by Regeti's Photography.

PLATE 98 (ABOVE).
Photograph by Regeti's Photography.

PLATE 99 (TOP RIGHT).
Photograph by Regeti's Photography.

PLATE 100 (CENTER RIGHT).
Photograph by Regeti's Photography.

PLATE 101 (BOTTOM RIGHT).
Photograph by Regeti's Photography.

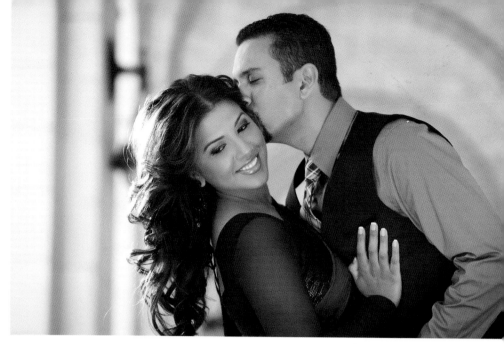

PLATE 102. Photograph by Kevin Kubota.

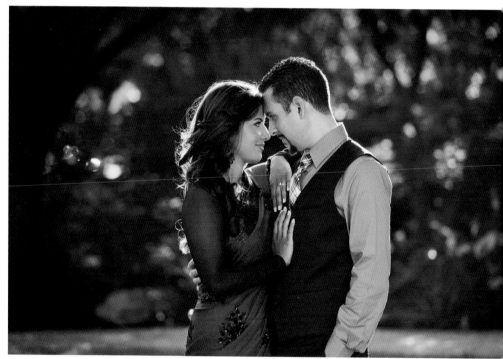

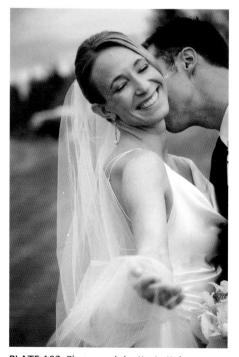

PLATE 103. Photograph by Kevin Kubota.

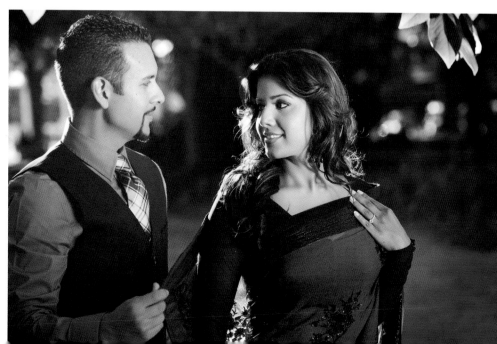

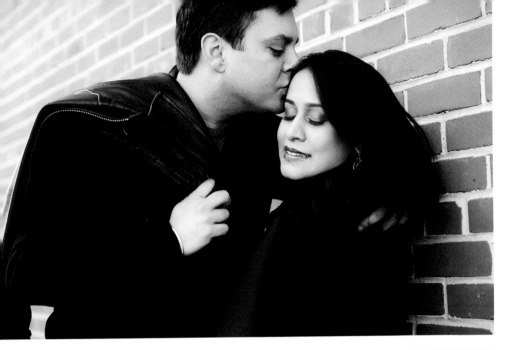

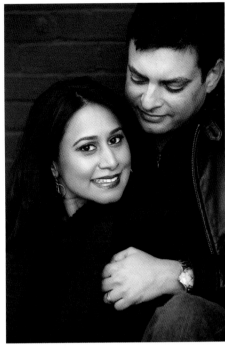

PLATE 104. Photo by Regeti's Photography.

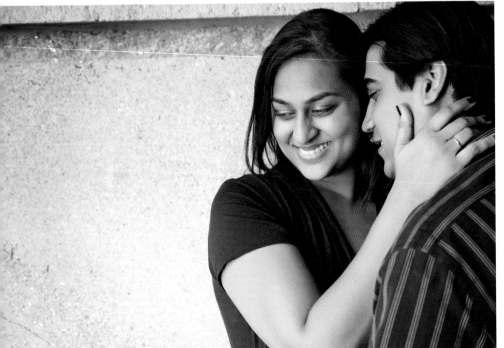

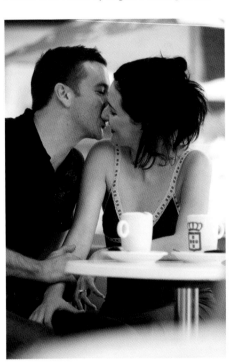

PLATE 105. Photograph by Brett Florens.

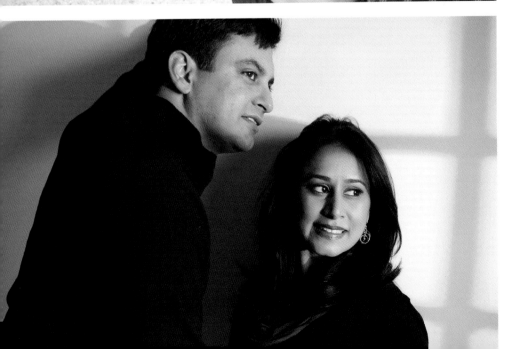

PLATE 106 (TOP LEFT).
Photograph by Regeti's Photography.

PLATE 107 (CENTER LEFT).
Photograph by Regeti's Photography.

PLATE 108 (BOTTOM LEFT).
Photograph by Regeti's Photography.

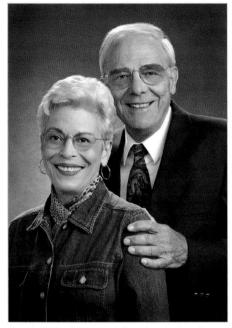

PLATE 109. Photograph by Christopher Grey.

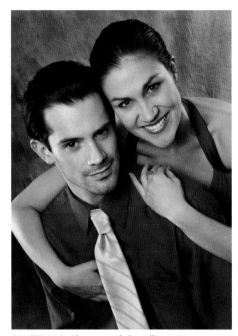

PLATE 110. Photograph by Allison Earnest.

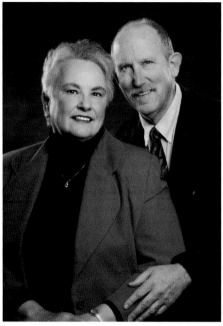

PLATE 111. Photograph by Allison Earnest.

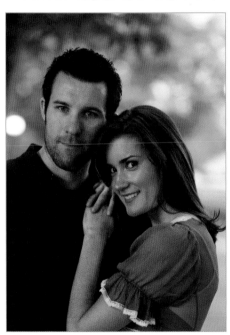

PLATE 112. Photograph by Neil van Niekerk.

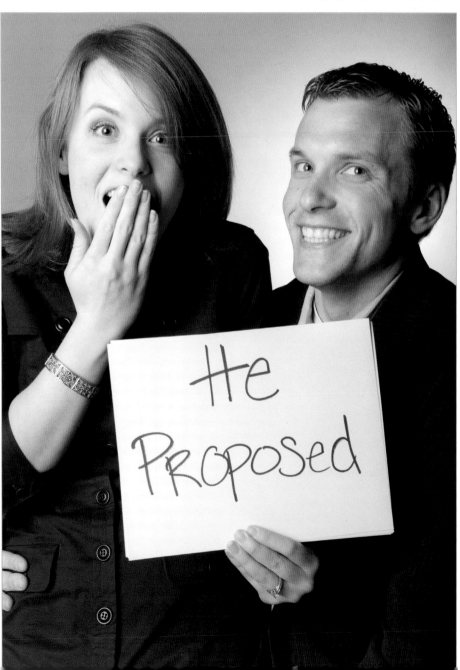

PLATE 113 (RIGHT).
Photograph by Paul D. Van Hoy II.

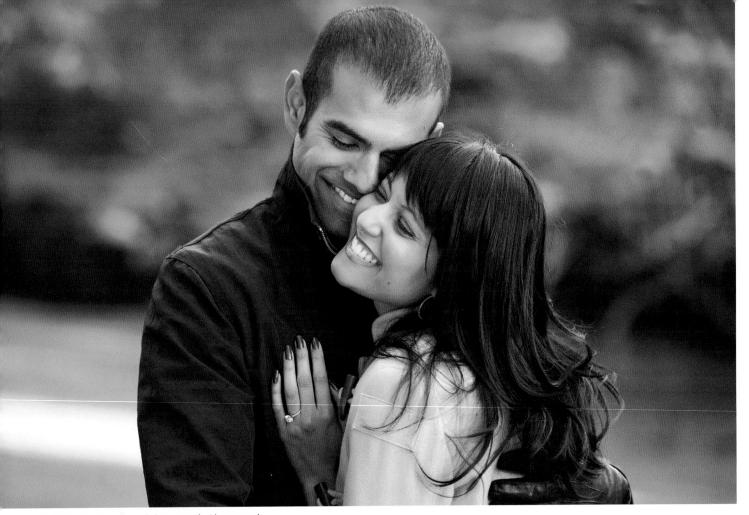

PLATE 114. Photograph by Regeti's Photography.

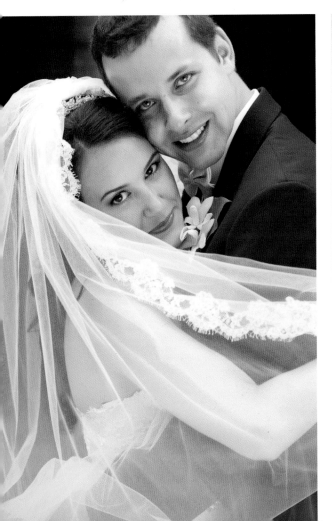

PLATE 115 (LEFT). Photograph by Regeti's Photography.

PLATE 116 (ABOVE). Photograph by Regeti's Photography.

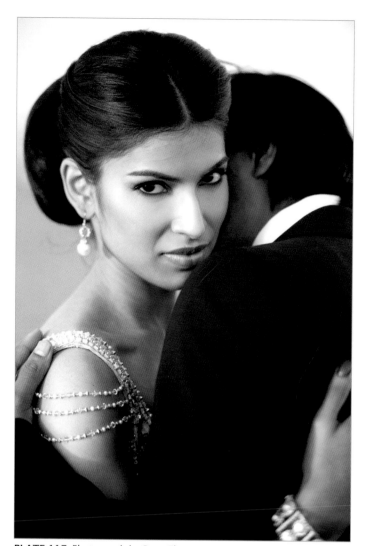

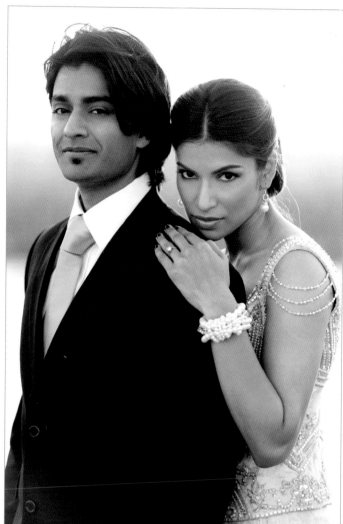

PLATE 117. Photograph by Brett Florens.

PLATE 118. Photograph by Brett Florens.

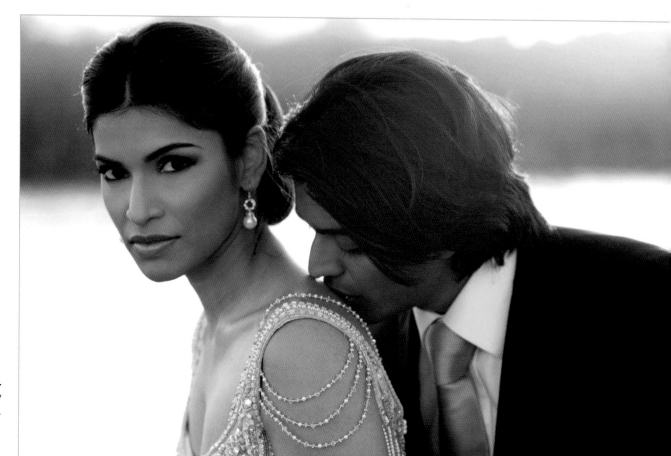

PLATE 119.
Photograph by
Brett Florens.

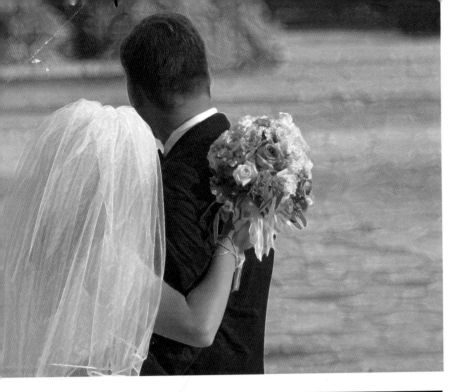

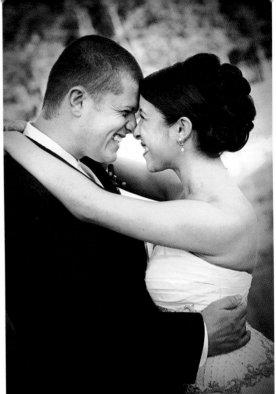

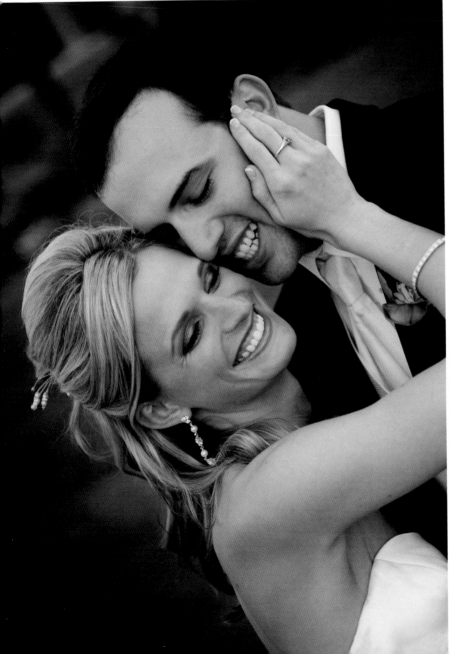

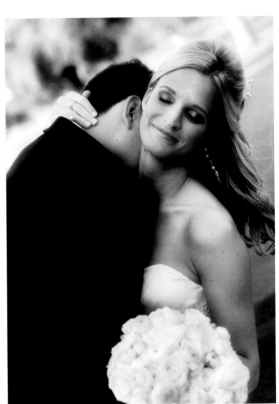

PLATE 120 (LEFT). Photograph by Jeff Hawkins.

PLATE 121 (ABOVE). Photograph by Paul D. Van Hoy II.

PLATE 122 (LEFT).
Photograph by Jeff Hawkins.

PLATE 123 (ABOVE).
Photograph by Jeff Hawkins.

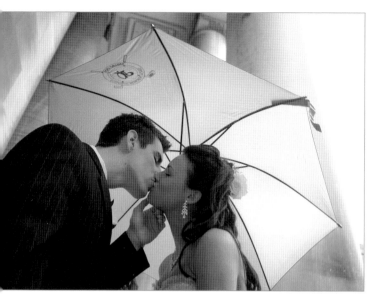

PLATE 124. Photograph by Cal Landau.

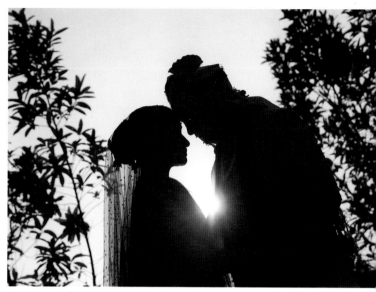

PLATE 125. Photograph by Regeti's Photography.

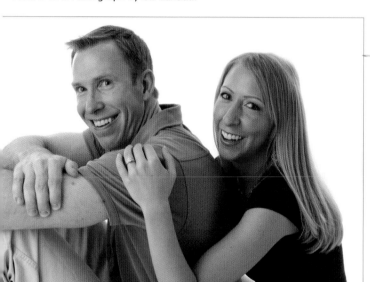

PLATE 126. Photograph by Mark Chen.

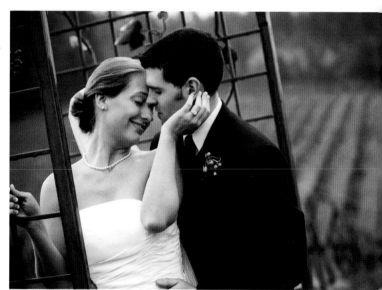

PLATE 127. Photograph by Kevin Kubota.

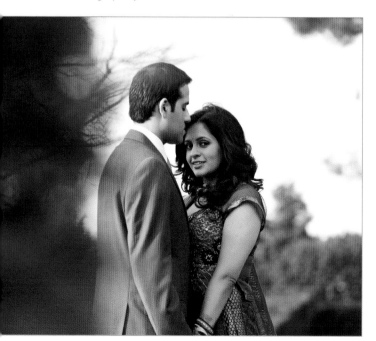

PLATE 128. Photograph by Regeti's Photography.

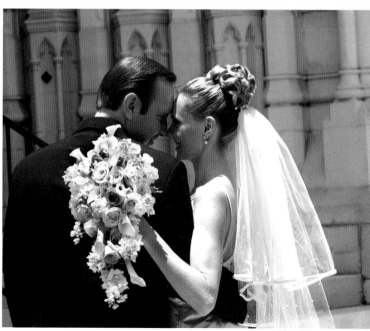

PLATE 129. Photograph by Jeff Hawkins.

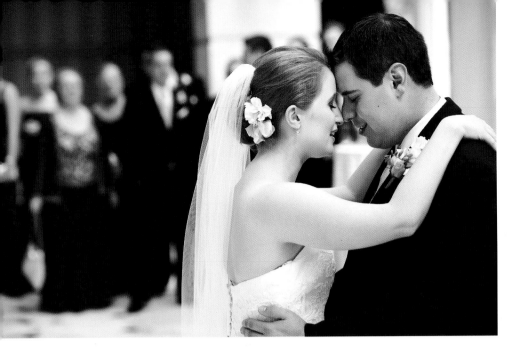

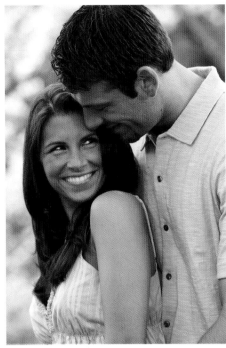

PLATE 130. Photo by Neil van Niekerk.

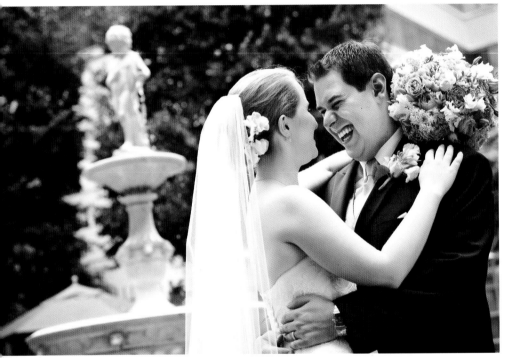

"If you follow a nontraditional vein of photography, you need your clients to understand and appreciate the unusual work that you will provide and not entertain erroneous expectations about formal posing or traditional shots.[4]" —Tracy Dorr

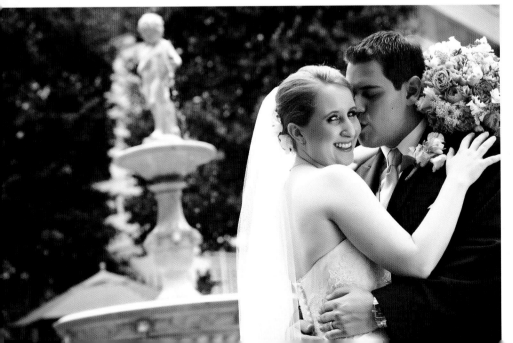

PLATE 131 (TOP LEFT).
Photograph by Regeti's Photography.

PLATE 132 (CENTER LEFT).
Photograph by Regeti's Photography.

PLATE 133 (BOTTOM LEFT).
Photograph by Regeti's Photography.

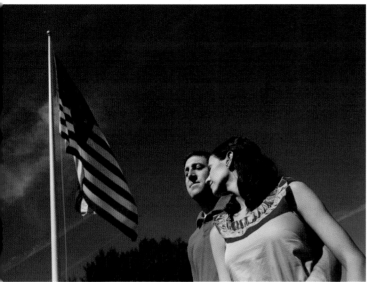

PLATE 134. Photograph by Regeti's Photography.

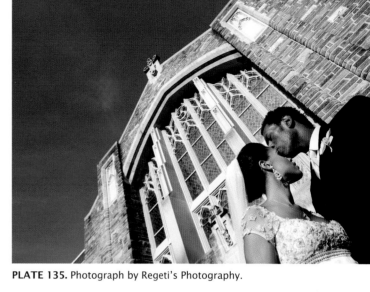

PLATE 135. Photograph by Regeti's Photography.

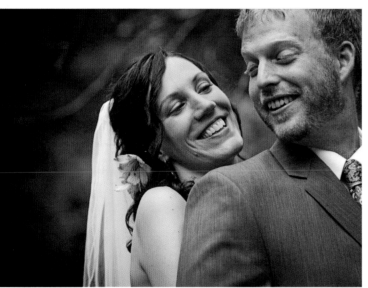

PLATE 136. Photograph by Paul D. Van Hoy II.

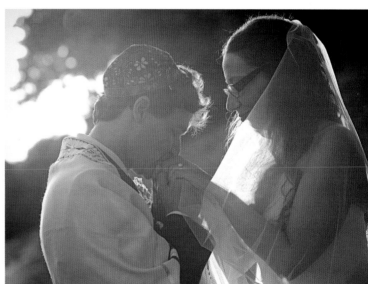

PLATE 137. Photograph by Paul D. Van Hoy II.

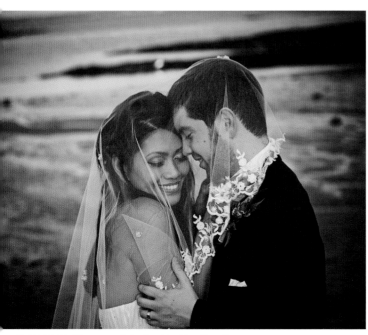

PLATE 138. Photograph by Paul D. Van Hoy II.

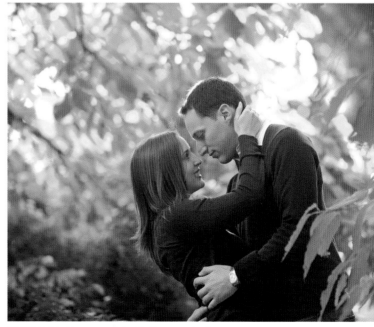

PLATE 139. Photograph by Neil van Niekerk.

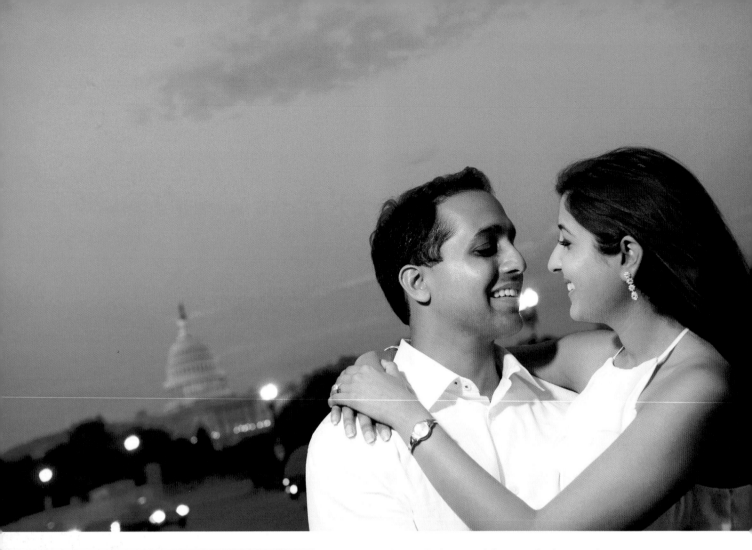

PLATE 140 (ABOVE). Photograph by Regeti's Photography.

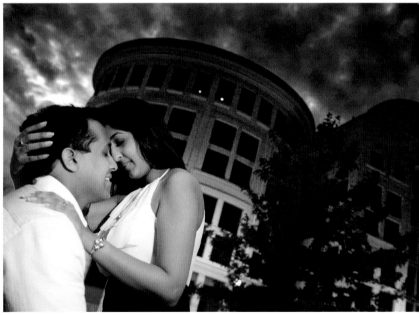

PLATE 141 (LEFT). Photograph by Regeti's Photography.

PLATE 142 (ABOVE). Photograph by Regeti's Photography.

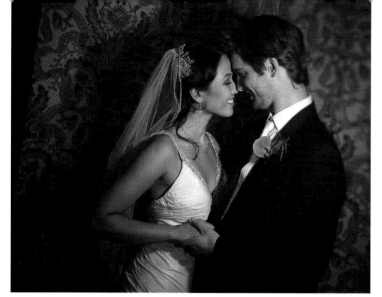

PLATE 143. Photograph by Cherie Steinberg Coté.

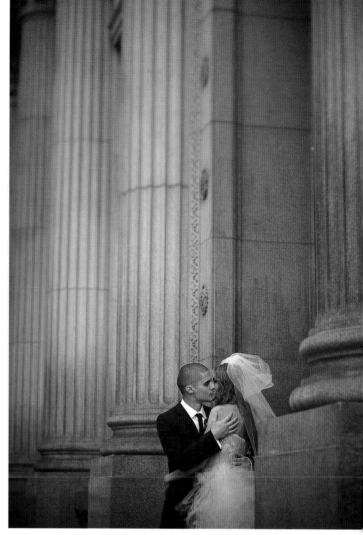

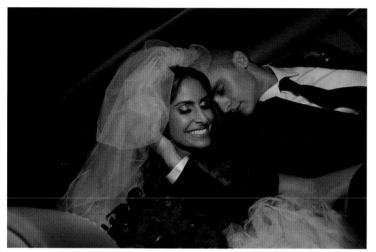

PLATE 144. Photograph by Cherie Steinberg Coté.

PLATE 145. Photograph by Cherie Steinberg Coté.

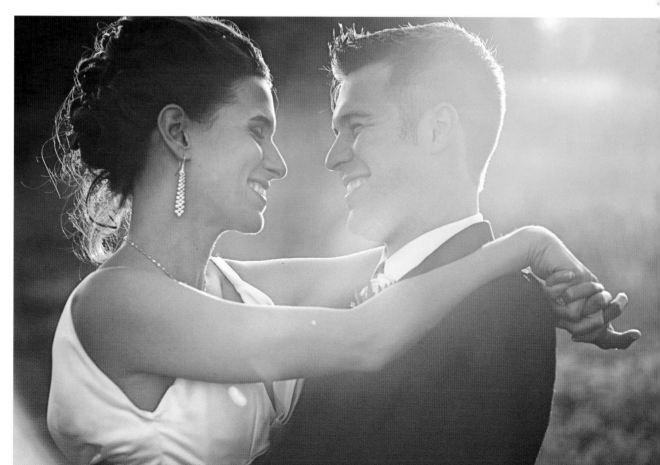

PLATE 146. Photograph by Paul D. Van Hoy II.

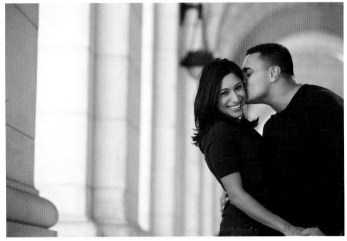

PLATE 147. Photograph by Regeti's Photography.

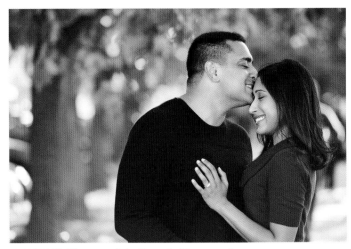

PLATE 148. Photograph by Regeti's Photography.

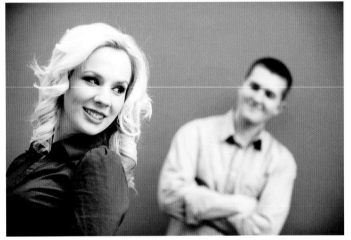

PLATE 149. Photograph by Regeti's Photography.

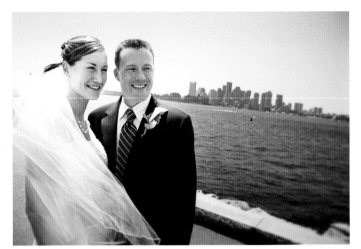

PLATE 150. Photograph by Paul D. Van Hoy II.

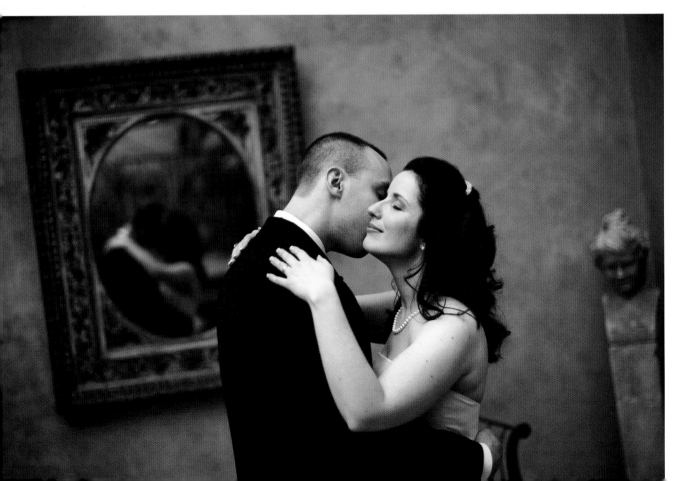

PLATE 151. Photograph by Neil van Niekerk.

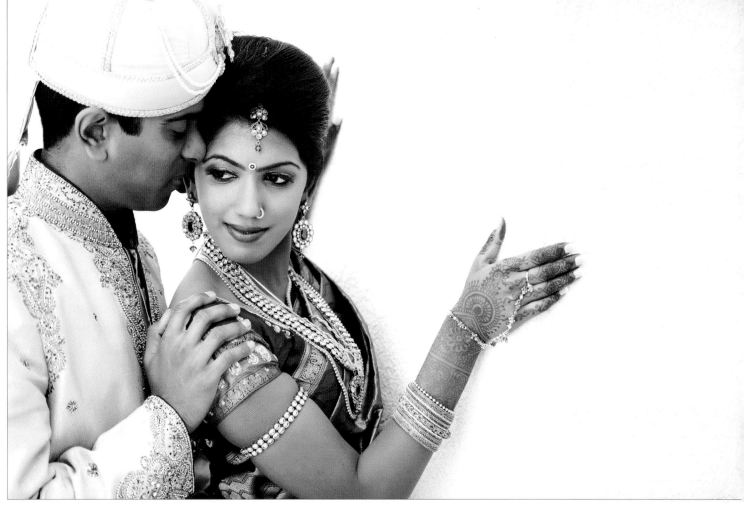

PLATE 152. Photograph by Regeti's Photography.

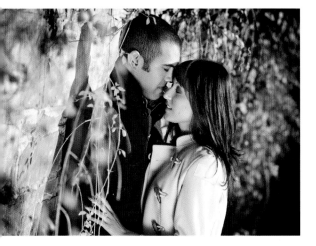

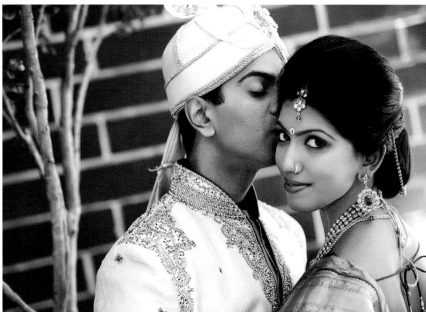

PLATE 153. Photograph by Regeti's Photography.

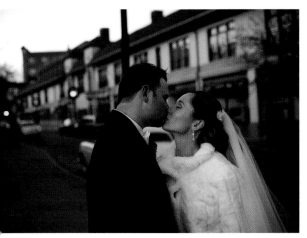

PLATE 154 (ABOVE LEFT). Photograph by Regeti's Photography.

PLATE 155 (BOTTOM LEFT). Photograph by Neil van Niekerk.

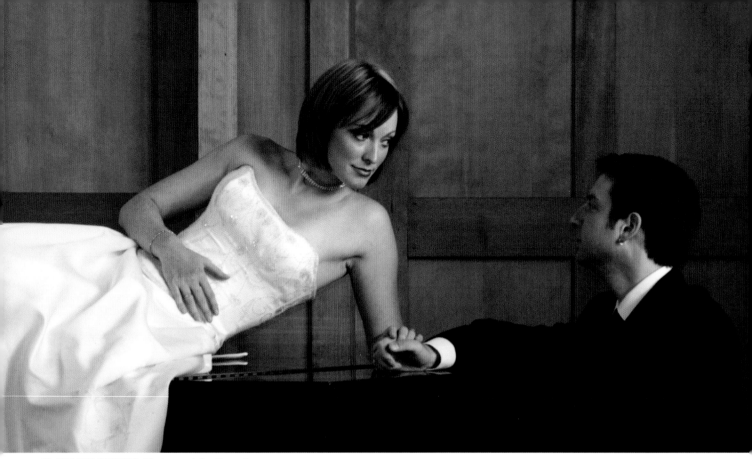

PLATE 156 (ABOVE). Photograph by Doug Box.

PLATE 157 (BELOW). Photograph by Brett Florens.

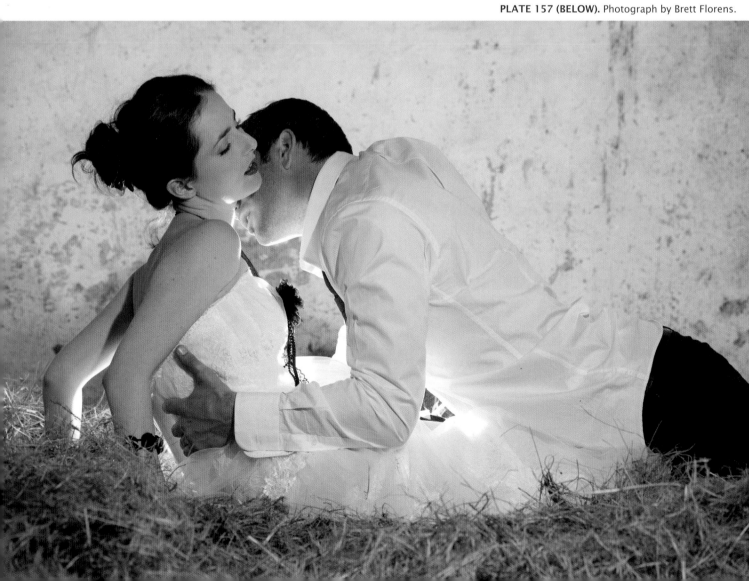

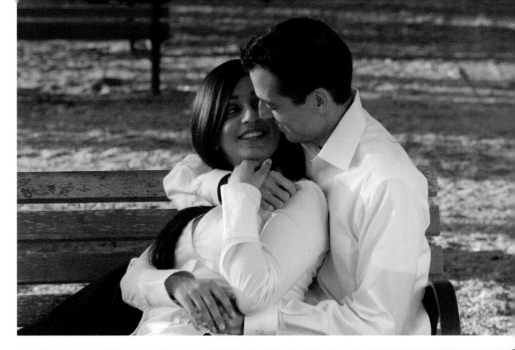

PLATE 158 (TOP RIGHT).
Photograph by Mark Chen.

PLATE 159 (CENTER RIGHT).
Photograph by Regeti's Photography.

PLATE 160 (BOTTOM RIGHT).
Photograph by Paul D. Van Hoy II.

PLATE 161. Photograph by Hernan Rodriguez.

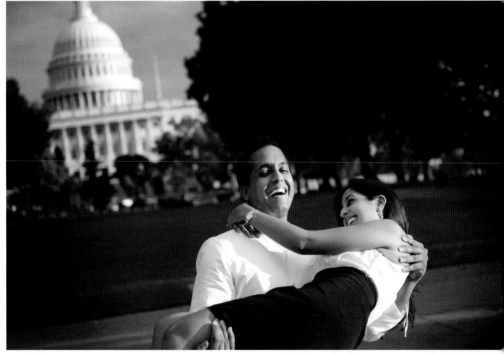

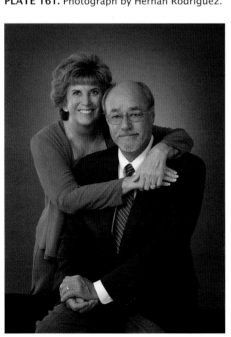

PLATE 162. Photograph by Hernan Rodriguez.

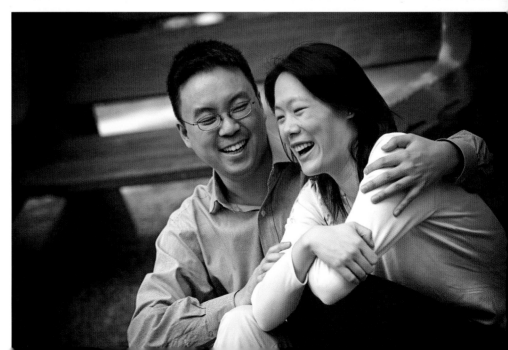

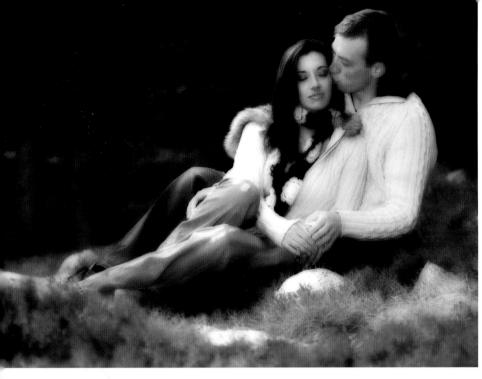

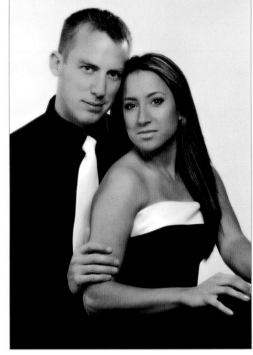

PLATE 163. Photograph by Allison Earnest.

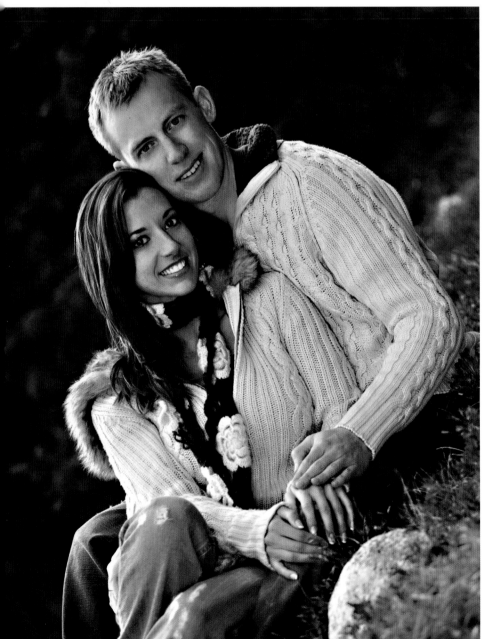

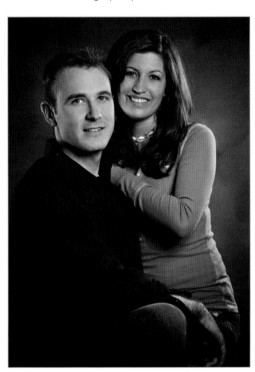

PLATE 164. Photograph by Allison Earnest.

PLATE 165 (TOP LEFT).
Photograph by Allison Earnest.

PLATE 166 (BOTTOM LEFT).
Photograph by Allison Earnest.

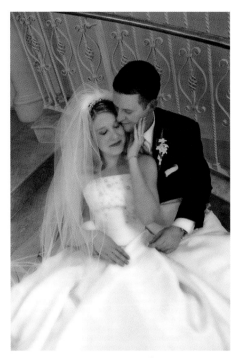

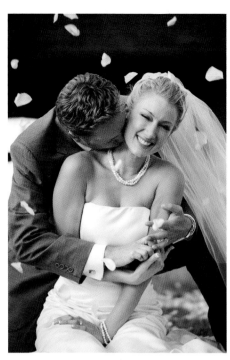

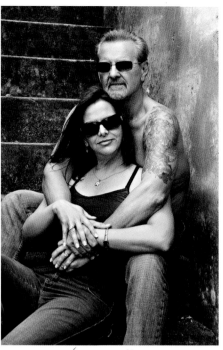

PLATE 167. Photograph by Jeff Hawkins.

PLATE 168. Photograph by Kevin Kubota.

PLATE 169. Photograph by Allison Earnest.

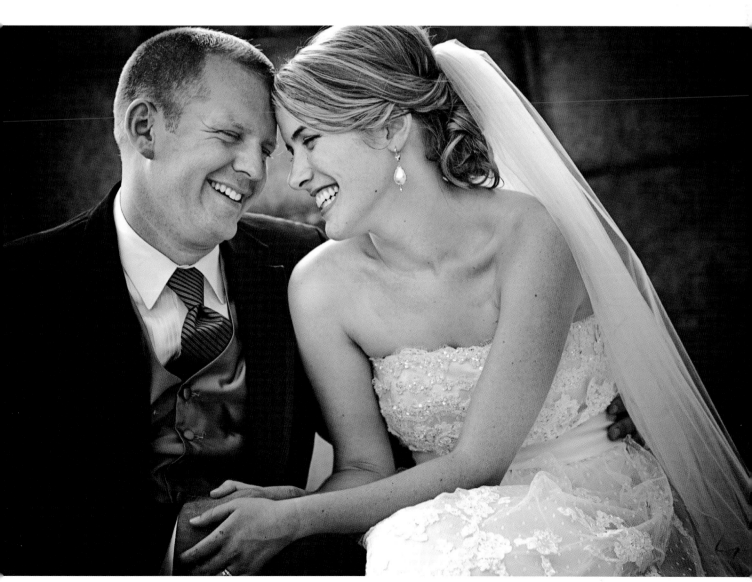

PLATE 170. Photograph by Paul D. Van Hoy II.

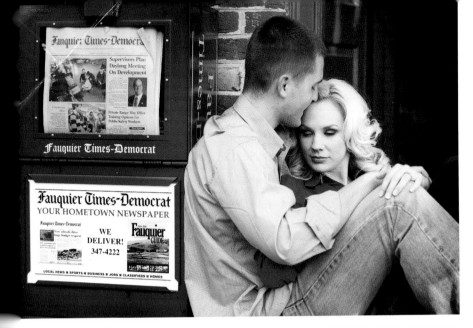

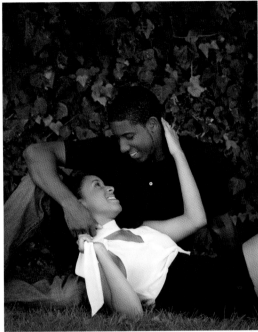

PLATE 171. Photograph by Hernan Rodriguez.

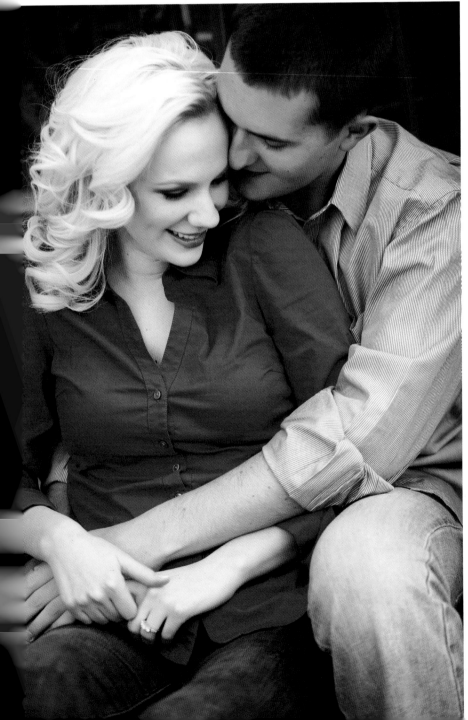

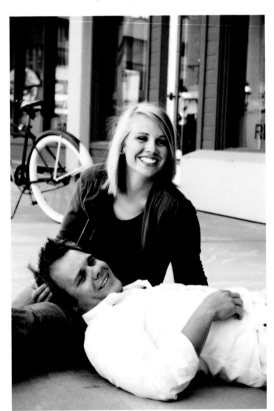

PLATE 172. Photograph by Allison Earnest.

PLATE 173 (TOP LEFT).
Photograph by Photograph by Regeti's Photography.

PLATE 174 (BOTTOM LEFT).
Photograph by Photograph by Regeti's Photography.

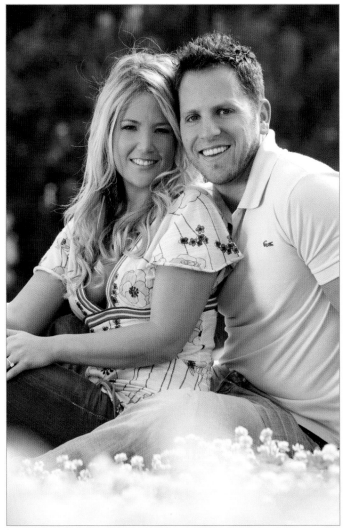

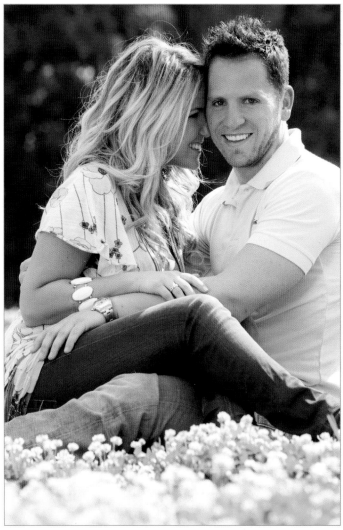

PLATE 175. Photograph by Brett Florens.

PLATE 176. Photograph by Brett Florens.

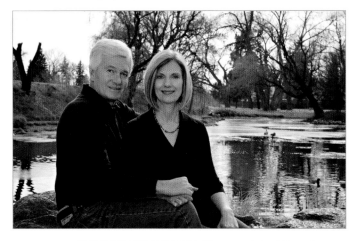

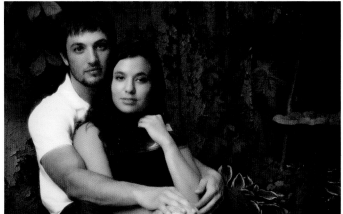

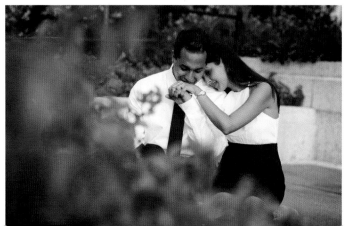

PLATE 177 (ABOVE LEFT). Photograph by Allison Earnest.

PLATE 178 (ABOVE RIGHT). Photograph by Allison Earnest.

PLATE 179 (RIGHT). Photograph by Regeti's Photography.

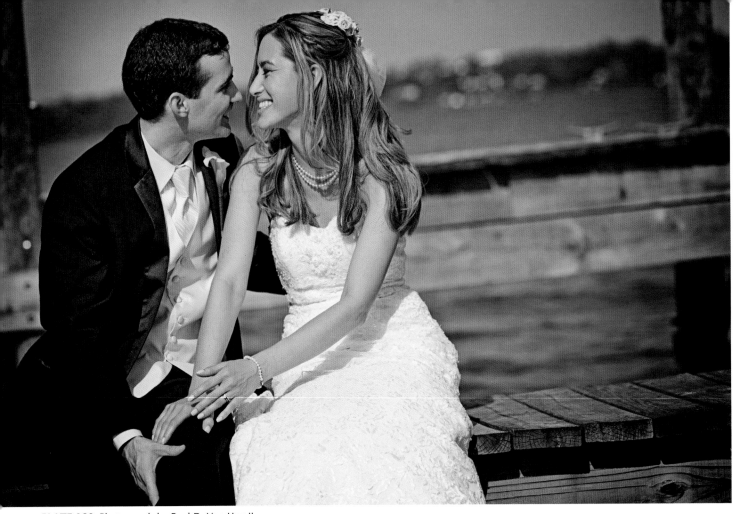

PLATE 180. Photograph by Paul D. Van Hoy II.

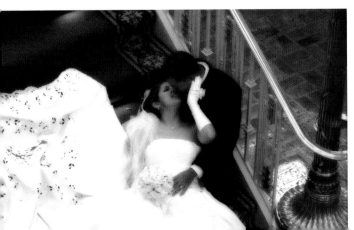

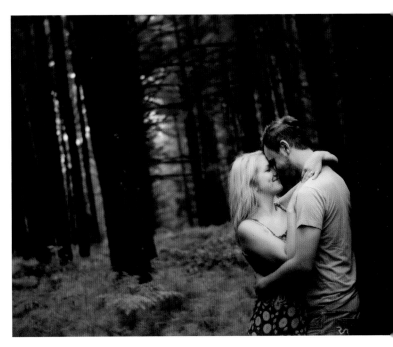

PLATE 181 (ABOVE LEFT). Photograph by Hernan Rodriguez.

PLATE 182 (BOTTOM LEFT). Photograph by Jeff Hawkins.

PLATE 183 (ABOVE). Photograph by Tracy Dorr.

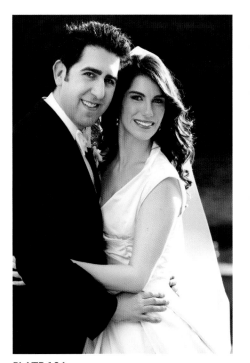

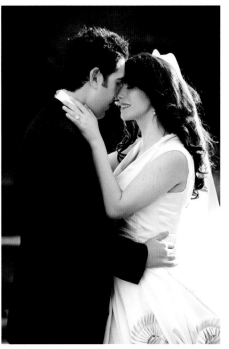

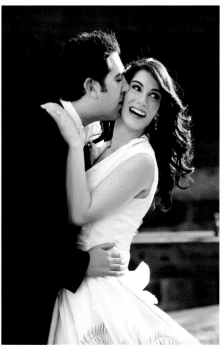

PLATE 184.
Photograph by Regeti's Photography.

PLATE 185.
Photograph by Regeti's Photography.

PLATE 186.
Photograph by Regeti's Photography.

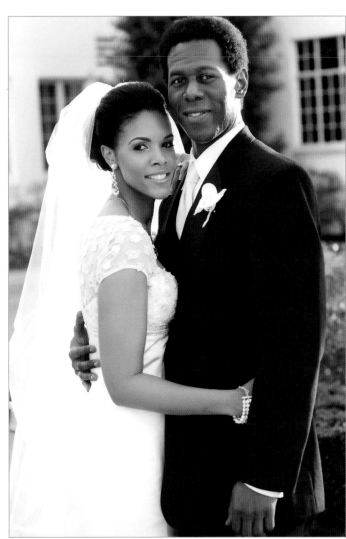

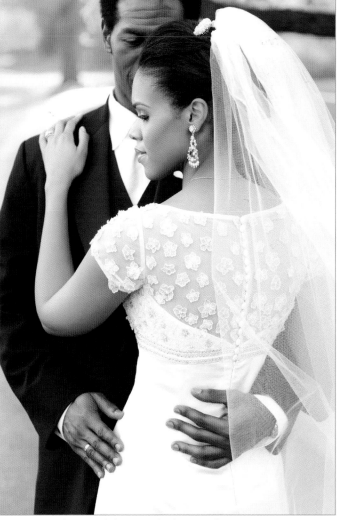

PLATE 187. Photograph by Regeti's Photography.

PLATE 188. Photograph by Regeti's Photography.

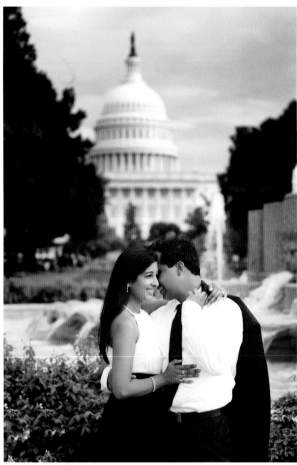

PLATE 189. Photograph by Regeti's Photography.

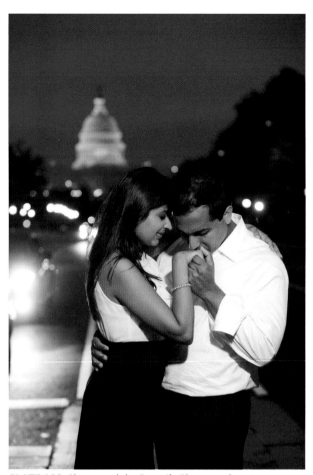

PLATE 190. Photograph by Regeti's Photography.

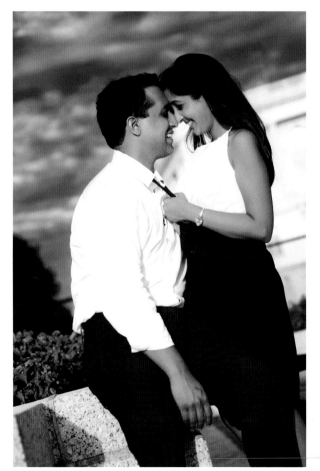

PLATE 191. Photograph by Regeti's Photography.

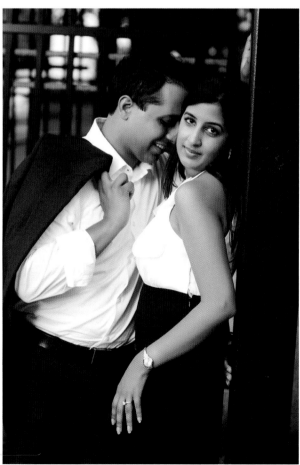

PLATE 192. Photograph by Regeti's Photography.

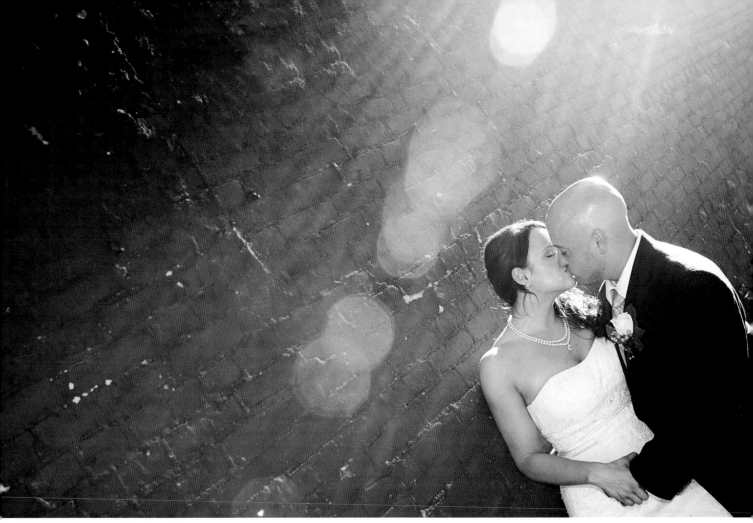

PLATE 193. Photograph by Tracy Dorr.

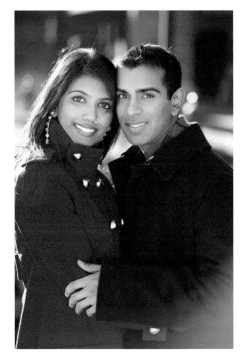

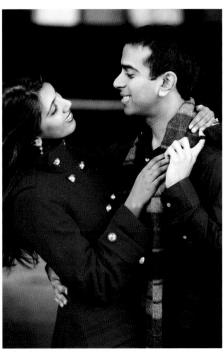

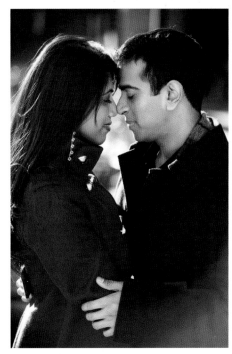

PLATE 194.
Photograph by Regeti's Photography.

PLATE 195.
Photograph by Regeti's Photography.

PLATE 196.
Photograph by Regeti's Photography.

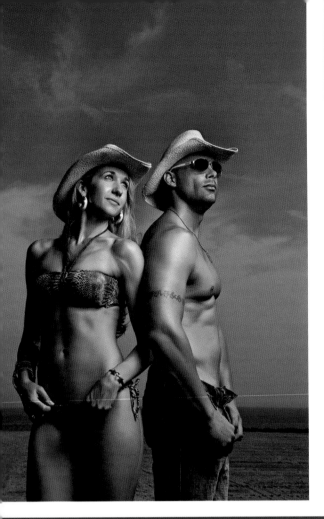
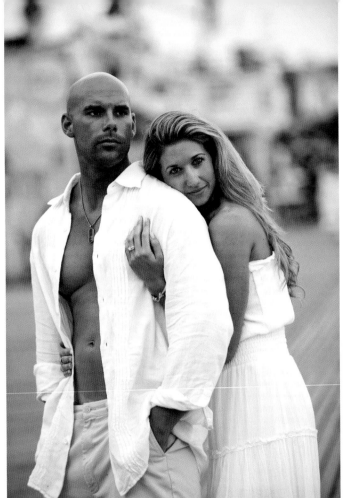
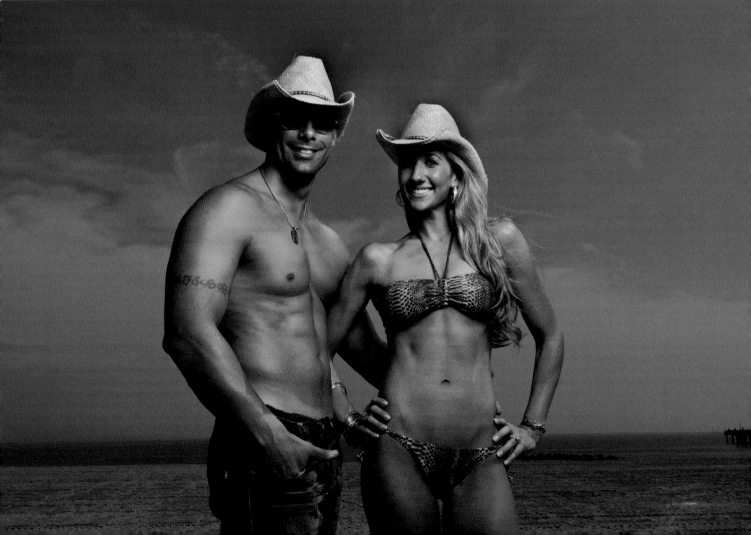

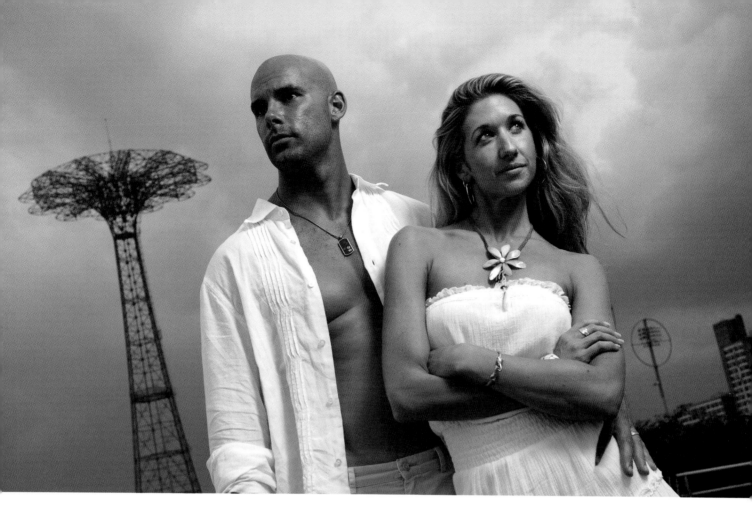

PLATE 197 (FACING PAGE, TOP LEFT). Photograph by Neil van Niekerk.

PLATE 198 (FACING PAGE, TOP RIGHT). Photograph by Neil van Niekerk.

PLATE 199 (FACING PAGE, BOTTOM). Photograph by Neil van Niekerk.

PLATE 200 (ABOVE). Photograph by Neil van Niekerk.

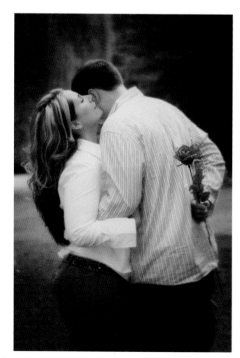

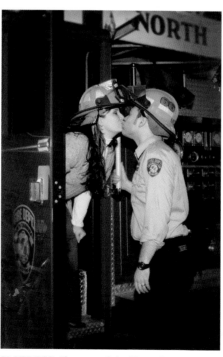

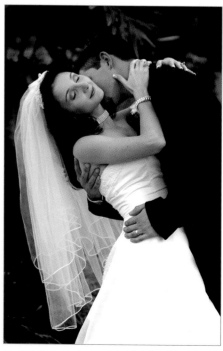

PLATE 201. Photograph by Tracy Dorr.

PLATE 202. Photograph by Tracy Dorr.

PLATE 203. Photograph by Jeff Hawkins.

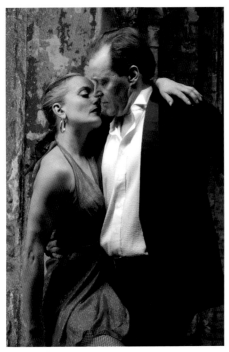

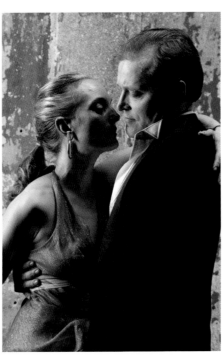

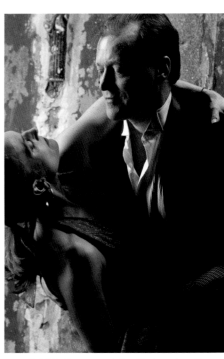

PLATE 204. Photograph by Christopher Grey.

PLATE 205. Photograph by Christopher Grey.

PLATE 206. Photograph by Christopher Grey.

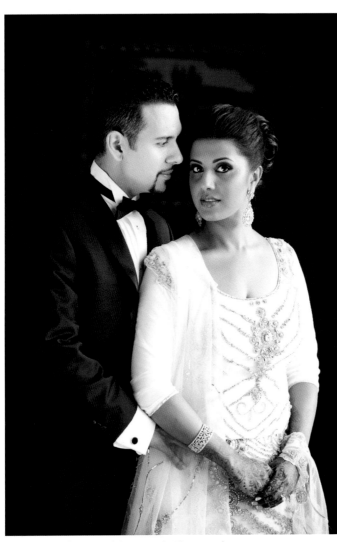

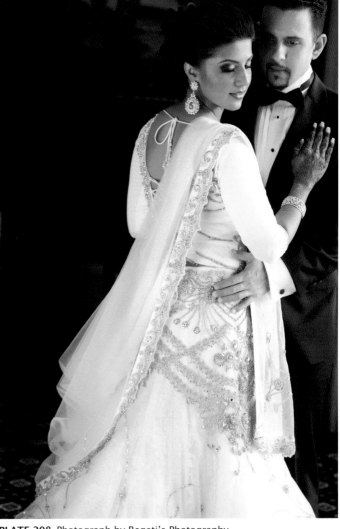

PLATE 207. Photograph by Regeti's Photography.

PLATE 208. Photograph by Regeti's Photography.

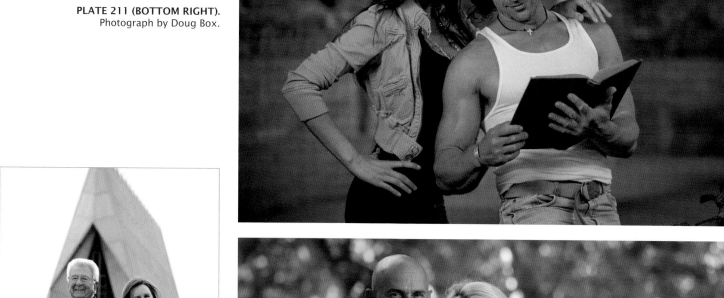

PLATE 209 (TOP RIGHT).
Photograph by Doug Box.

PLATE 210 (CENTER RIGHT).
Photograph by Doug Box.

PLATE 211 (BOTTOM RIGHT).
Photograph by Doug Box.

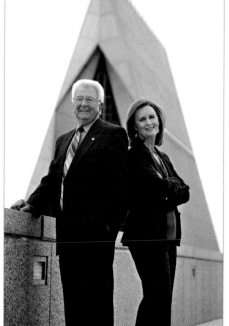

PLATE 212. Photograph by Allison Earnest.

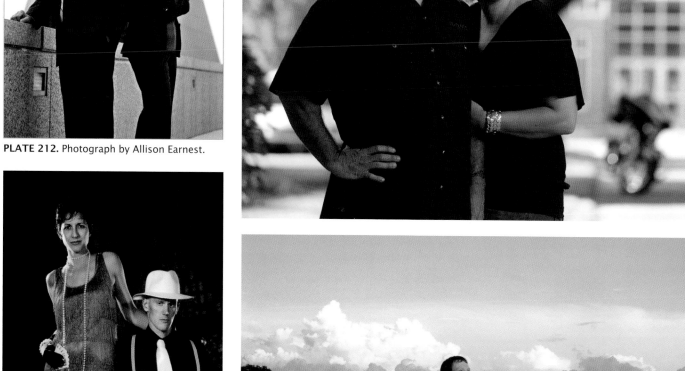

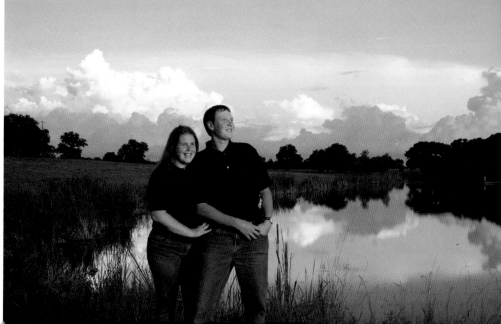

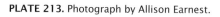

PLATE 213. Photograph by Allison Earnest.

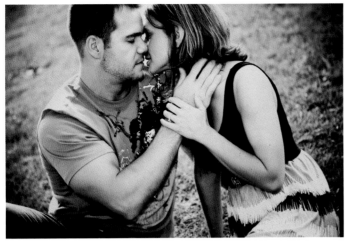

PLATE 214. Photograph by Tracy Dorr.

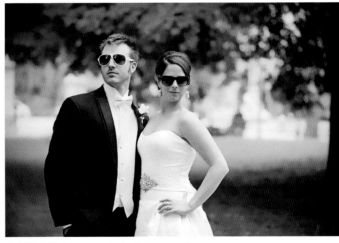

PLATE 215. Photograph by Salvatore Cincotta.

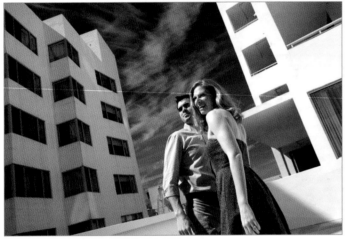

PLATE 216. Photograph by Cal Landau.

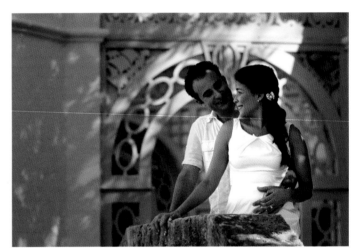

PLATE 217. Photograph by Cal Landau.

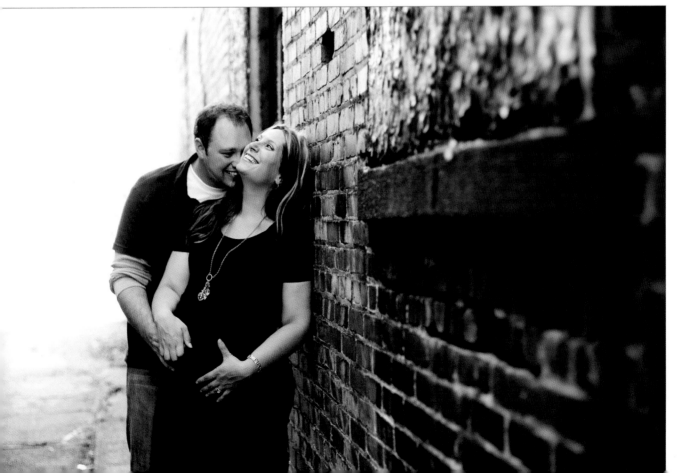

PLATE 218.
Photograph
by Tracy
Dorr.

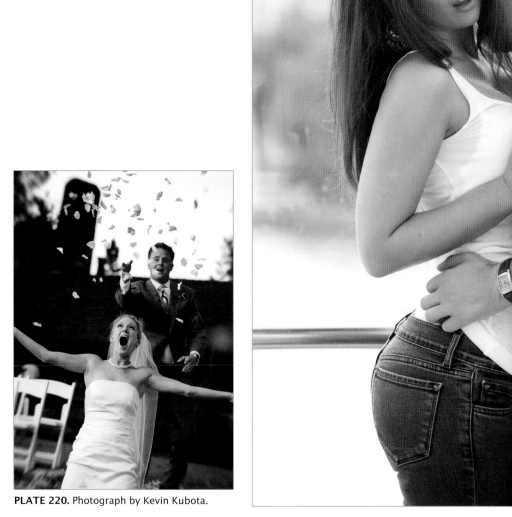

PLATE 219 (RIGHT).
Photograph by Brett Florens.

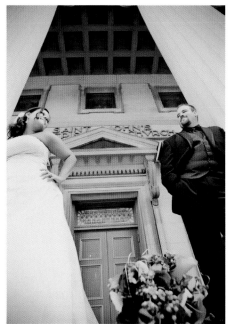

PLATE 220. Photograph by Kevin Kubota.

PLATE 221. Photograph by Salvatore Cincotta.

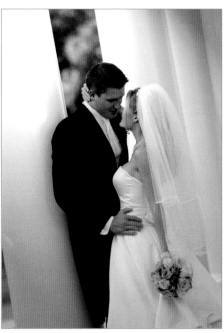

PLATE 222. Photograph by Jeff Hawkins.

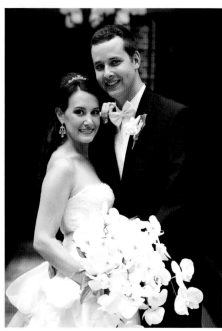

PLATE 223. Photo by Regeti's Photography.

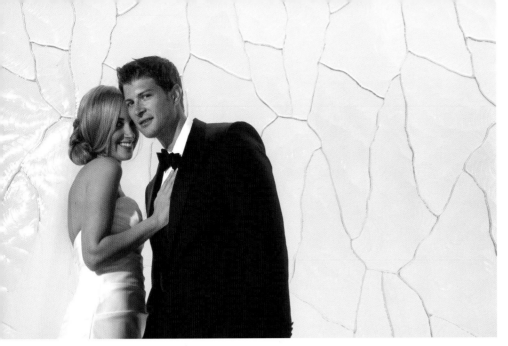

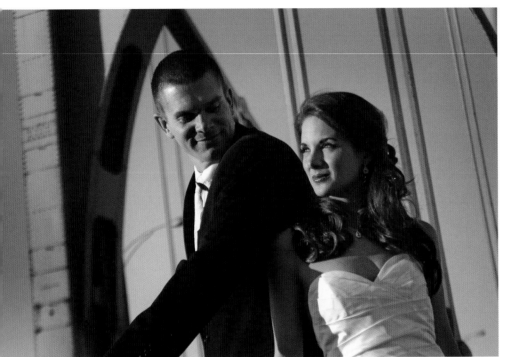

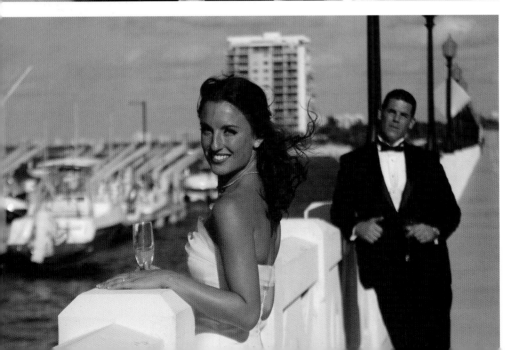

PLATE 224 (TOP LEFT).
Photograph by Cal Landau.

PLATE 225 (CENTER LEFT).
Photograph by Cal Landau.

PLATE 226 (BOTTOM LEFT).
Photograph by Cal Landau.

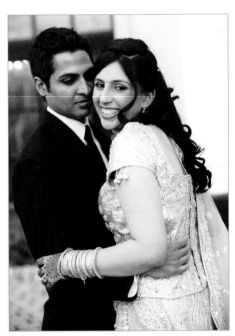

PLATE 227. Photo by Regeti's Photography.

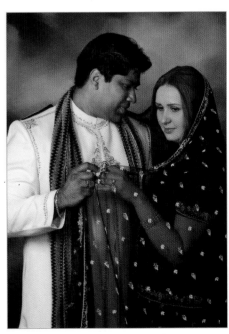

PLATE 228. Photo by Hernan Rodriguez.

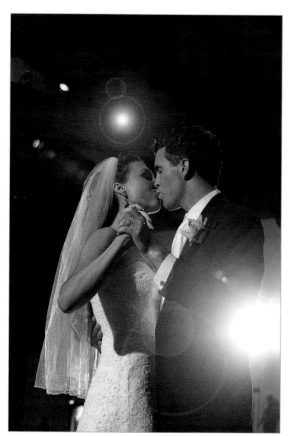

PLATE 229. Photograph by Cherie Steinberg Coté.

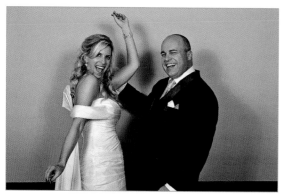

PLATE 230. Photograph by Cherie Steinberg Coté.

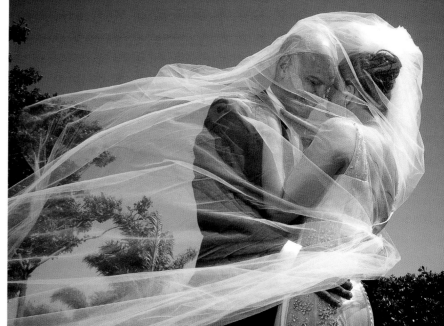

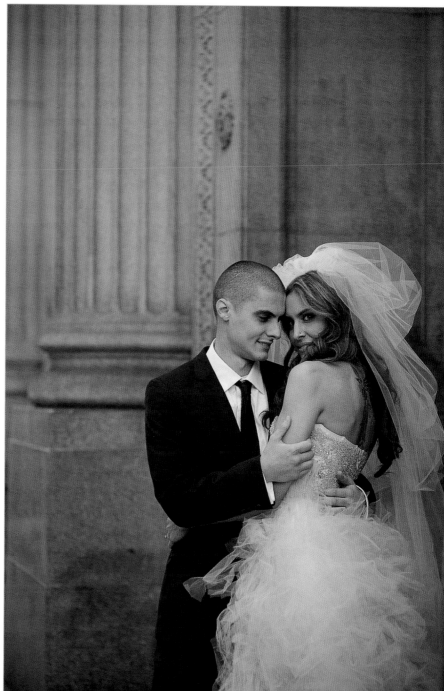

PLATE 231 (TOP RIGHT).
Photograph by Cherie Steinberg Coté.

PLATE 232 (RIGHT).
Photograph by Cherie Steinberg Coté.

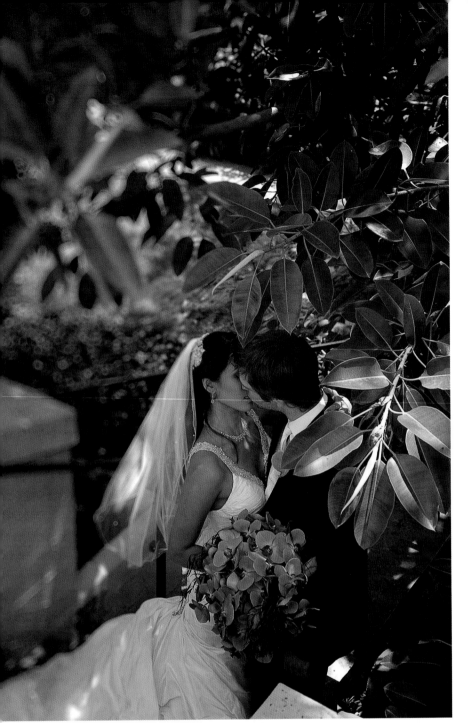

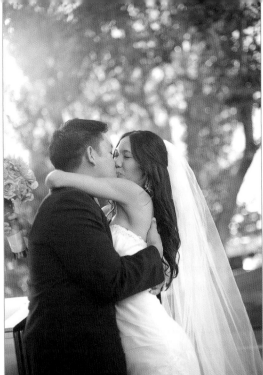

PLATE 233 (LEFT).
Photograph by Cherie Steinberg Coté.

PLATE 234 (ABOVE).
Photograph by Cherie Steinberg Coté.

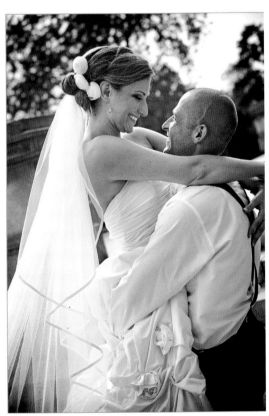

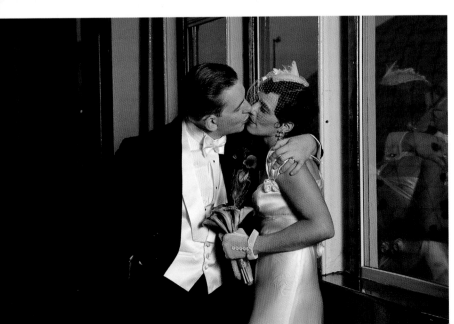

PLATE 235 (ABOVE). Photo by Paul D. Van Hoy II.

PLATE 236 (LEFT). Photo by Cherie Steinberg Coté.

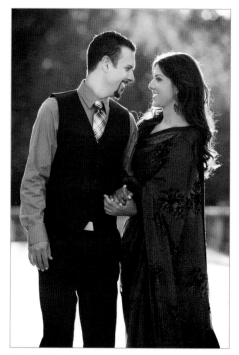

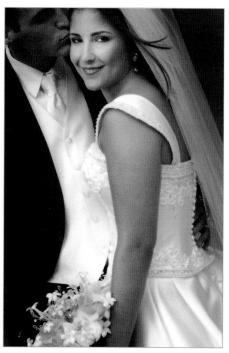

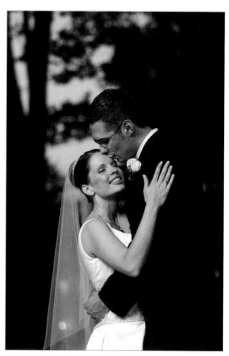

PLATE 237. Photo by Regeti's Photography.

PLATE 238. Photo by Damon Tucci.

PLATE 239. Photo by Neil van Niekerk.

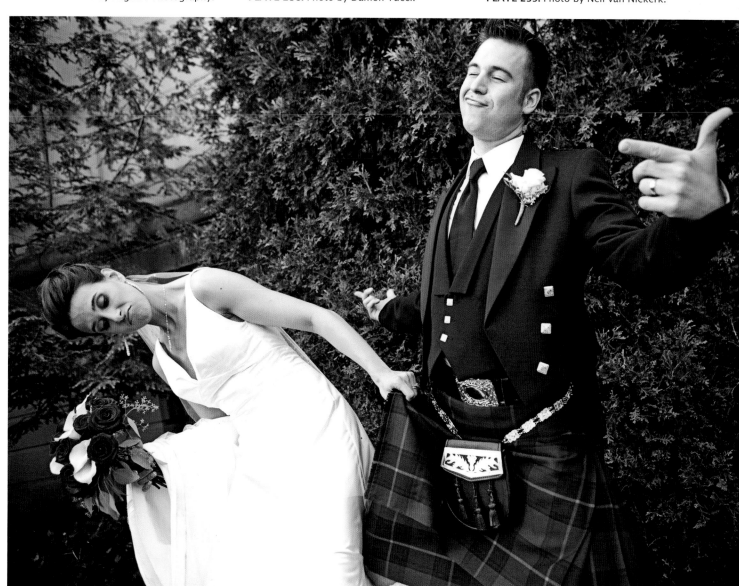

PLATE 240. Photo by Paul D. Van Hoy II.

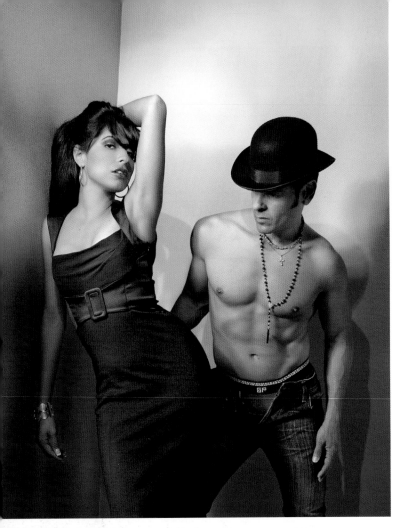

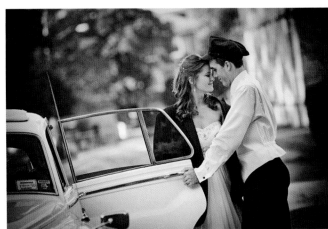

PLATE 241. Photograph by Paul D. Van Hoy II.

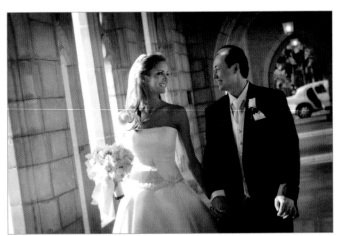

PLATE 242 Photograph by Damon Tucci.

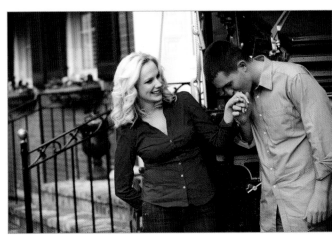

PLATE 243. Photograph by Regeti's Photography.

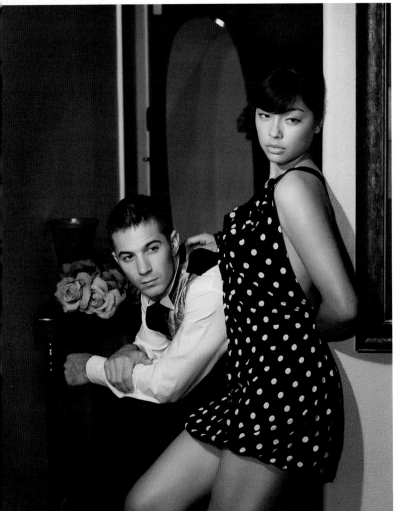

PLATE 244 (TOP LEFT). Photograph by Hernan Rodriguez.

PLATE 245 (BOTTOM LEFT). Photograph by Hernan Rodriguez.

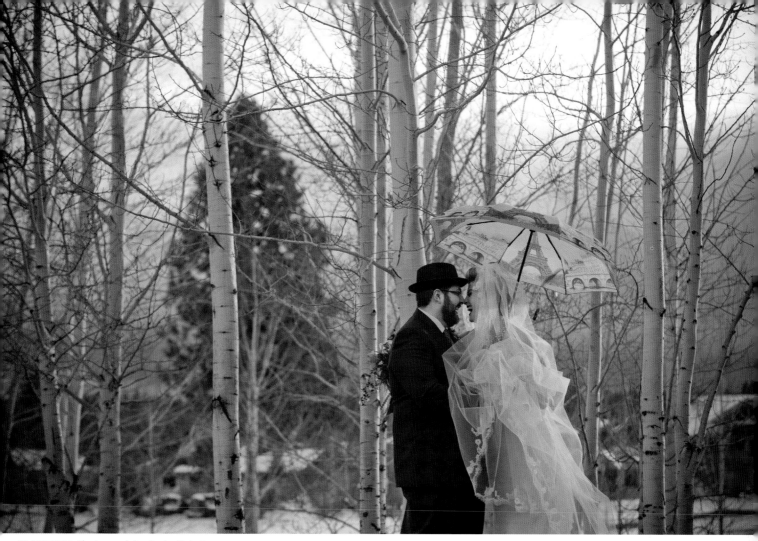

PLATE 246. Photograph by Kevin Kubota.

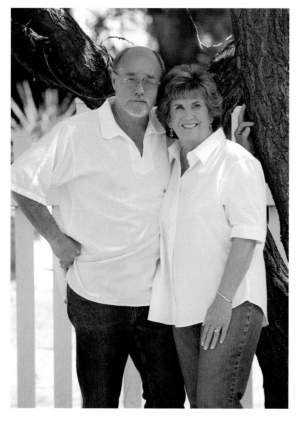

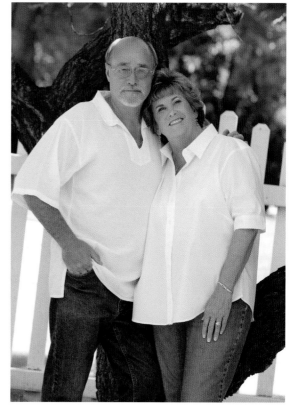

PLATE 247 (LEFT).
Photograph by
Hernan Rodriguez.

PLATE 248 (RIGHT).
Photograph by
Hernan Rodriguez.

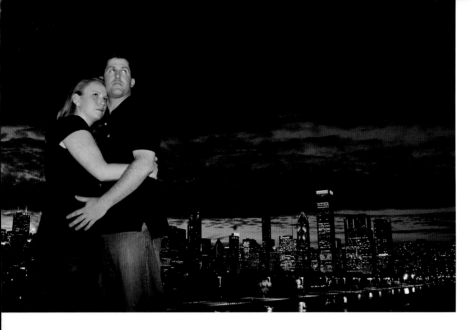

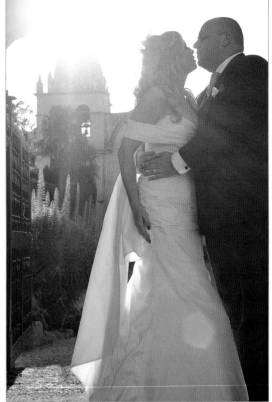

PLATE 249. Photo by Cherie Steinberg Coté.

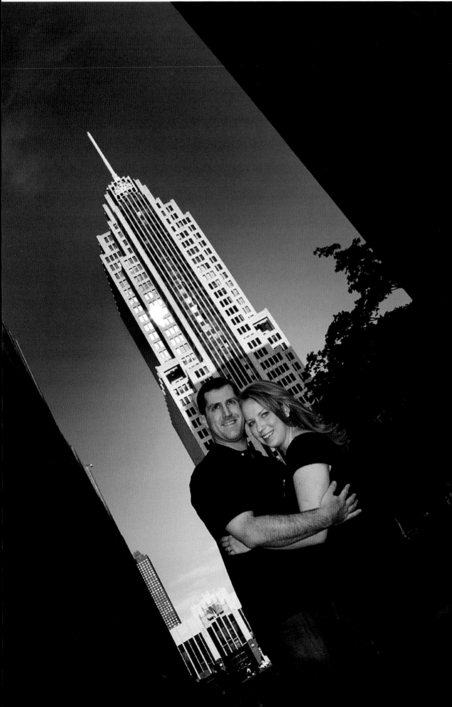

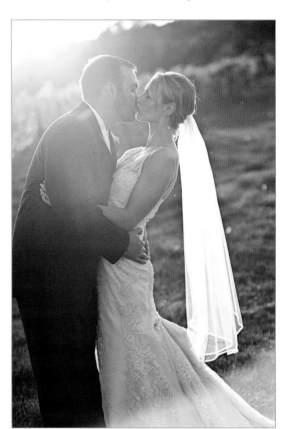

PLATE 250. Photograph by Paul D. Van Hoy II.

PLATE 251 (TOP LEFT).
Photograph by Jeff Hawkins.

PLATE 252 (BOTTOM LEFT).
Photograph by Jeff Hawkins.

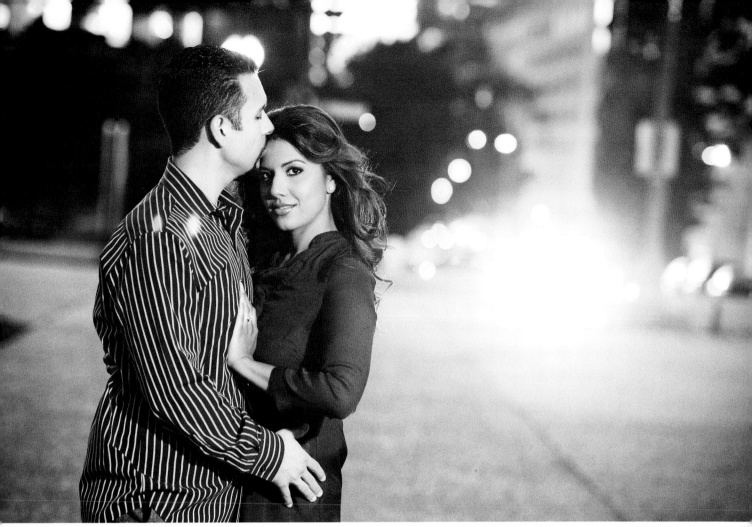

PLATE 253. Photograph by Regeti's Photography.

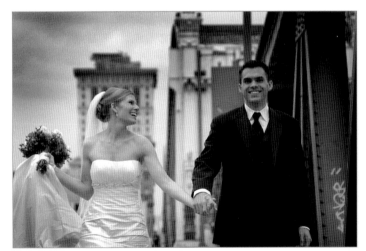

PLATE 254. Photograph by Cal Landau.

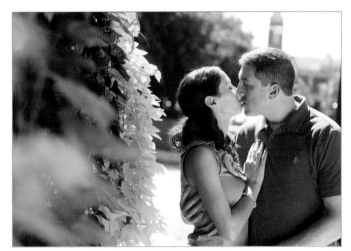

PLATE 255. Photograph by Regeti's Photography.

"Be sure to give guidance and direction to your couple; this is a big area of weakness for so many photographers. It's likely that your couple has never been professionally photographed together, so be prepared to contend with some camera shyness.[5]" —Paul D. Van Hoy II

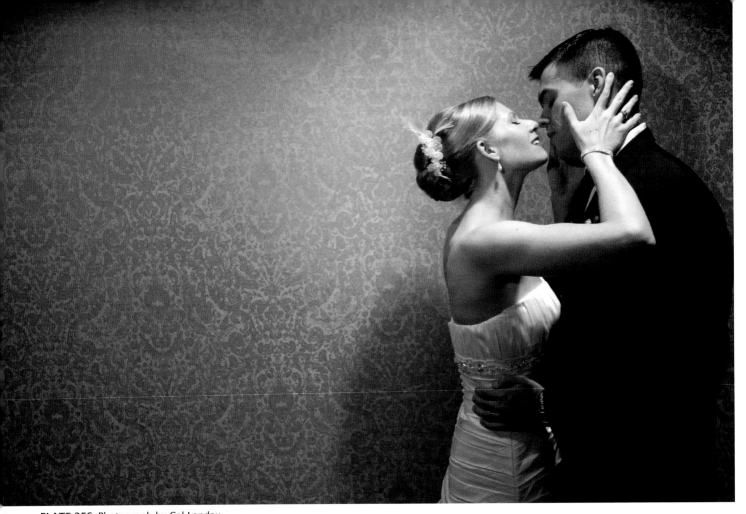

PLATE 256. Photograph by Cal Landau.

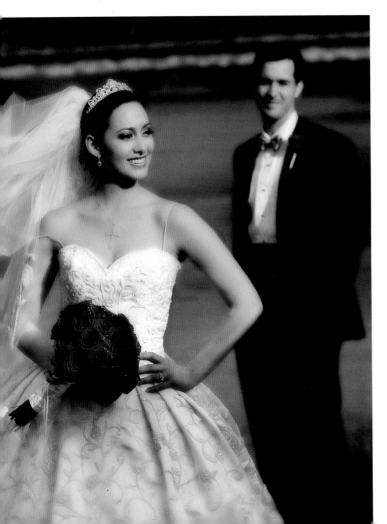

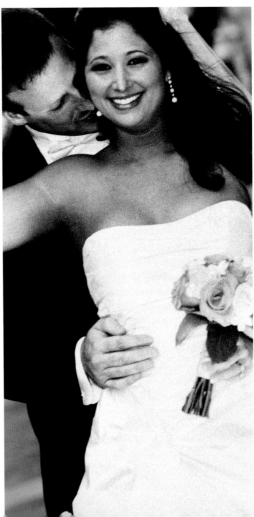

PLATE 257. Photograph by Jeff Hawkins.

PLATE 258. Photograph by Jeff Hawkins.

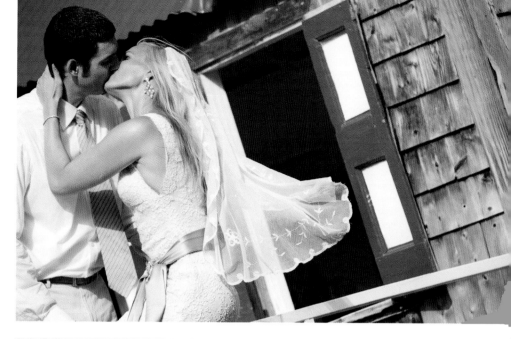

PLATE 259 (TOP RIGHT).
Photograph by Kevin Kubota.

PLATE 260 (CENTER RIGHT).
Photograph by Kevin Kubota.

PLATE 261 (BOTTOM RIGHT).
Photograph by Paul D. Van Hoy II.

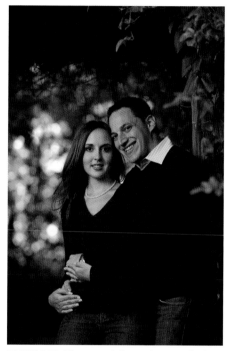

PLATE 262. Photograph by Neil van Niekerk.

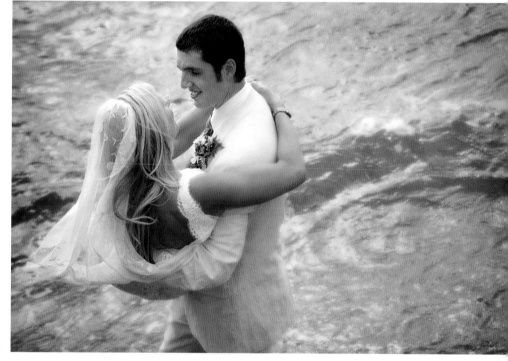

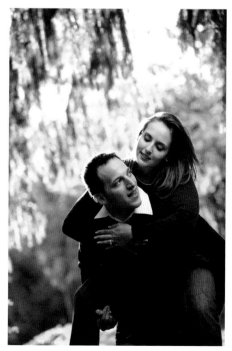

PLATE 263. Photograph by Neil van Niekerk.

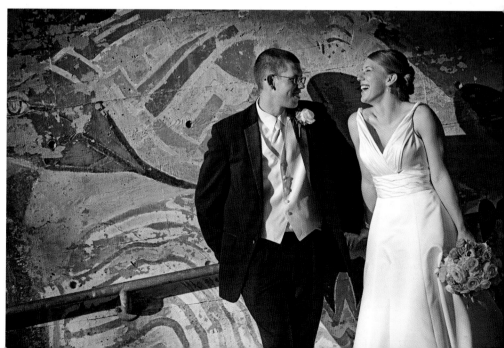

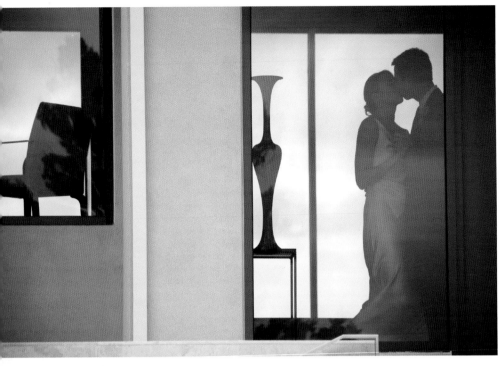

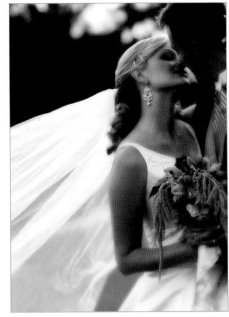

PLATE 264. Photograph by Jeff Hawkins.

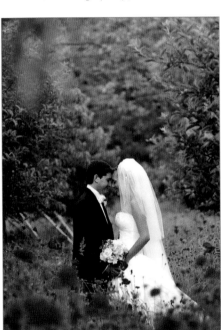

PLATE 265. Photograph by Jeff Hawkins.

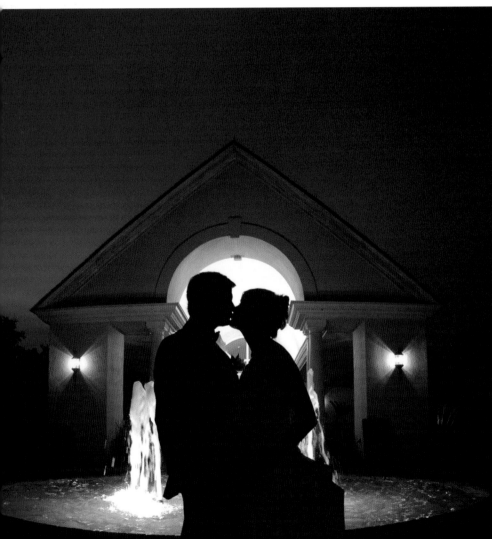

PLATE 266 (TOP LEFT).
Photograph by Kevin Kubota.

PLATE 267 (BOTTOM LEFT).
Photograph by Damon Tucci.

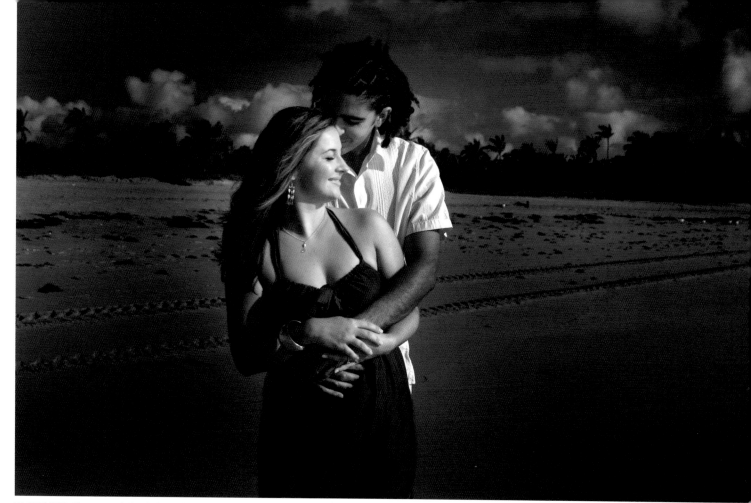

PLATE 268. Photograph by Cal Landau.

PLATE 269. Photograph by Neil van Niekerk.

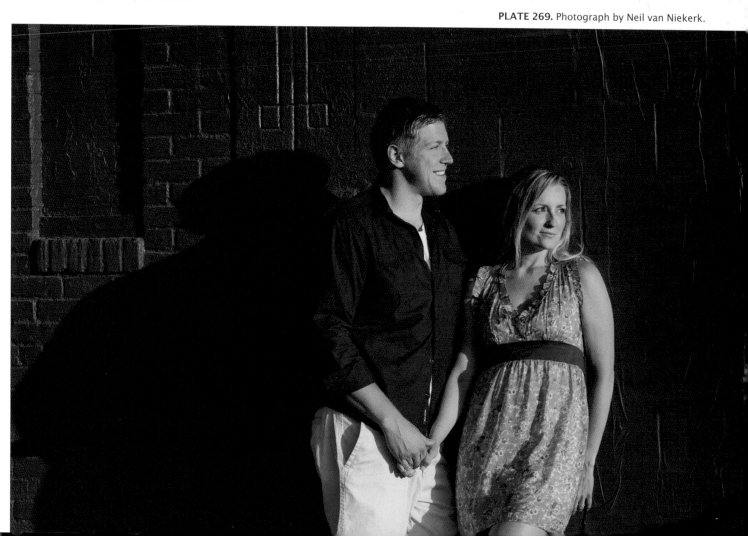

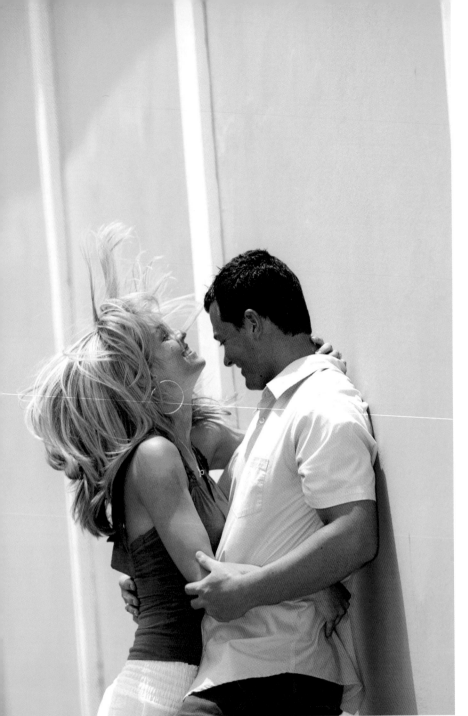

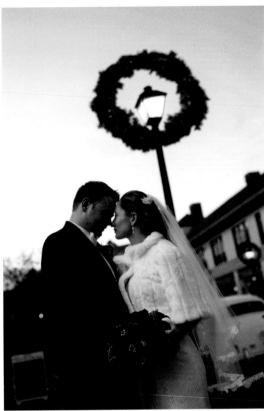

PLATE 270. Photograph by Neil van Niekerk.

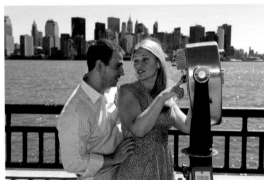

PLATE 271. Photograph by Neil van Niekerk.

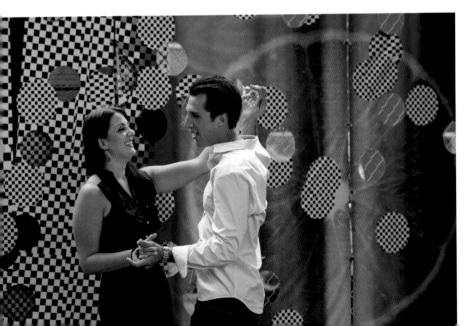

PLATE 272 (TOP LEFT).
Photograph by Neil van Niekerk.

PLATE 273 (BOTTOM LEFT).
Photograph by Neil van Niekerk.

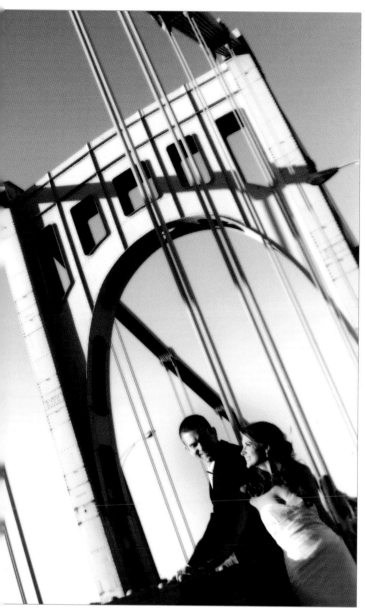

PLATE 274. Photograph by Cal Landau.

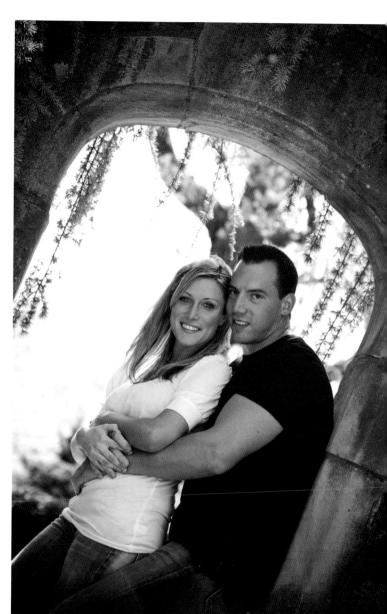

PLATE 275. Photograph by Neil van Niekerk.

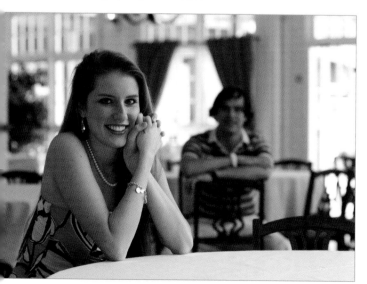

PLATE 276. Photograph by Neil van Niekerk.

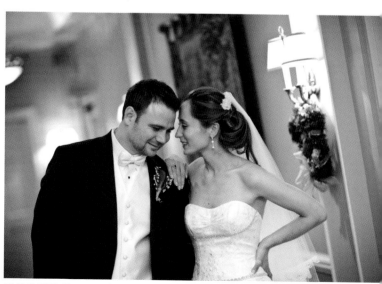

PLATE 277. Photograph by Neil van Niekerk.

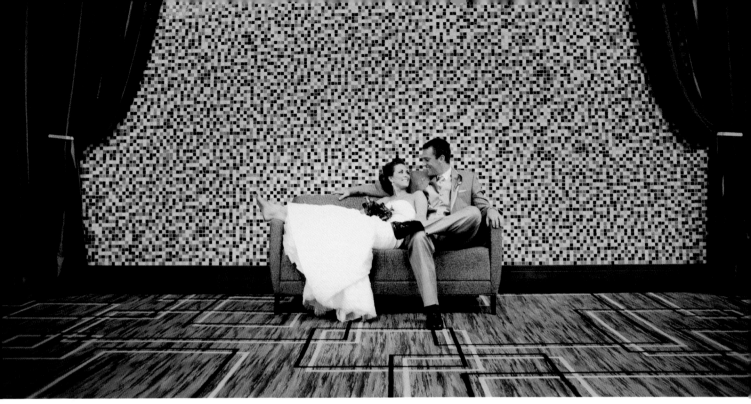

PLATE 278. Photograph by Salvatore Cincotta.

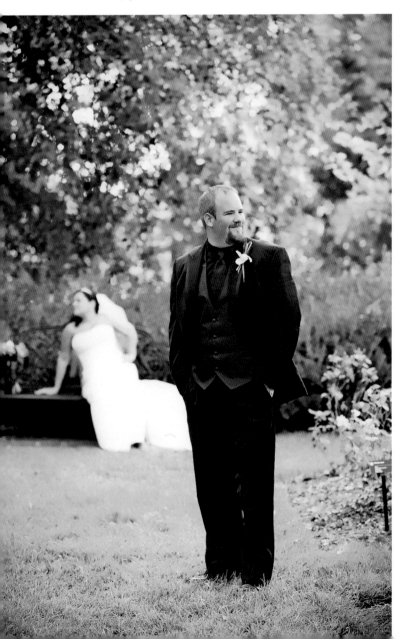

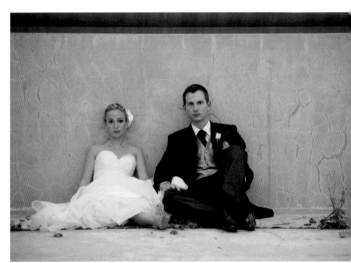

PLATE 279. Photograph by Brett Florens.

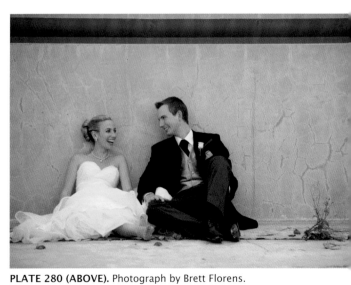

PLATE 280 (ABOVE). Photograph by Brett Florens.

PLATE 281 (LEFT). Photograph by Salvatore Cincotta.

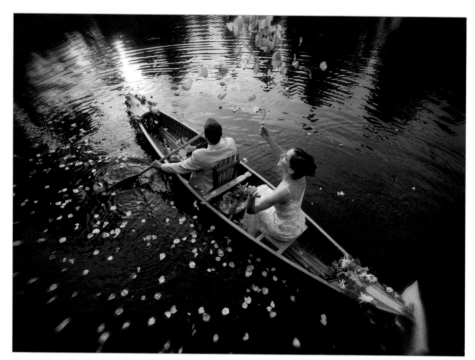

PLATE 282. Photograph by Kevin Kubota

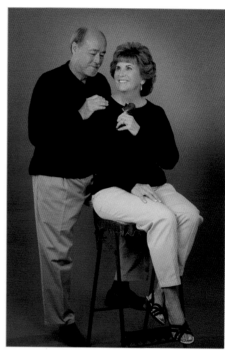

PLATE 283. Photograph by Hernan Rodriguez.

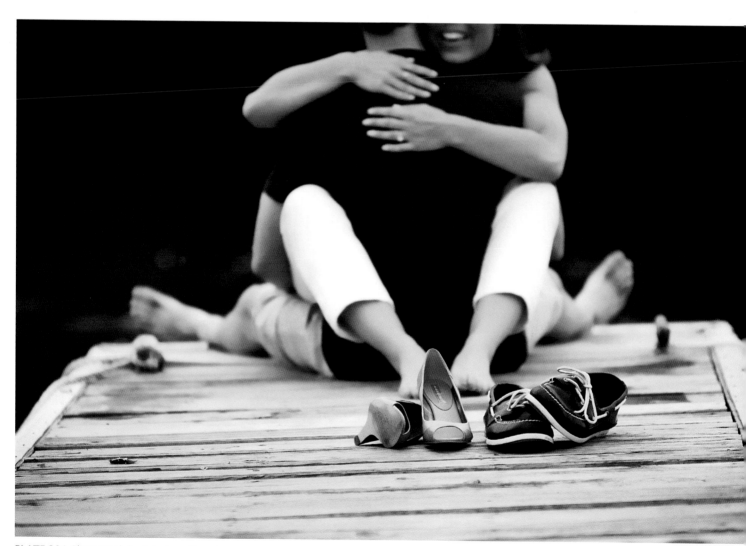

PLATE 284. Photograph by Salvatore Cincotta.

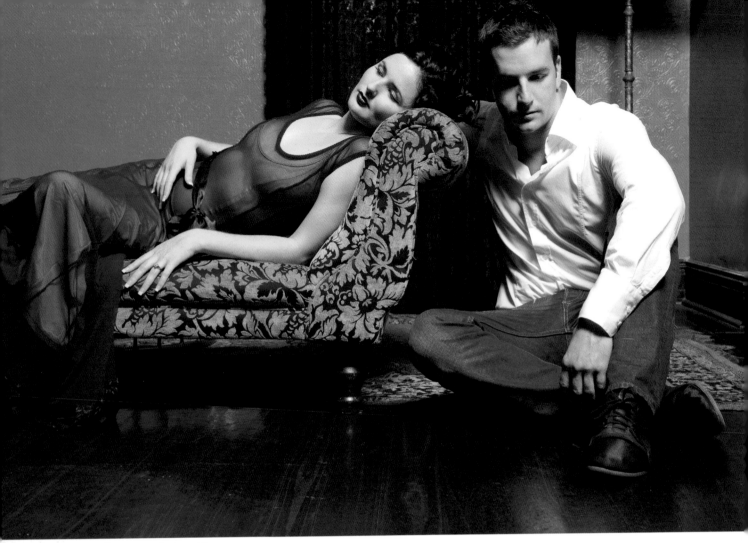

PLATE 285. Photography by Brett Florens.

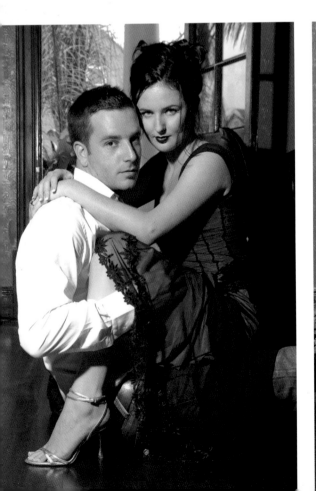

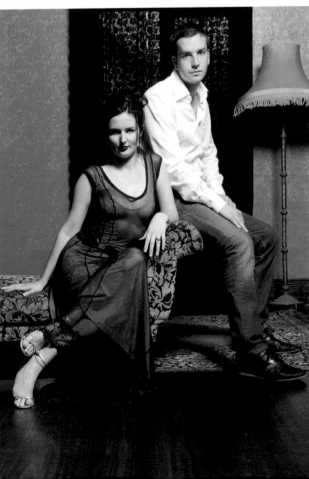

PLATE 286 (LEFT). Photograph by Brett Florens.

PLATE 287 (RIGHT). Photograph by Brett Florens.

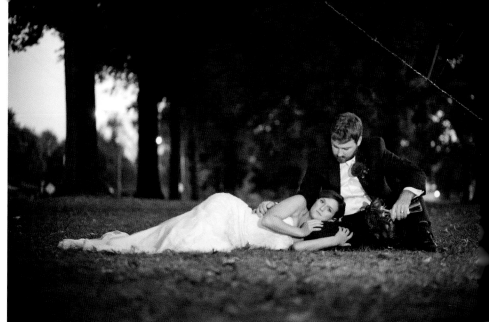

PLATE 288 (TOP RIGHT).
Photograph by Salvatore Cincotta.

PLATE 289 (CENTER RIGHT).
Photograph by Salvatore Cincotta.

PLATE 290 (BOTTOM RIGHT).
Photograph by Salvatore Cincotta.

PLATE 291. Photograph by Jeff Hawkins.

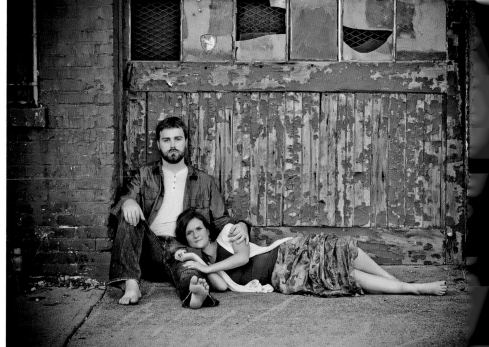

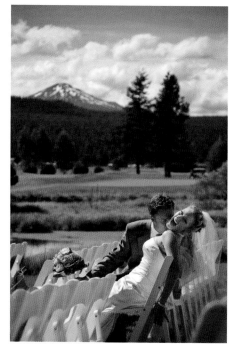

PLATE 292. Photograph by Kevin Kubota.

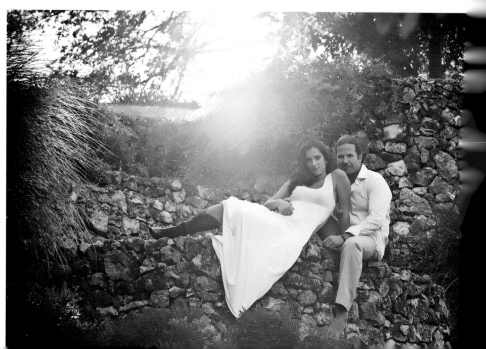

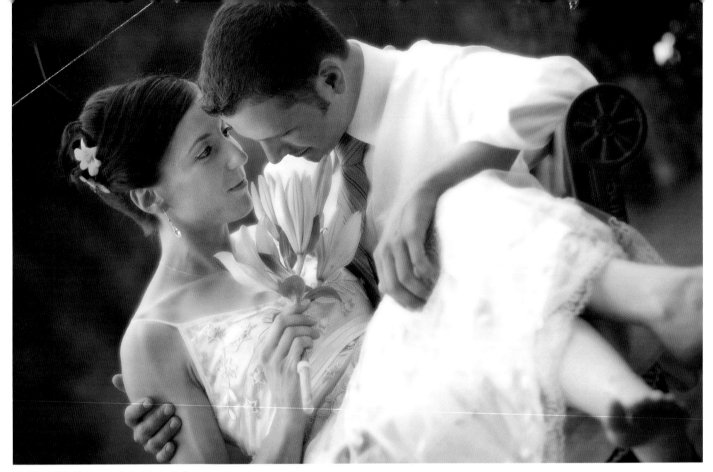

PLATE 293. Photograph by Kevin Kubota.

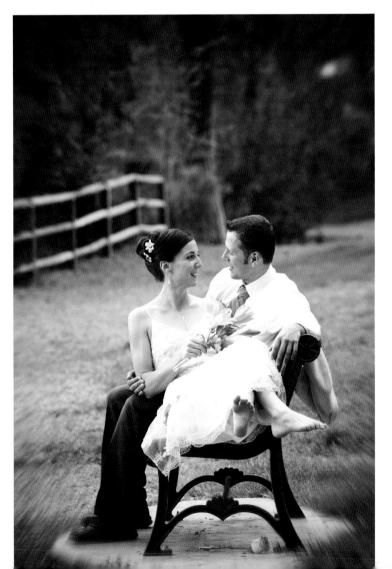

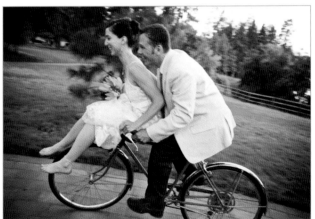

PLATE 294. Photograph by Kevin Kubota.

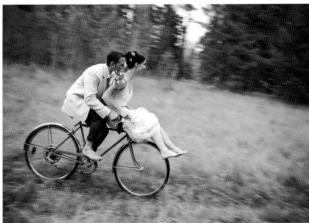

PLATE 295 (ABOVE). Photograph by Kevin Kubota.

PLATE 296 (LEFT). Photograph by Kevin Kubota.

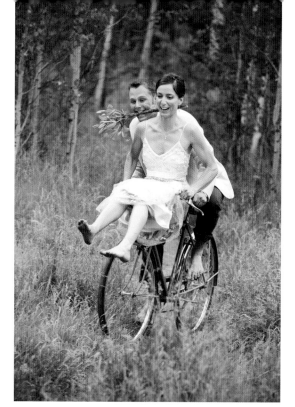

PLATE 297. Photograph by Kevin Kubota.

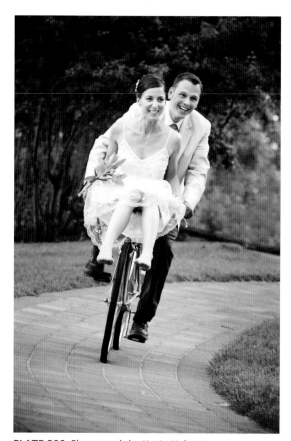

PLATE 298. Photograph by Kevin Kubota.

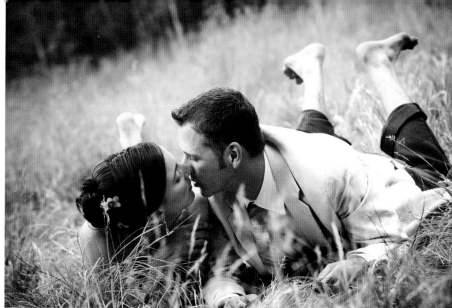

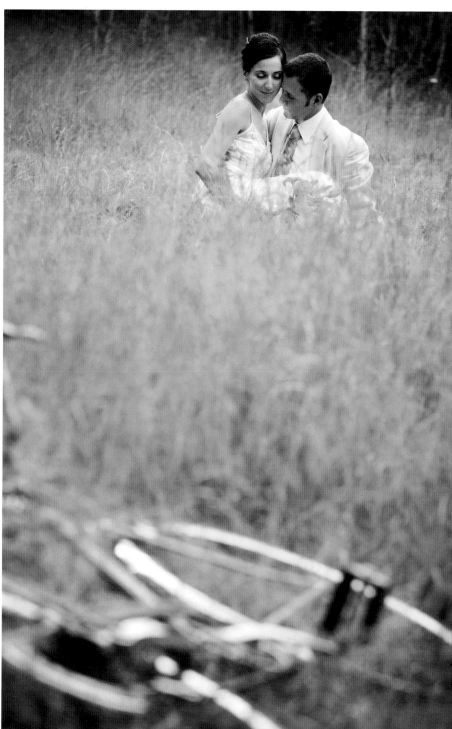

PLATE 299 (TOP RIGHT). Photograph by Kevin Kubota.

PLATE 300 (RIGHT). Photograph by Kevin Kubota.

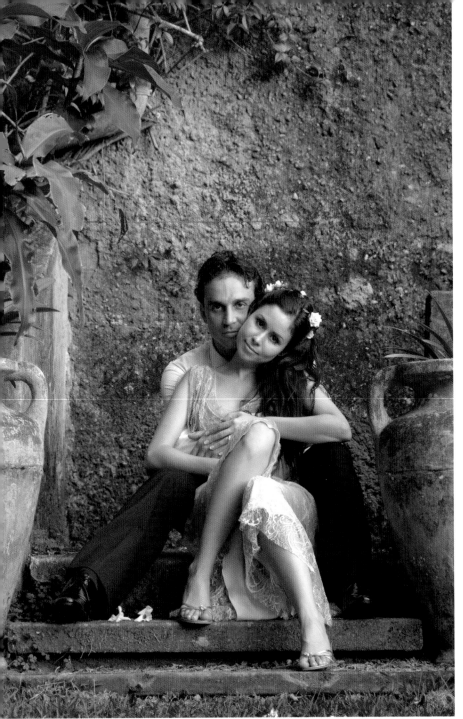

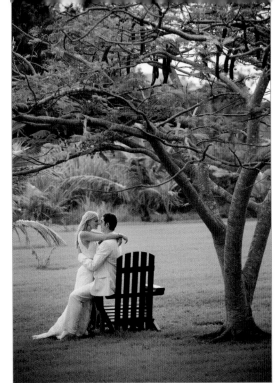

PLATE 301 (LEFT).
Photograph by Brett Florens.

PLATE 302 (ABOVE).
Photograph by Kevin Kubota.

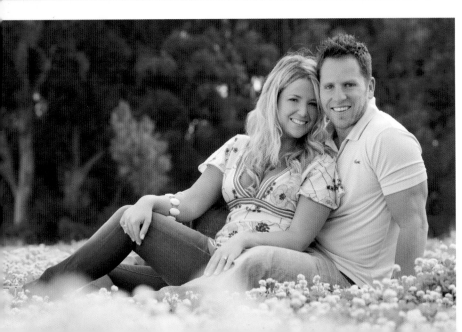

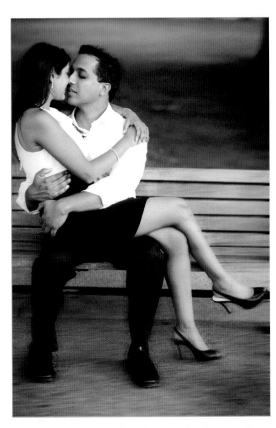

PLATE 303 (ABOVE). Photo by Regeti's Photography.

PLATE 304 (LEFT). Photo by Brett Florens.

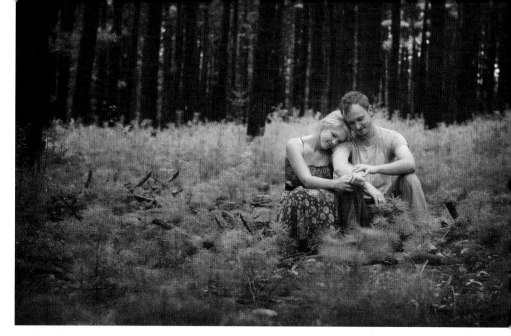

PLATE 305 (TOP RIGHT).
Photograph by Tracy Dorr.

PLATE 306 (CENTER RIGHT).
Photograph by Doug Box.

PLATE 307 (BOTTOM RIGHT).
Photograph by Doug Box.

"I approach every engagement session with the same attitude as when I'm playing and making silly pictures with my closest friends. Laughter is my secret weapon when it comes to countering camera shyness. If you can get your couple to laugh, they'll be like putty in your hands.[6]"
—Paul D. Van Hoy II

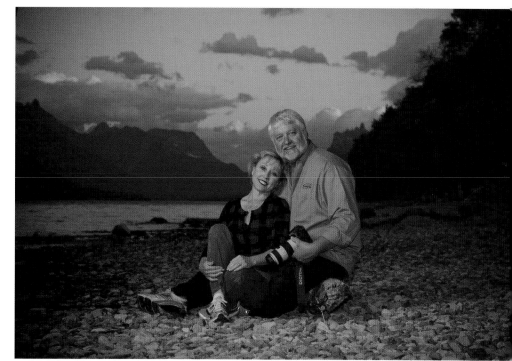

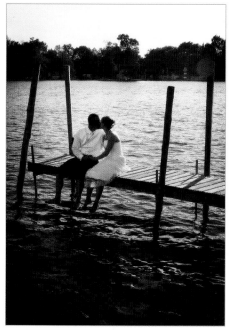

PLATE 308. Photograph by Tracy Dorr.

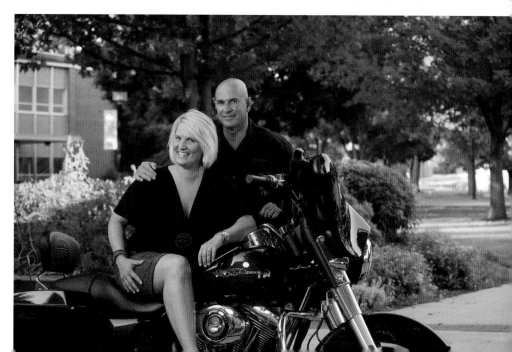

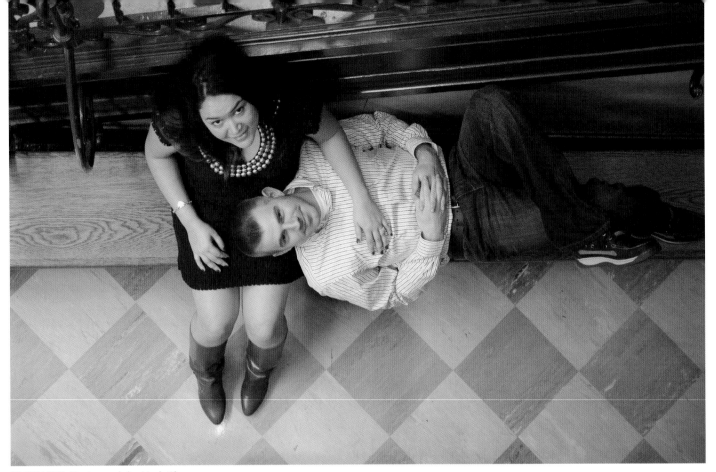

PLATE 309. Photograph by Mark Chen.

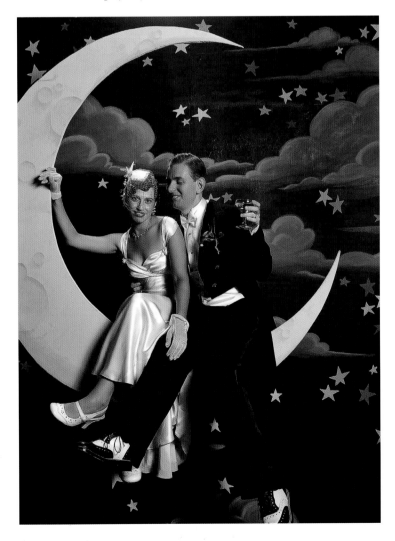

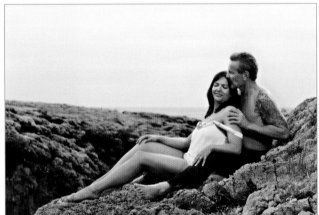

PLATE 310. Photograph by Allison Earnest.

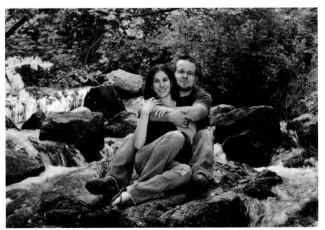

PLATE 311 (ABOVE). Photograph by Allison Earnest.

PLATE 312 (LEFT). Photograph by Cherie Steinberg Coté.

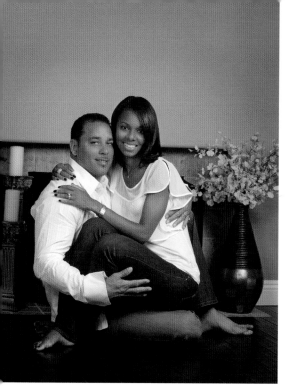

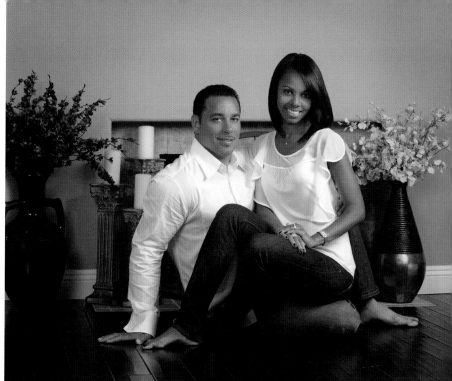

PLATE 313. Photograph by Hernan Rodriguez.

PLATE 314. Photograph by Hernan Rodriguez.

PLATE 315. Photograph by Salvatore Cincotta.

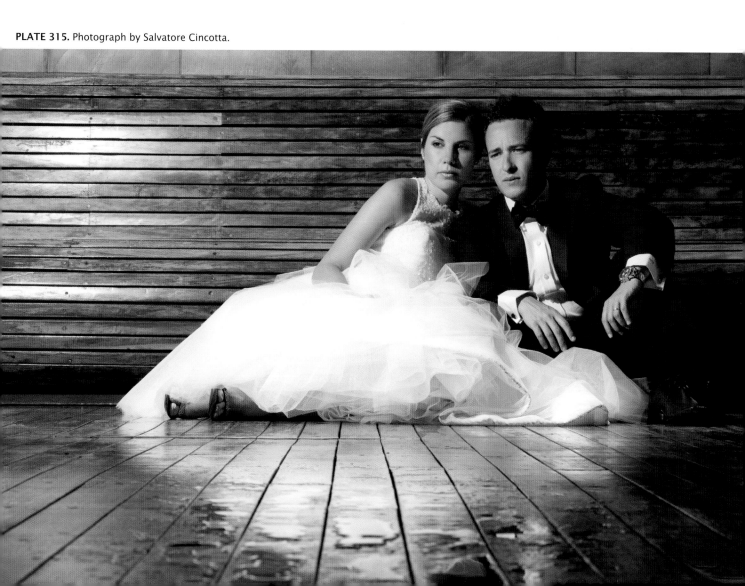

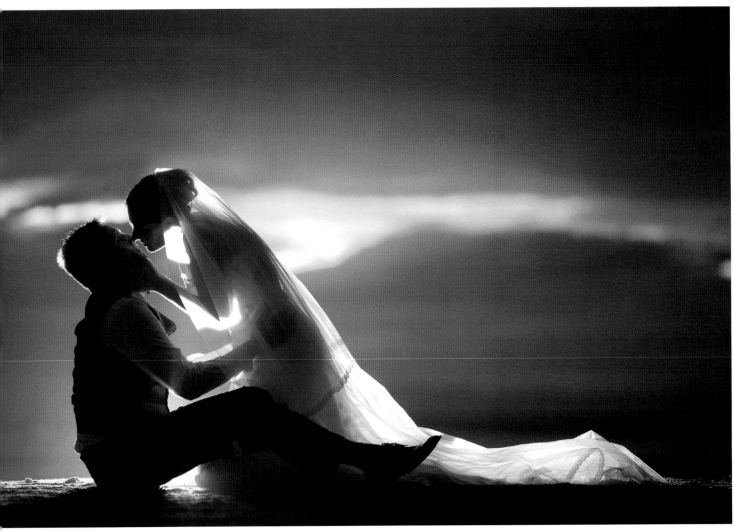

PLATE 316. Photograph by Brett Florens.

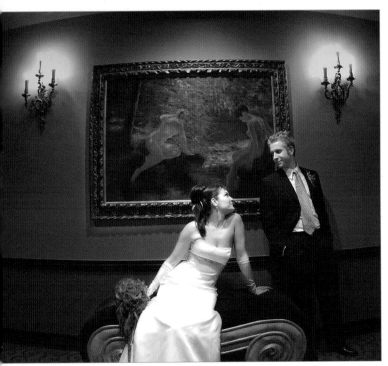

PLATE 317. Photograph by Damon Tucci.

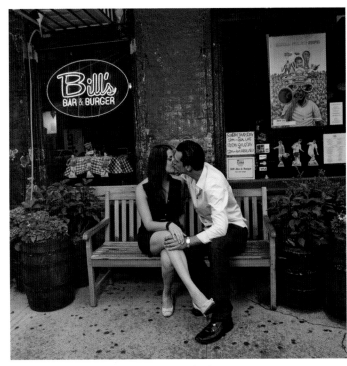

PLATE 318. Photograph by Neil van Niekerk.

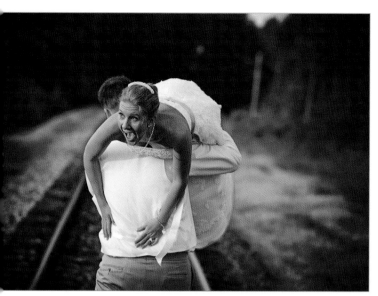

PLATE 319. Photograph by Paul D. Van Hoy II.

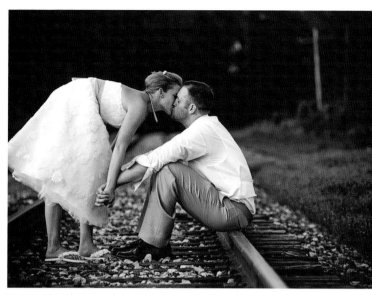

PLATE 320. Photograph by Paul D. Van Hoy II.

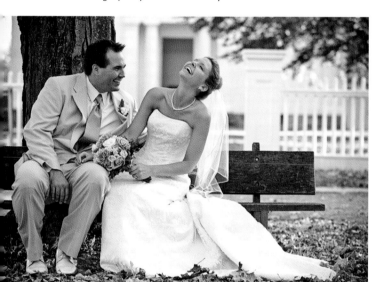

PLATE 321. Photograph by Paul D. Van Hoy II.

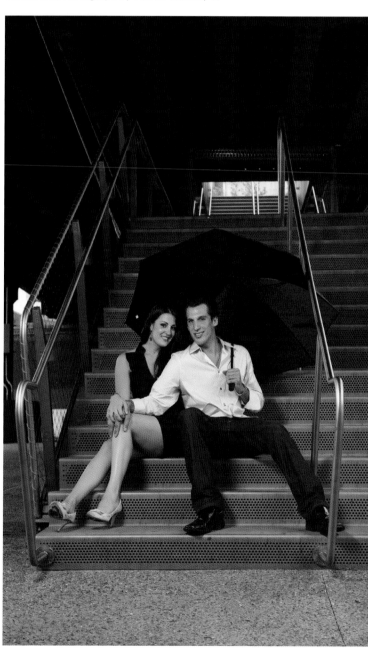

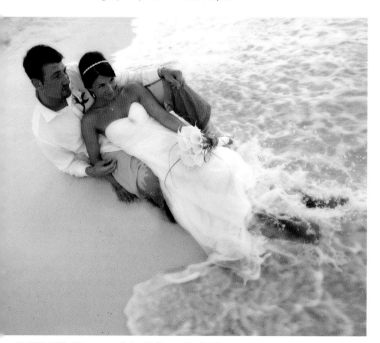

PLATE 322. Photograph by Neil van Niekerk.

PLATE 323. Photograph by Neil van Niekerk.

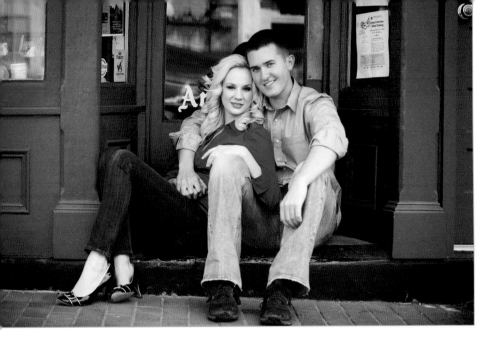

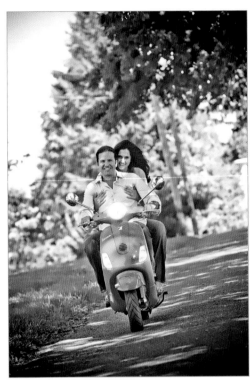

PLATE 324 (TOP LEFT).
Photograph by Regeti's Photography.

PLATE 325 (CENTER LEFT).
Photograph by Jeff Hawkins.

PLATE 326 (BOTTOM LEFT).
Photograph by Kevin Kubota.

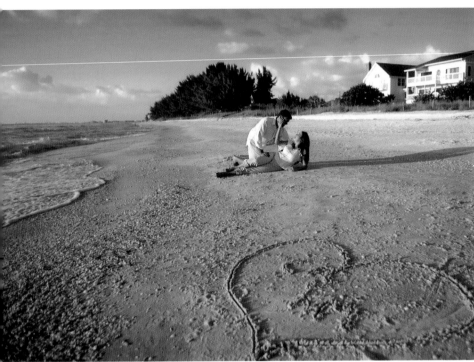

PLATE 327. Photo by Salvatore Cincotta.

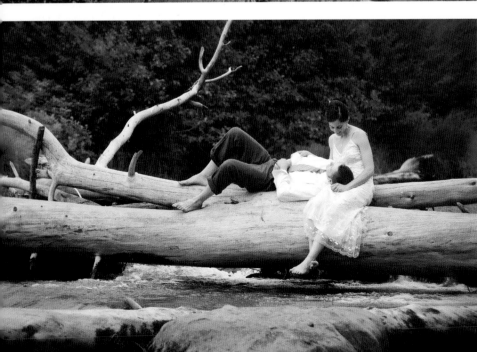

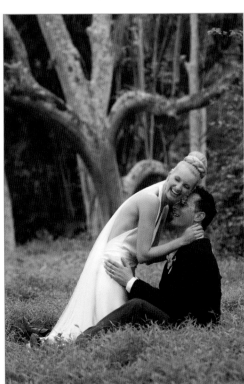

PLATE 328. Photograph by Brett Florens.

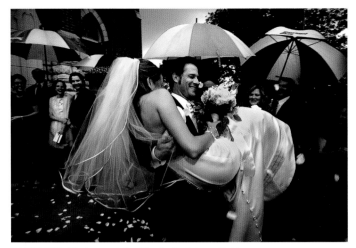

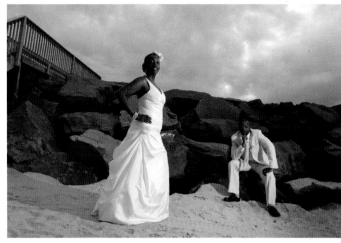

PLATE 329. Photograph by Cherie Steinberg Coté.

PLATE 330. Photograph by Neil van Niekerk.

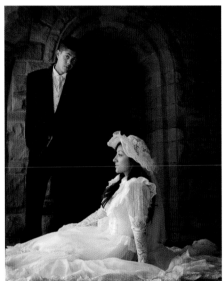

PLATE 331. Photograph by Hernan Rodriguez.

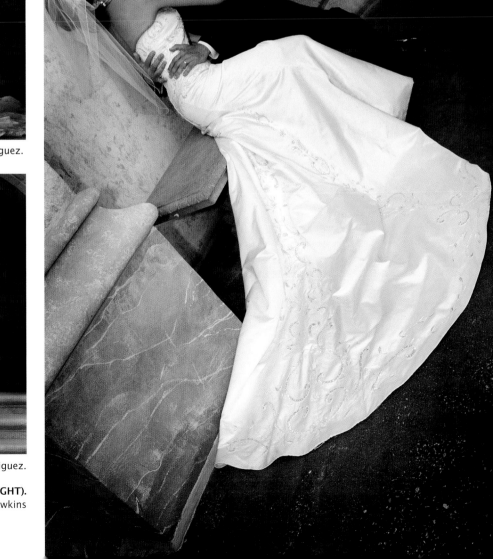

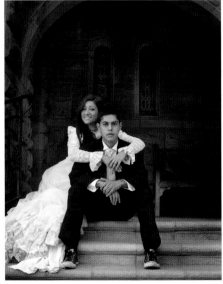

PLATE 332. Photograph by Hernan Rodriguez.

PLATE 333 (RIGHT).
Photograph by Jeff Hawkins

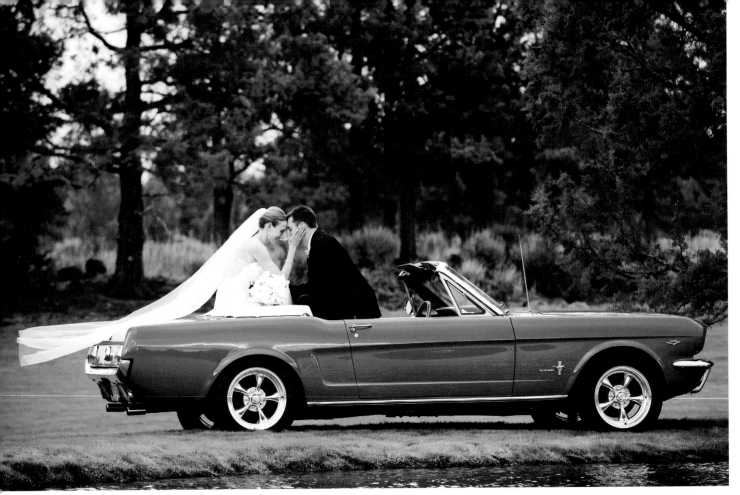

PLATE 334. Photograph by Kevin Kubota.

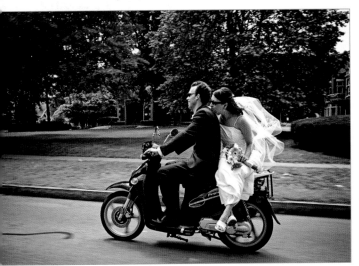

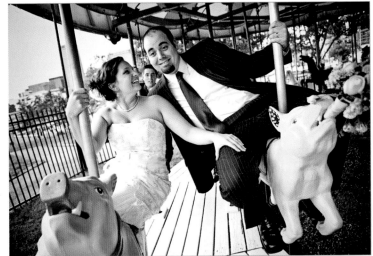

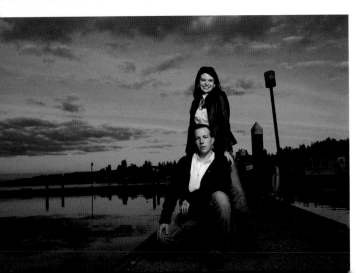

PLATE 335 (ABOVE LEFT). Photograph by Paul D. Van Hoy II.

PLATE 336 (ABOVE RIGHT). Photograph by Paul D. Van Hoy II.

PLATE 337 (LEFT). Photograph by Neil van Niekerk.

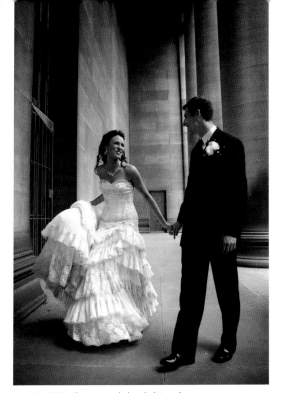

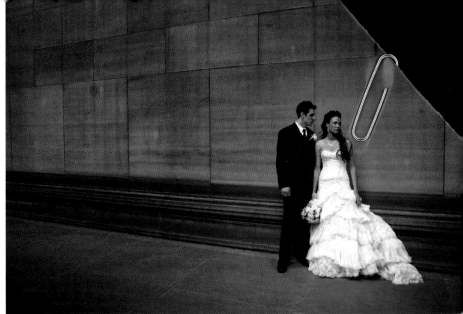

PLATE 338. Photograph by Cal Landau.

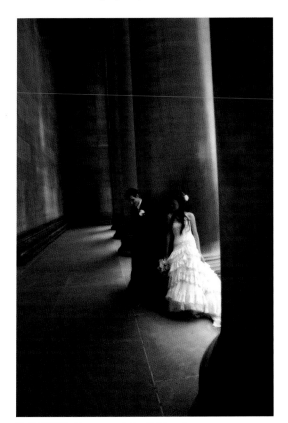

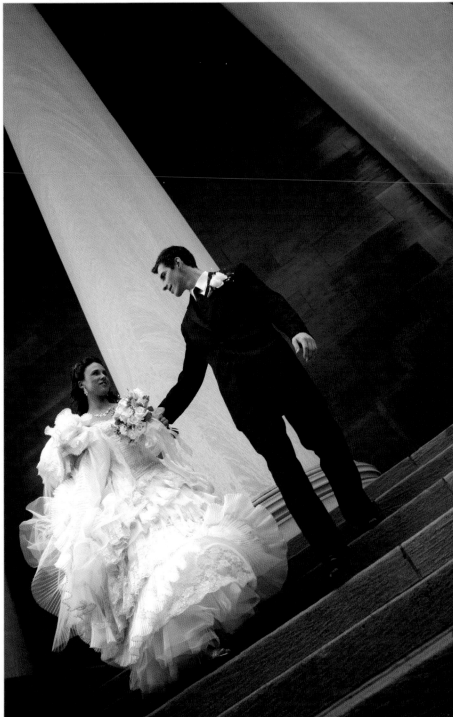

PLATE 339. Photograph by Cal Landau.

PLATE 340 (TOP RIGHT).
Photograph by Cal Landau.

PLATE 341 (BOTTOM RIGHT).
Photograph by Cal Landau.

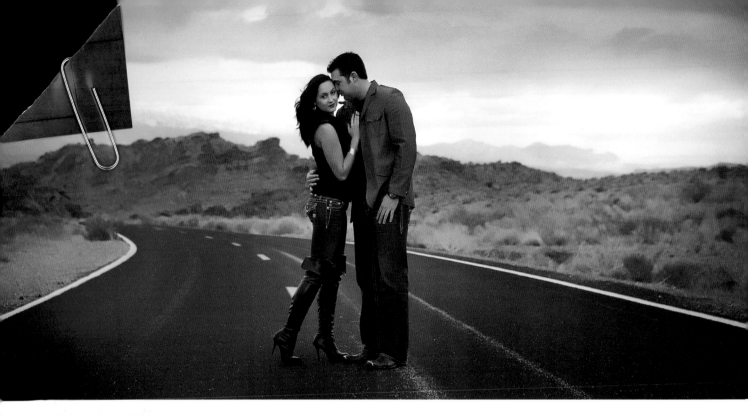

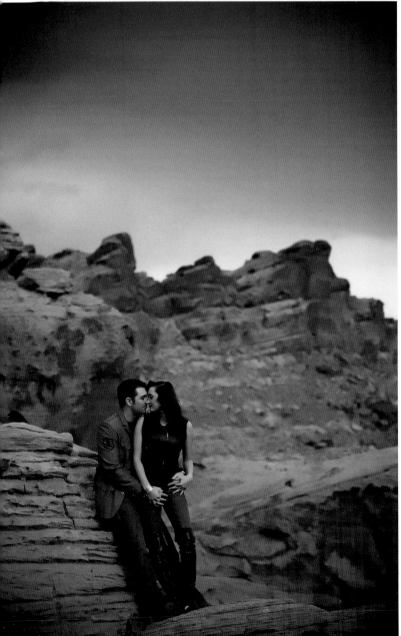

PLATE 342 (ABOVE). Photograph by Salvatore Cincotta.

PLATE 343 (LEFT). Photograph by Salvatore Cincotta.

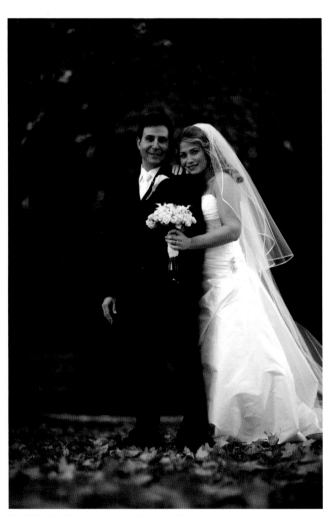

PLATE 344. Photograph by Neil van Niekerk.

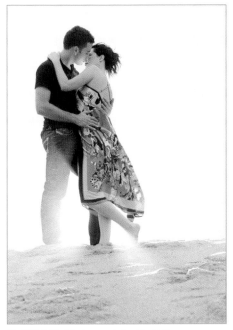

PLATE 345. Photograph by Brett Florens.

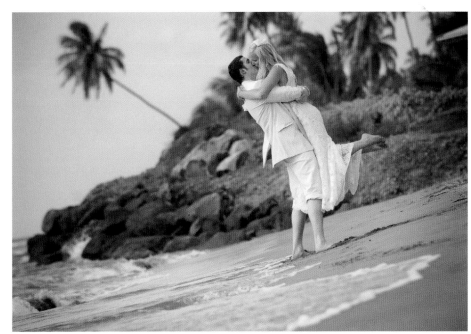

PLATE 346. Photograph by Kevn Kubota.

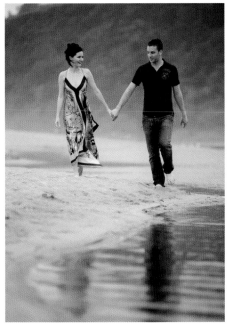

PLATE 347. Photograph by Brett Florens.

PLATE 348 (RIGHT).
Photograph by Doug Box.

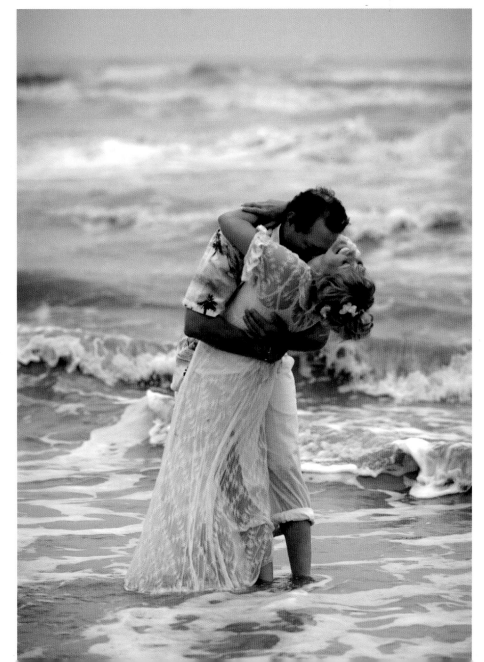

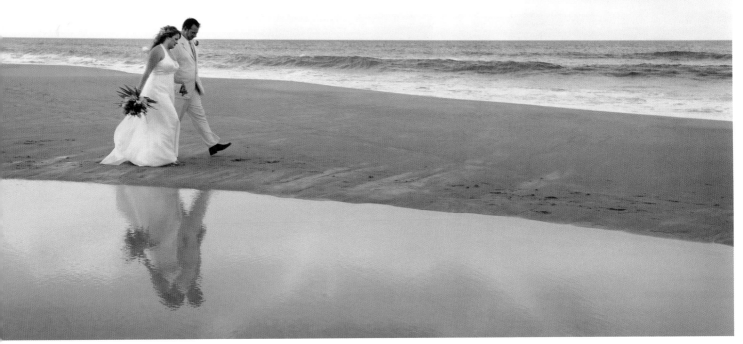

PLATE 349 (ABOVE). Photograph by Damon Tucci.

PLATE 350 (BELOW). Photograph by Damon Tucci.

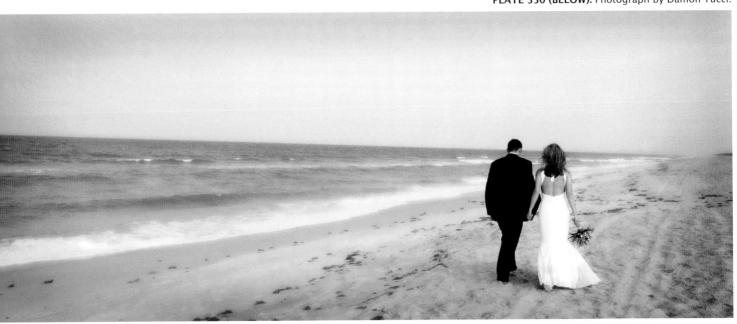

PLATE 351. Photograph by Neil van Niekerk.

PLATE 352. Photograph by Neil van Niekerk.

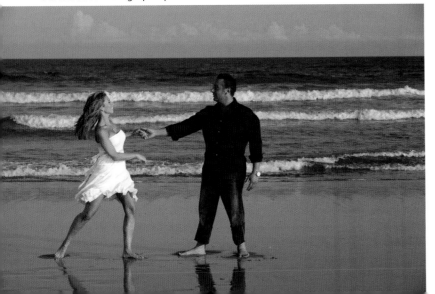

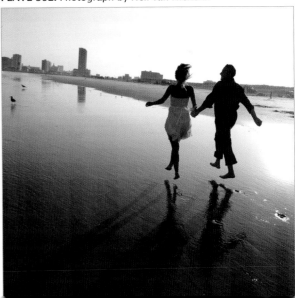

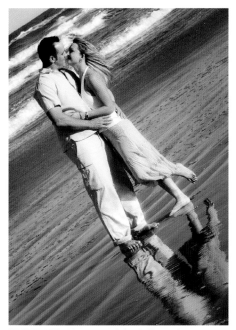

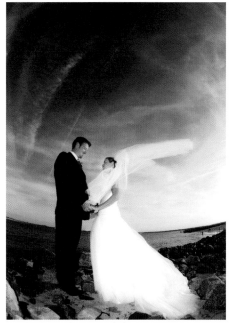

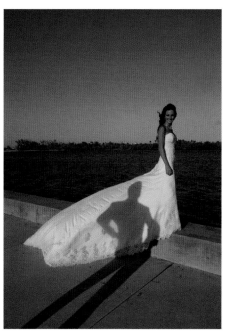

PLATE 353. Photograph by Jeff Hawkins

PLATE 354. Photograph by Damon Tucci.

PLATE 355. Photograph by Cal Landau.

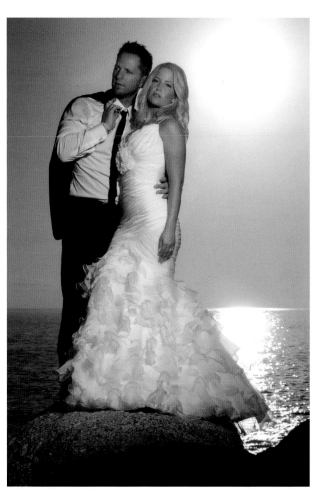

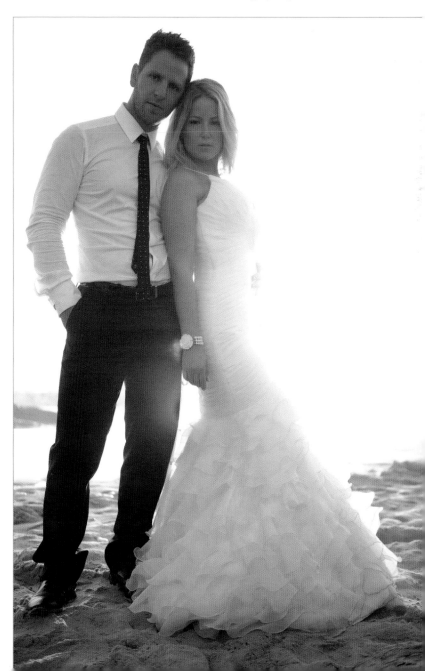

PLATE 356. Photograph by Brett Florens.

PLATE 357. Photograph by Brett Florens.

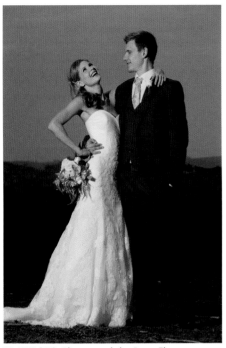

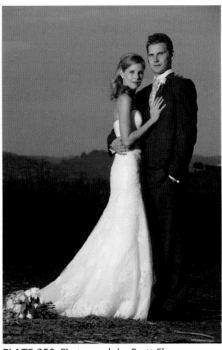

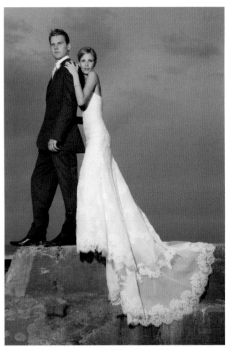

PLATE 358. Photograph by Brett Florens.

PLATE 359. Photograph by Brett Florens.

PLATE 360. Photograph by Brett Florens.

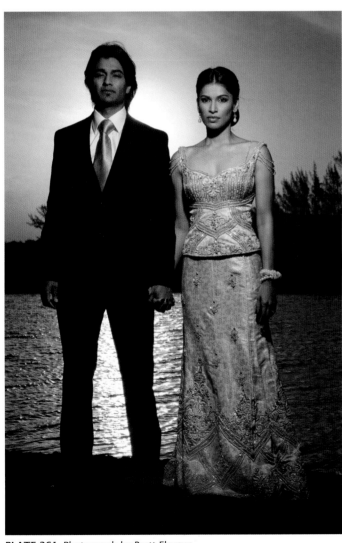

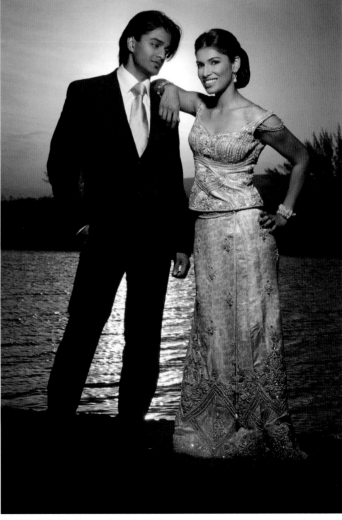

PLATE 361. Photograph by Brett Florens.

PLATE 362. Photograph by Brett Florens.

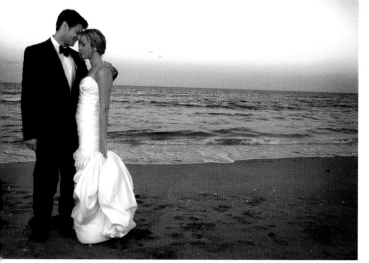

PLATE 363. Photograph by Cal Landau.

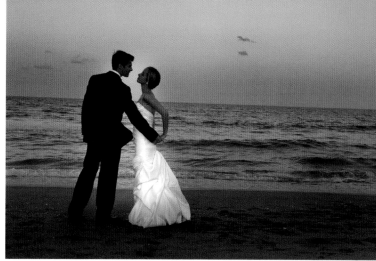

PLATE 364. Photograph by Cal Landau.

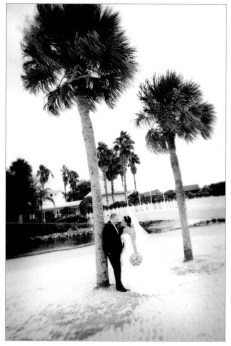

PLATE 365. Photograph by Damon Tucci.

"When posing couples, it is important that each individual looks their best, and then the two should be positioned in such a way that they seem to relate to one another.[7]" —Doug Box

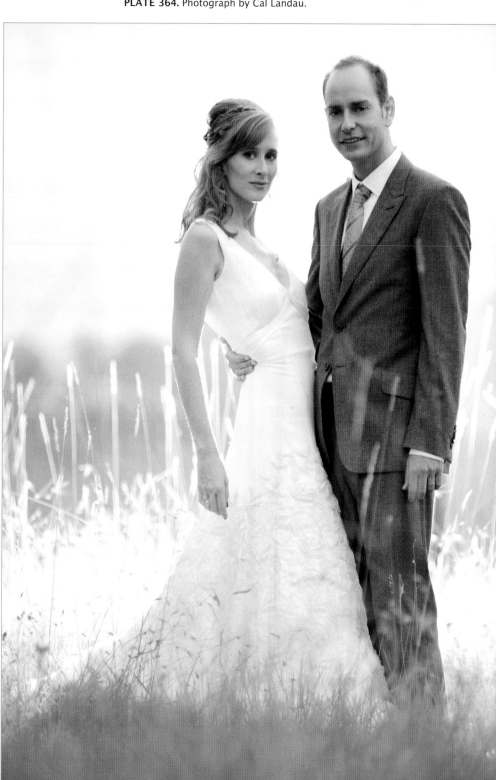

PLATE 366. Photograph by Brett Florens.

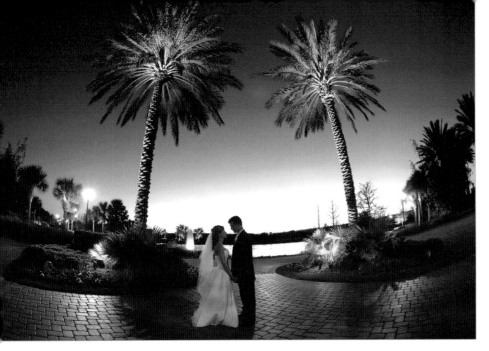

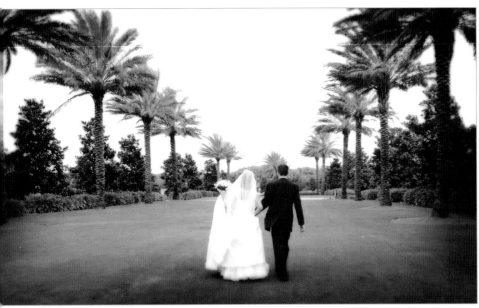

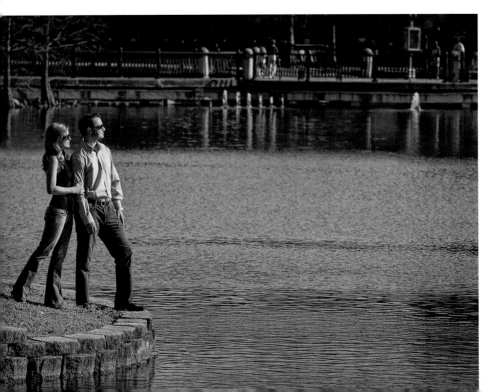

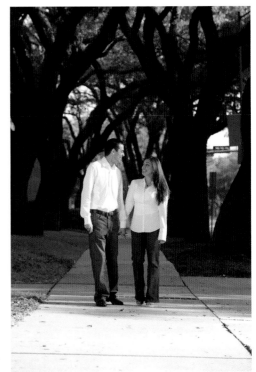

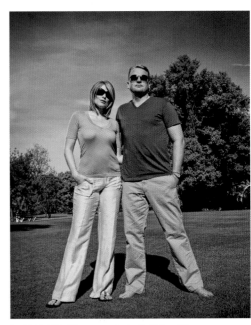

PLATE 367 (TOP LEFT).
Photograph by Damon Tucci.

PLATE 368 (CENTER LEFT).
Photograph by Damon Tucci.

PLATE 369 (BOTTOM LEFT).
Photograph by Jeff Hawkins.

PLATE 370. Photograph by Mark Chen.

PLATE 371. Photograph by Jeff Hawkins.

PLATE 372 (RIGHT).
Photograph by Doug Box.

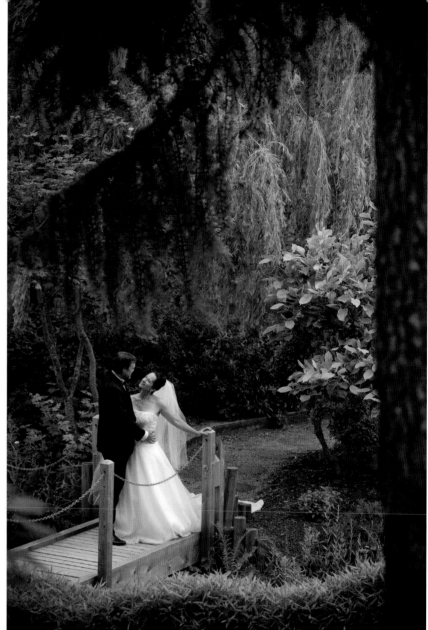

PLATE 373. Photograph by Tracy Dorr.

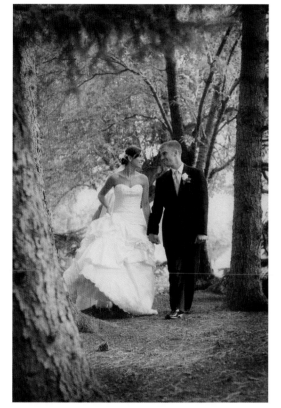

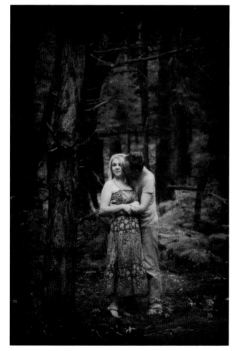

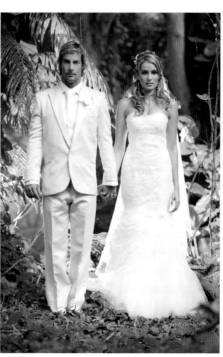

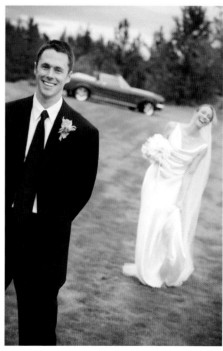

PLATE 374. Photograph by Tracy Dorr.

PLATE 375. Photograph by Brett Florens.

PLATE 376. Photograph by Kevin Kubota.

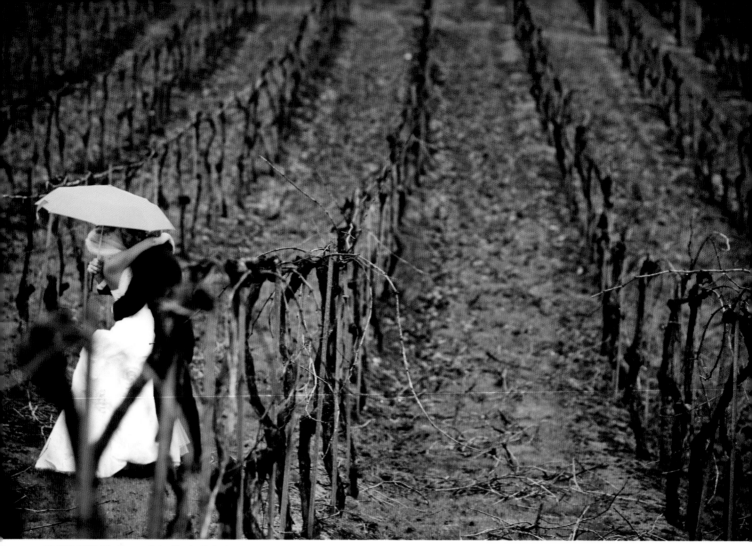

PLATE 377. Photograph by Kevin Kubota.

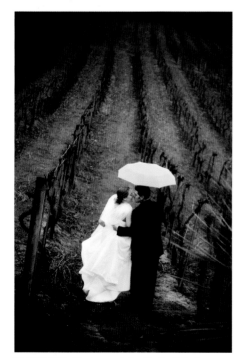

PLATE 378. Photograph by Kevin Kubota.

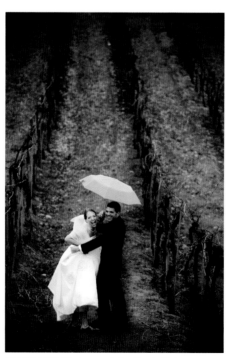

PLATE 379. Photograph by Kevin Kubota.

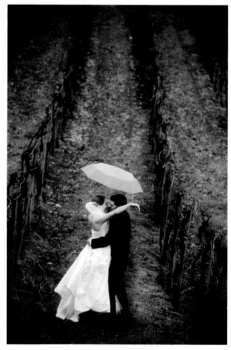

PLATE 380. Photograph by Kevin Kubota.

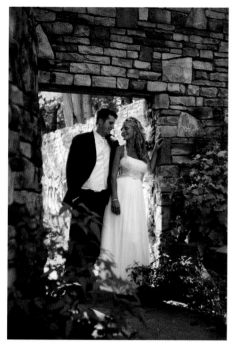

PLATE 381. Photograph by Tracy Dorr.

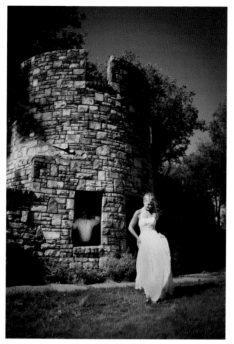

PLATE 382. Photograph by Tracy Dorr.

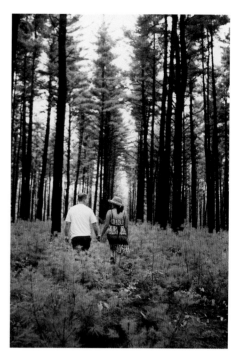

PLATE 383. Photograph by Tracy Dorr.

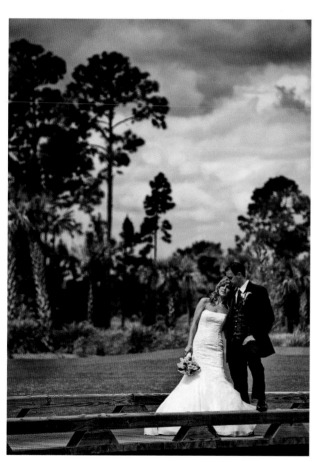

PLATE 384 (ABOVE). Photograph by Jeff Hawkins.

PLATE 385 (RIGHT). Photograph by Tracy Dorr.

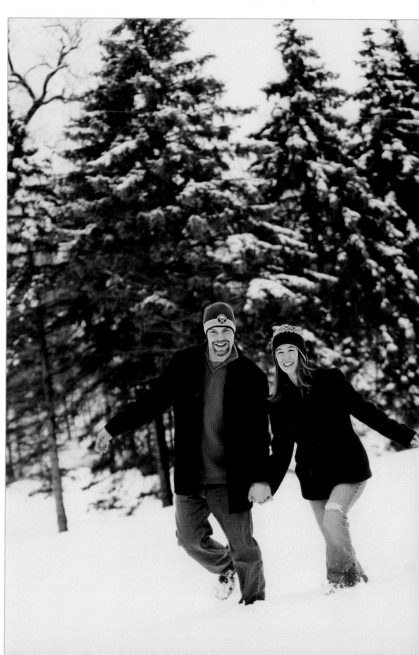

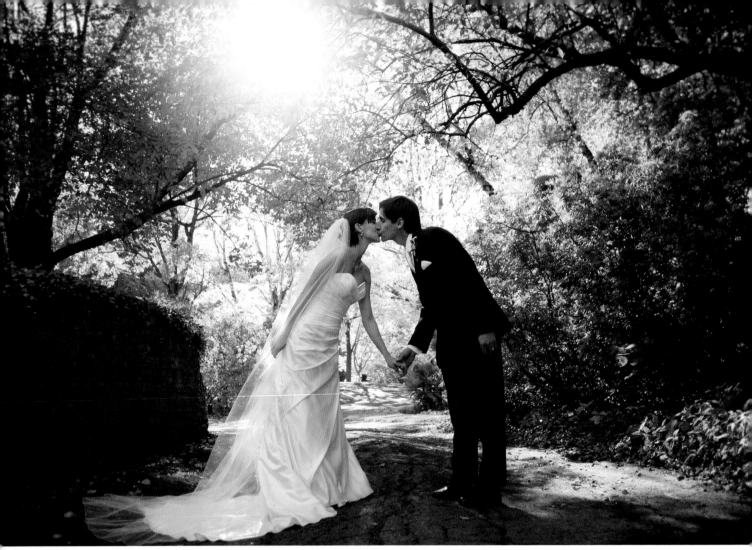

PLATE 386. Photograph by Tracy Dorr.

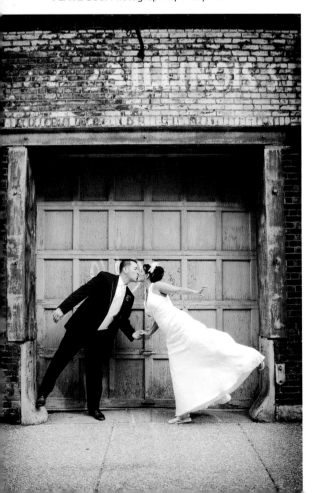

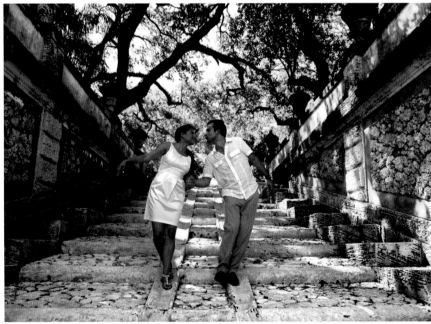

PLATE 387 (LEFT). Photograph by Tracy Dorr.

PLATE 388 (ABOVE). Photograph by Cal Landau.

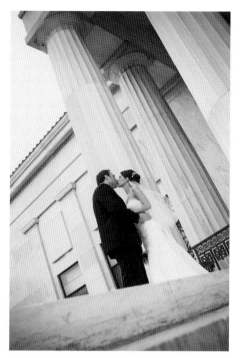

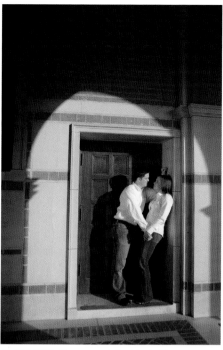

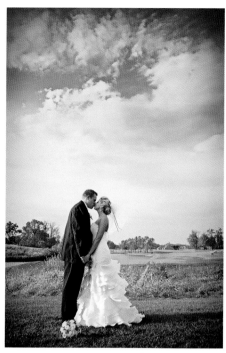

PLATE 389. Photograph by Tracy Dorr.

PLATE 390. Photograph by Mark Chen.

PLATE 391. Photograph by Salvatore Cincotta.

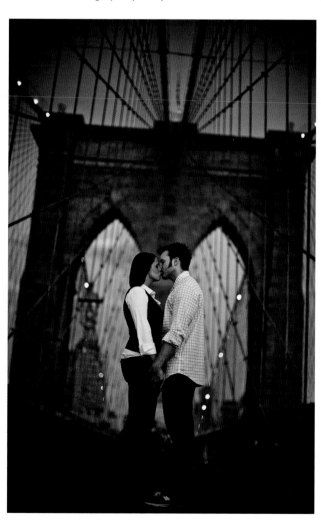

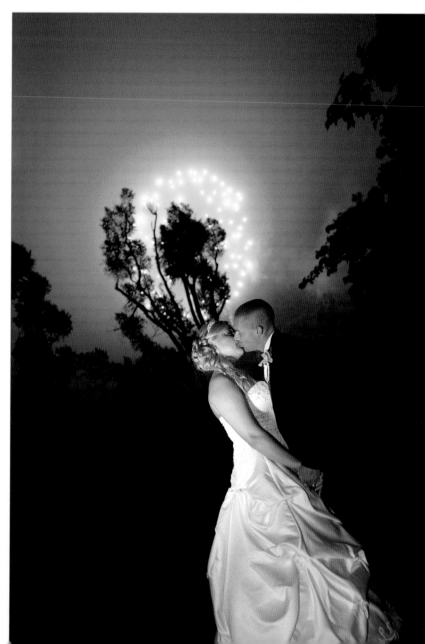

PLATE 392 (ABOVE). Photograph by Salvatore Cincotta.

PLATE 393 (RIGHT). Photograph by Tracy Dorr.

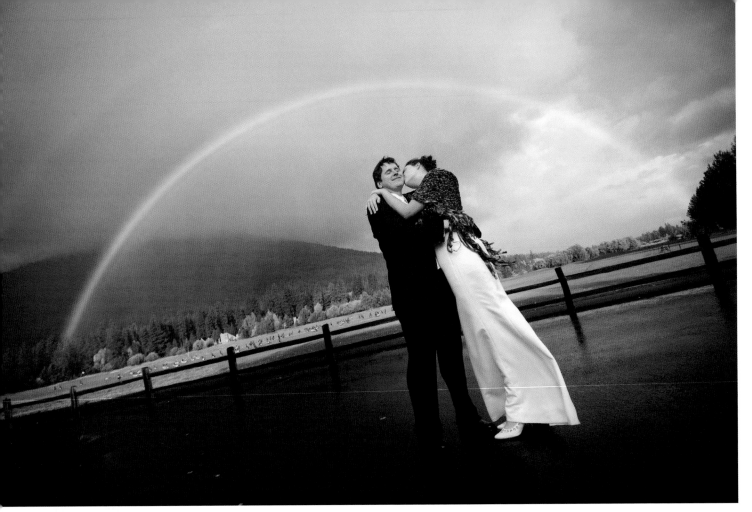

PLATE 394. Photograph by Kevin Kubota.

PLATE 395. Photograph by Kevin Kubota.

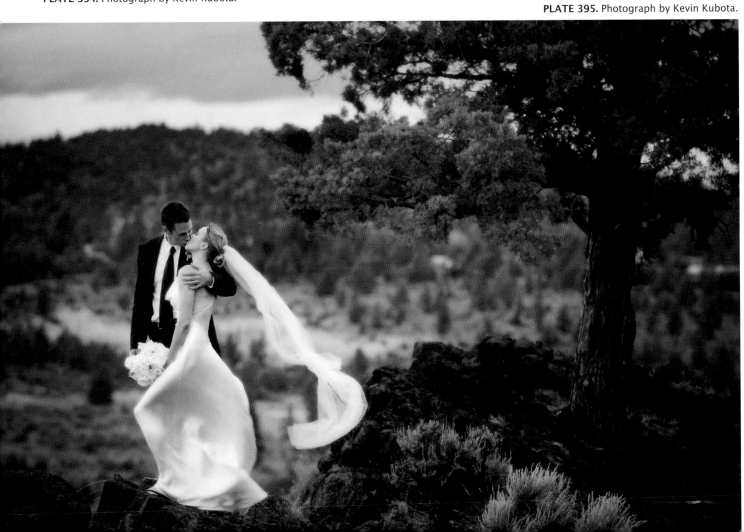

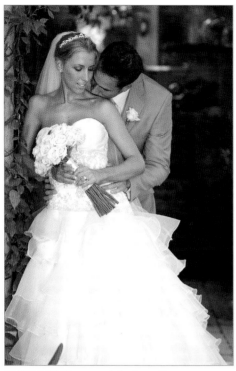

PLATE 396. Photograph by Brett Florens.

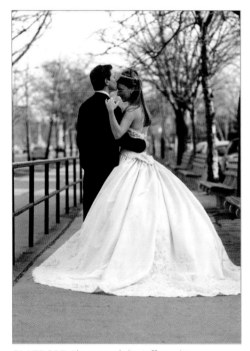

PLATE 397. Photograph by Jeff Hawkins.

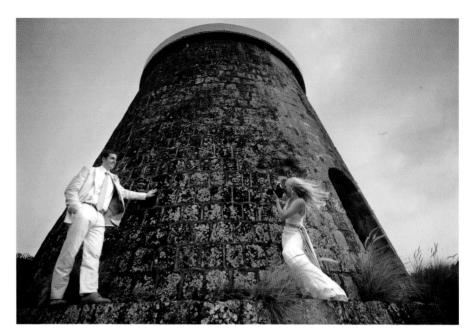

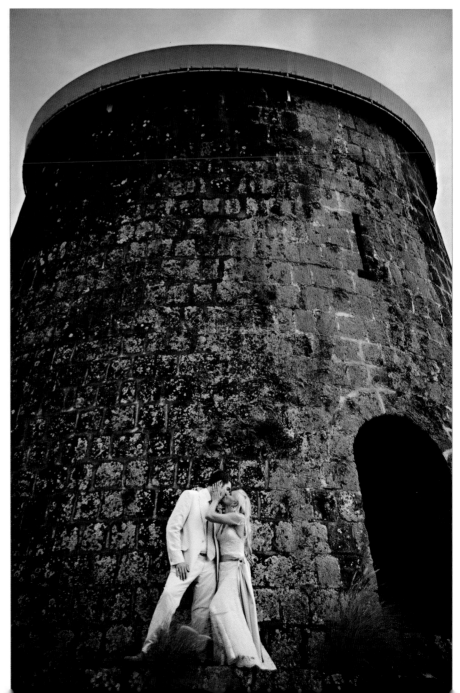

PLATE 398 (TOP RIGHT).
Photograph by Kevin Kubota.

PLATE 399 (BOTTOM RIGHT).
Photograph by Kevin Kubota.

PLATE 400 (LEFT). Photograph by Jeff Hawkins.

PLATE 401 (BELOW LEFT). Photograph by Brett Florens.

PLATE 402 (BELOW RIGHT). Photograph by Damon Tucci.

PLATE 403 (BOTTOM). Photograph by Kevin Kubota.

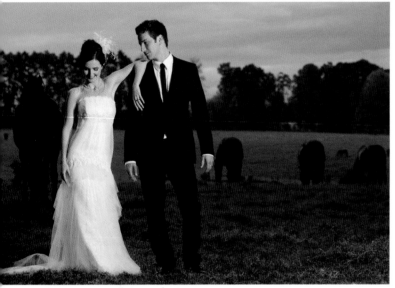

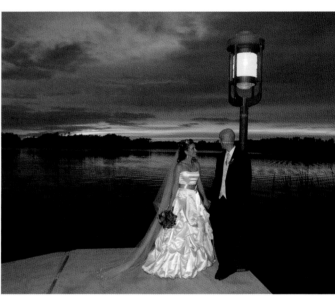

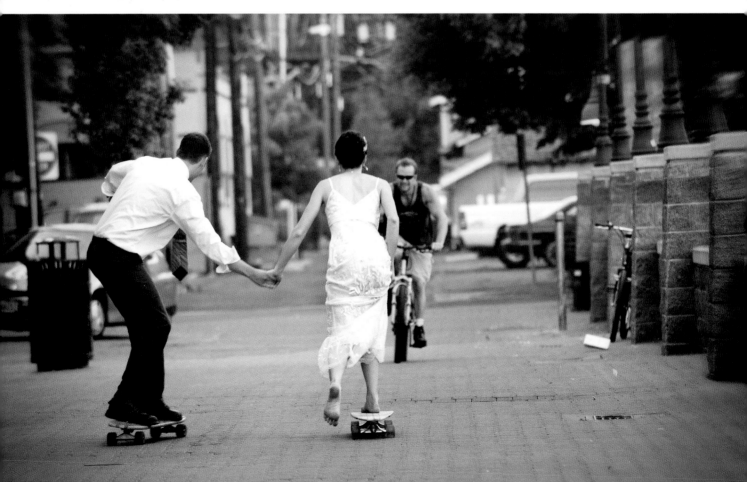

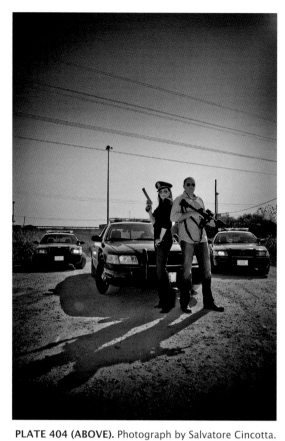

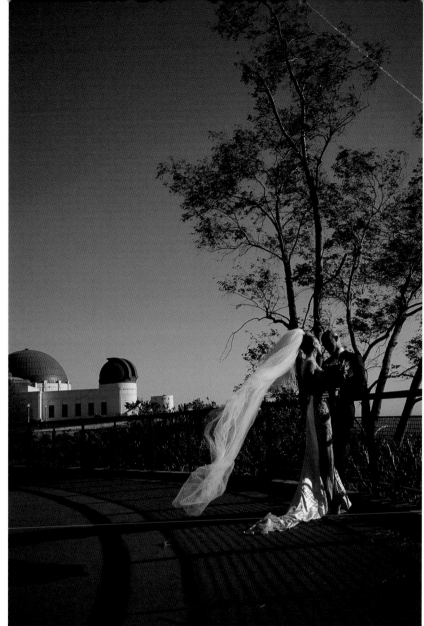

PLATE 404 (ABOVE). Photograph by Salvatore Cincotta.

PLATE 405 (RIGHT).
Photograph by Cherie Steinberg Coté.

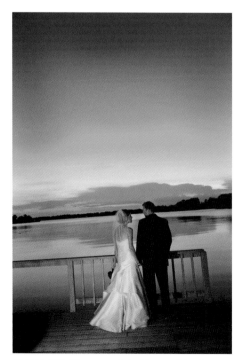

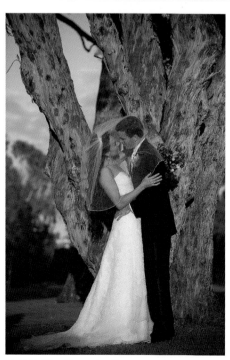

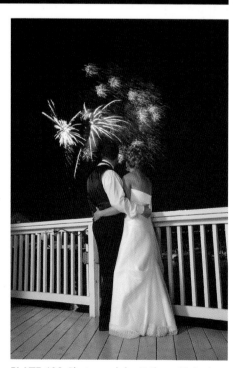

PLATE 406. Photograph by Damon Tucci.

PLATE 407. Photo by Cherie Steinberg Coté.

PLATE 408. Photograph by Neil van Niekerk.

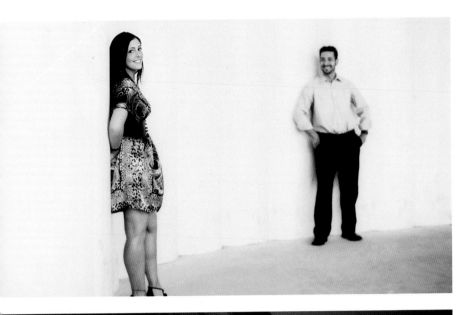

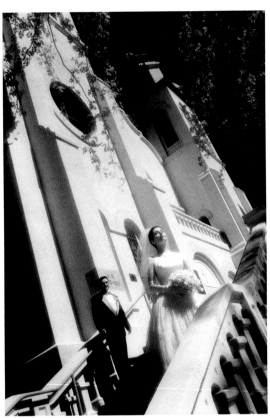

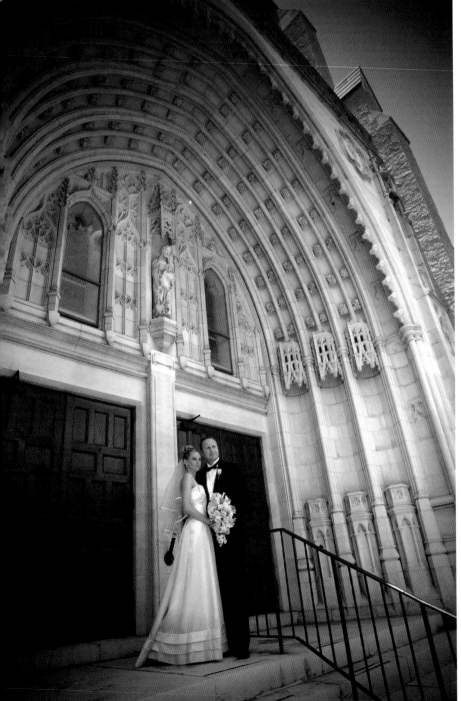

PLATE 409 (TOP LEFT). Photograph by Tracy Dorr.

PLATE 410 (ABOVE). Photograph by Jeff Hawkins

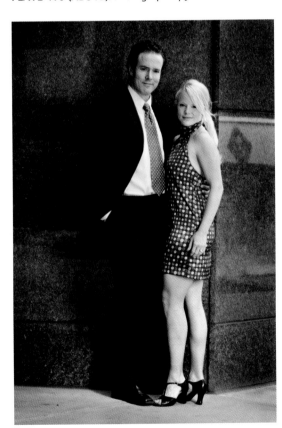

PLATE 411 (ABOVE). Photograph by Allison Earnest.

PLATE 412 (LEFT). Photograph by Jeff Hawkins.

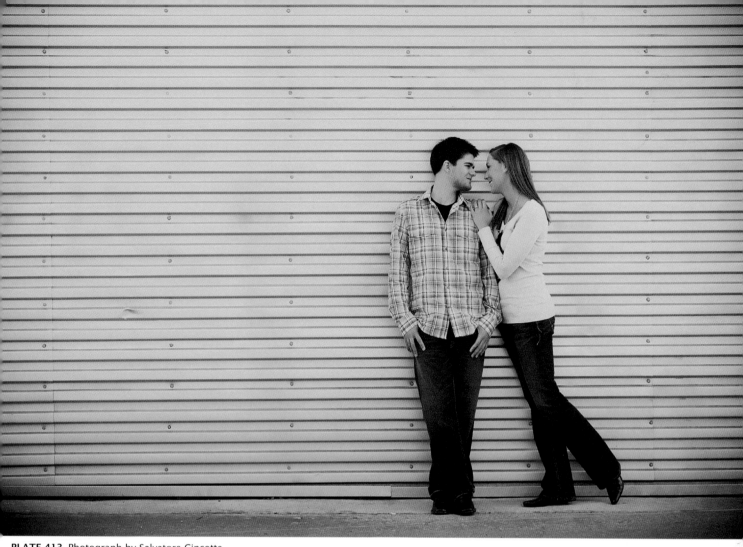

PLATE 413. Photograph by Salvatore Cincotta.

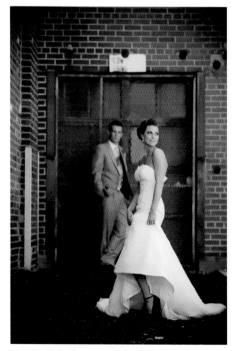

PLATE 414. Photograph by Salvatore Cincotta.

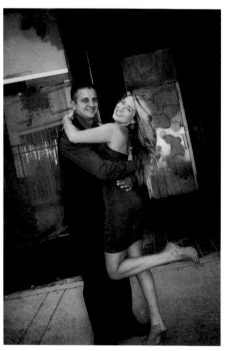

PLATE 415. Photograph by Tracy Dorr.

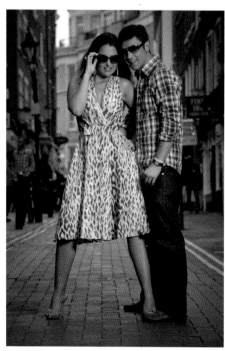

PLATE 416. Photograph by Brett Florens.

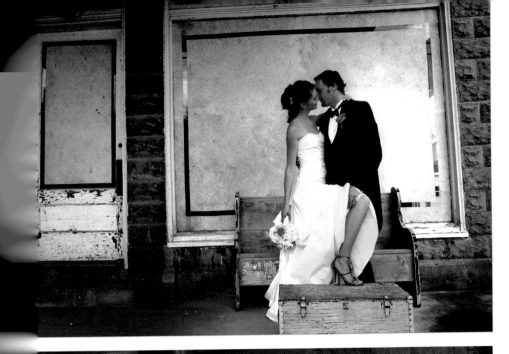

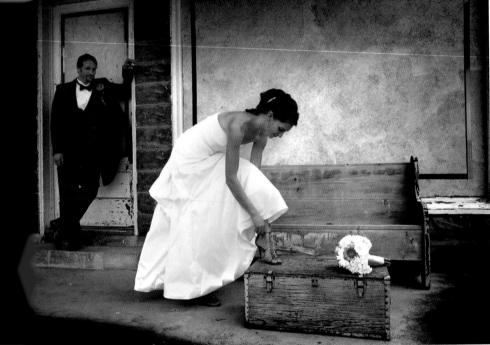

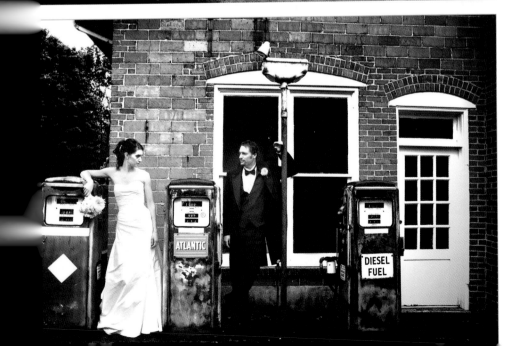

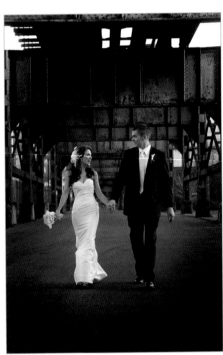

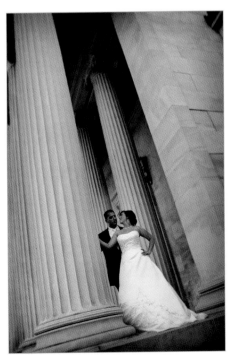

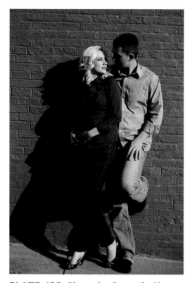

PLATE 422. Photo by Regeti's Photography.

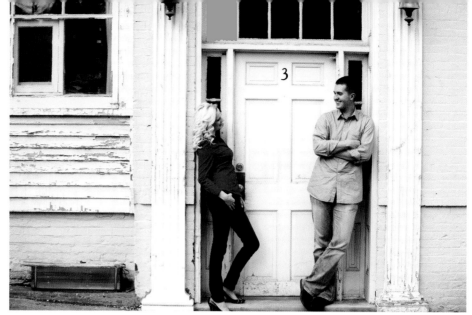

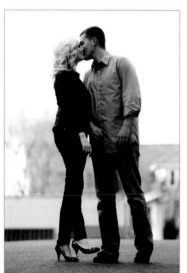

PLATE 423. Photo by Regeti's Photography.

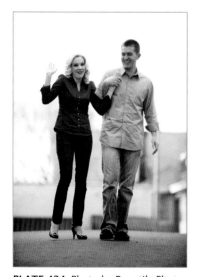

PLATE 424. Photo by Regeti's Photography.

PLATE 425 (TOP RIGHT).
Photograph by Regeti's Photography.

PLATE 426 (BOTTOM RIGHT).
Photograph by Regeti's Photography.

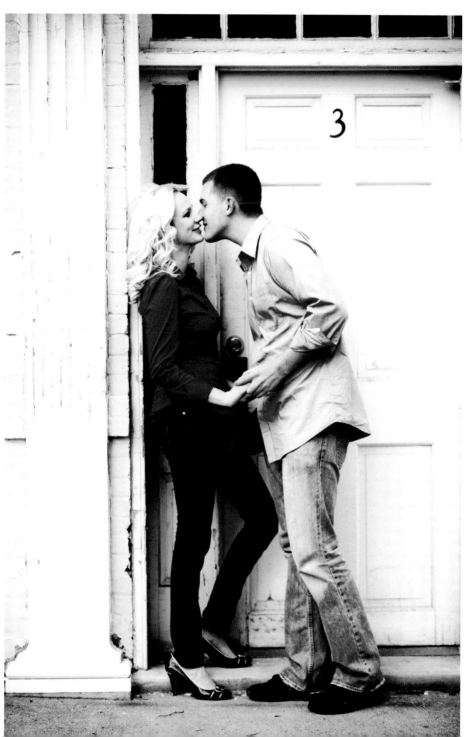

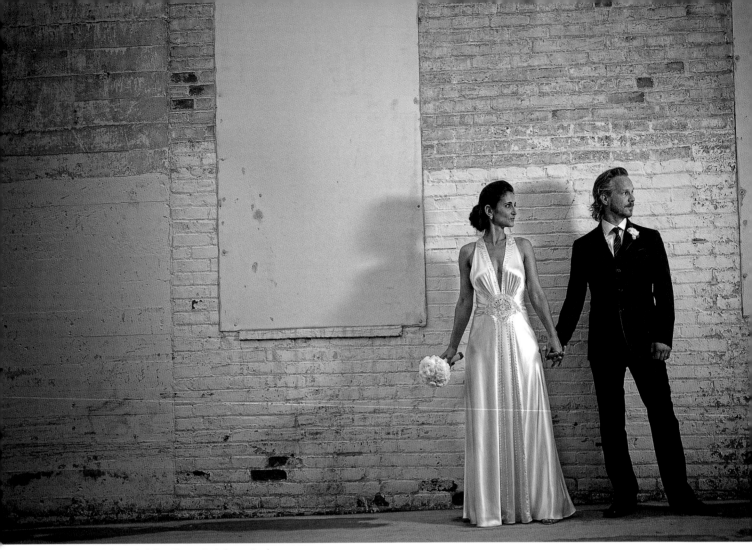

PLATE 427. Photograph by Cherie Steinberg Coté.

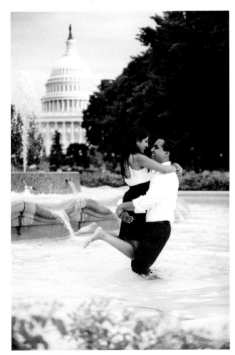

PLATE 428.
Photograph by Regeti's Photography.

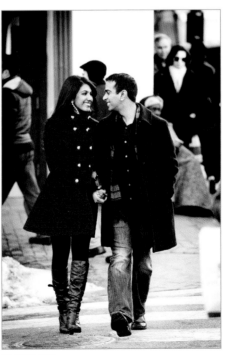

PLATE 429.
Photograph by Regeti's Photography.

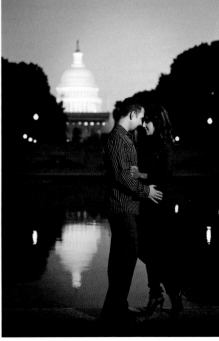

PLATE 430.
Photograph by Regeti's Photography.

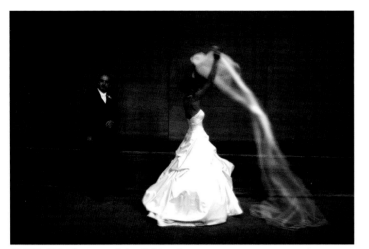

PLATE 431. Photograph by Cal Landau.

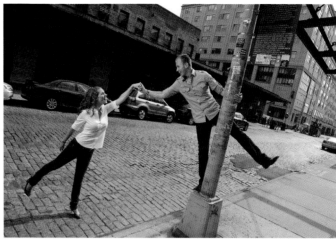

PLATE 432. Photograph by Neil van Niekerk.

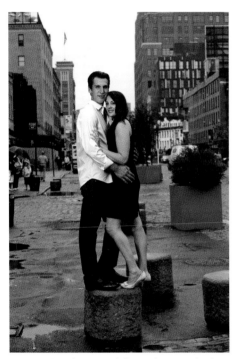

PLATE 433. Photograph by Neil van Niekerk.

"By angling the couple's faces toward one another, we can begin to build a storytelling image that speaks to the viewer about the unique bond the couple shares.[8]" —Doug Box

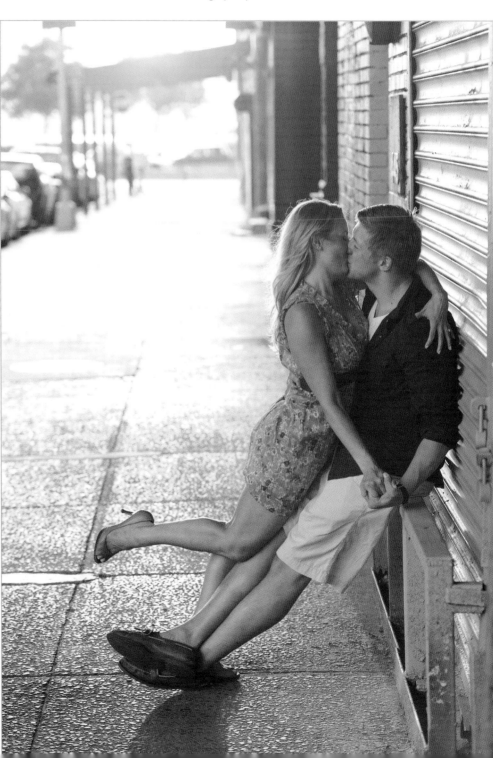

PLATE 434 (RIGHT).
Photograph by Neil van Niekerk.

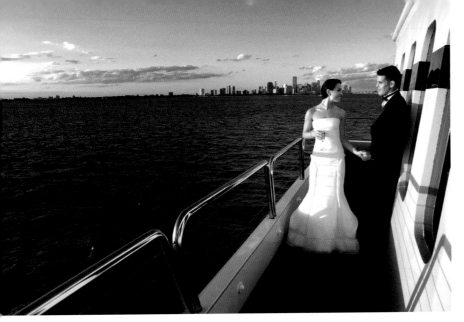

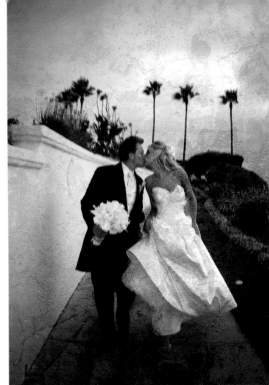

PLATE 435 (TOP LEFT). Photograph by Cal Landau.

PLATE 436 (ABOVE).
Photograph by Cherie Steinberg Coté.

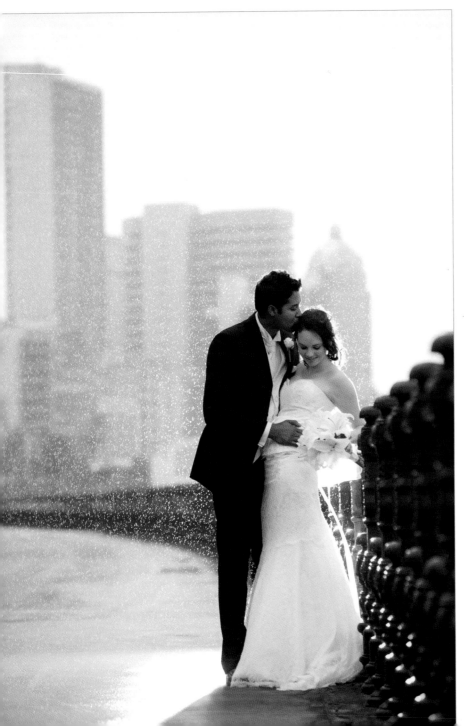

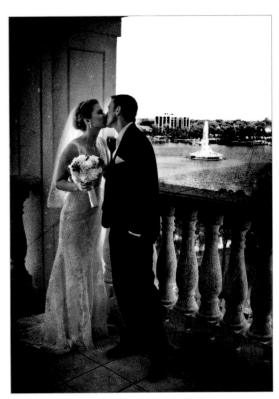

PLATE 437 (ABOVE). Photograph by Jeff Hawkins.

PLATE 438 (LEFT). Photograph by Brett Florens.

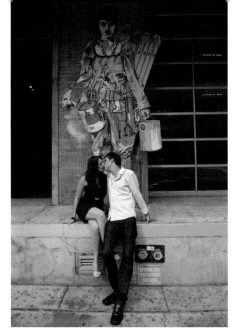

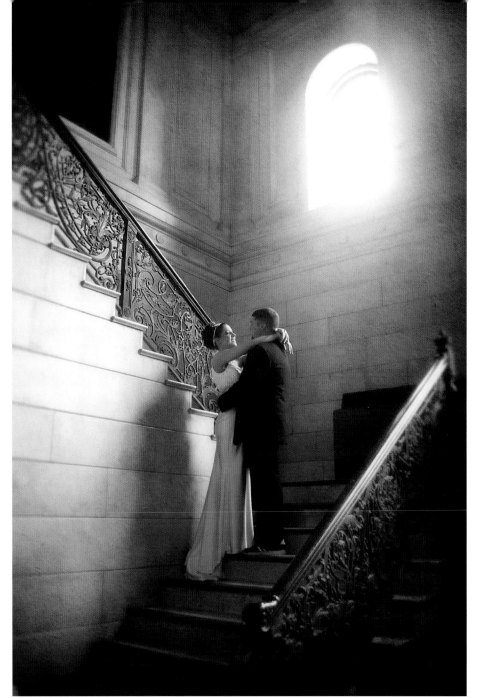

PLATE 439 (ABOVE).
Photograph by Neil van Niekerk.

PLATE 440 (RIGHT).
Photograph by Tracy Dorr.

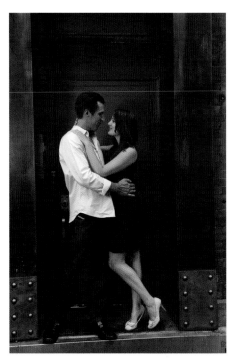

PLATE 441 (ABOVE).
Photograph by Neil van Niekerk.

PLATE 442 (RIGHT).
Photograph by Cherie Steinberg Coté.

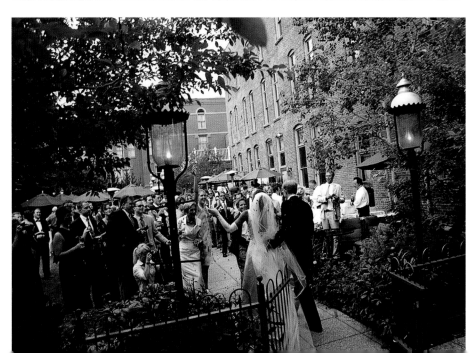

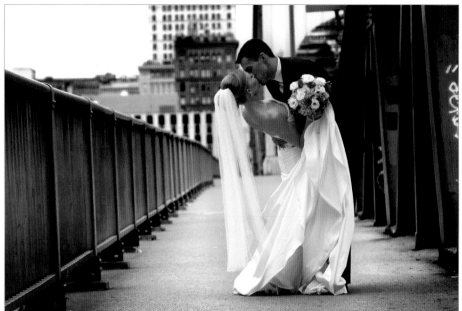

PLATE 443. Photograph by Cal Landau.

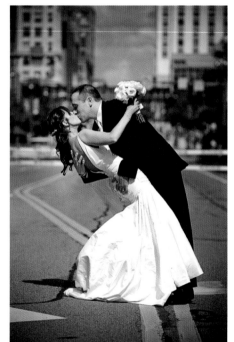

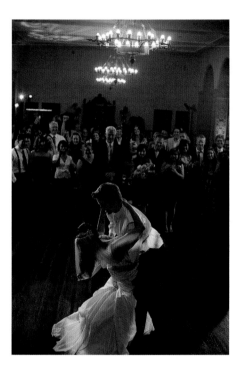

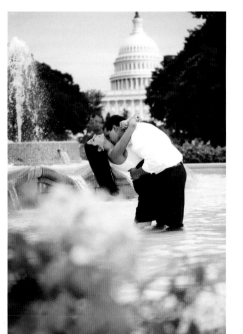

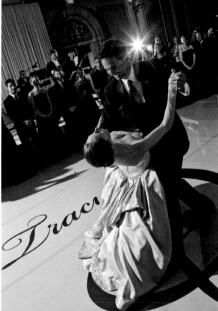

PLATE 444 (TOP LEFT).
Photograph by Cherie Steinberg Coté.

PLATE 445 (TOP CENTER).
Photograph by Paul D. Van Hoy II.

PLATE 446 (TOP RIGHT).
Photograph by Cherie Steinberg Coté.

PLATE 447 (BOTTOM LEFT).
Photograph by Regeti's Photography.

PLATE 448 (BOTTOM RIGHT).
Photograph by Jeff Hawkins.

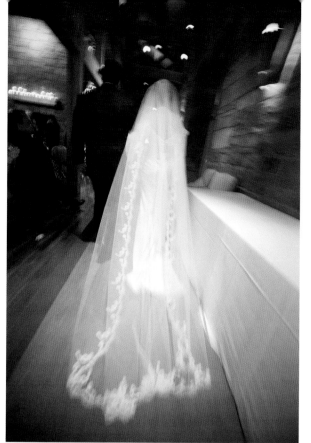

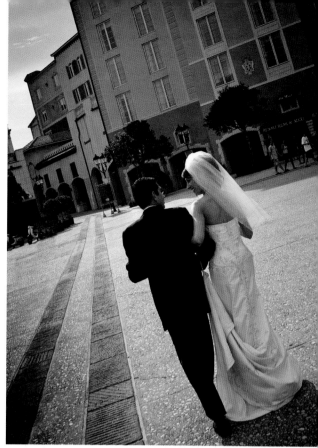

PLATE 449 (TOP LEFT). Photograph by Kevin Kubota.

PLATE 450 (TOP RIGHT). Photograph by Jeff Hawkins.

PLATE 451 (BOTTOM LEFT). Photograph by Damon Tucci.

PLATE 452 (BOTTOM RIGHT). Photograph by Cherie Steinberg Coté.

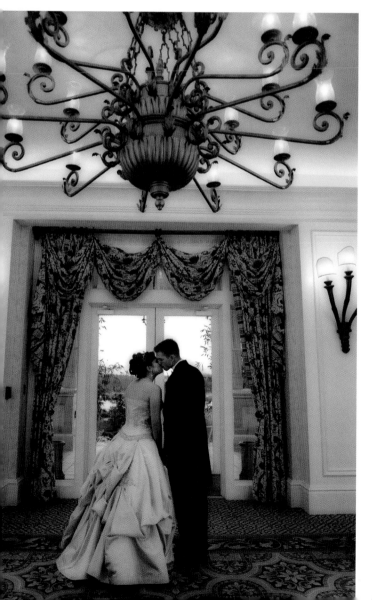

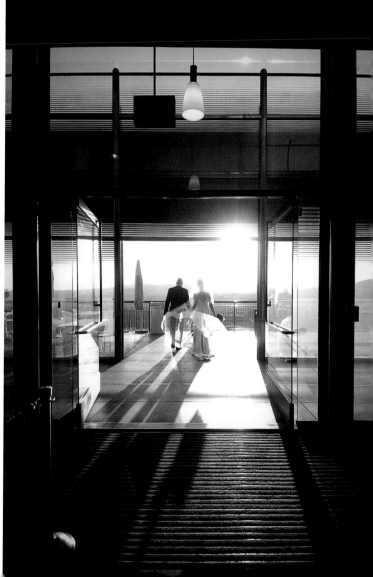

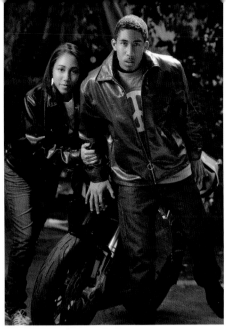

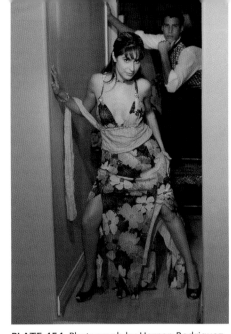

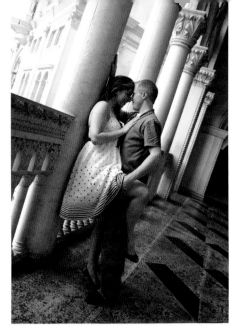

PLATE 453. Photograph by Hernan Rodriguez.　　**PLATE 454.** Photograph by Hernan Rodriguez.　　**PLATE 455.** Photograph by Neil van Niekerk.

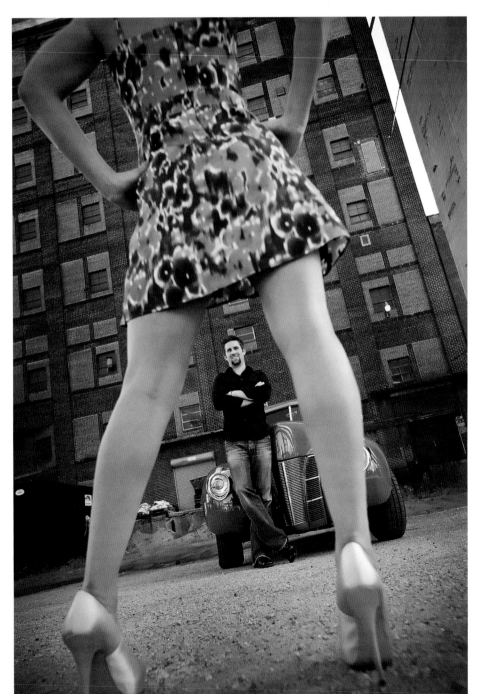

PLATE 456 (LEFT).
Photograph by Salvatore Cincotta.

PLATE 457 (ABOVE).
Photograph by Allison Earnest.

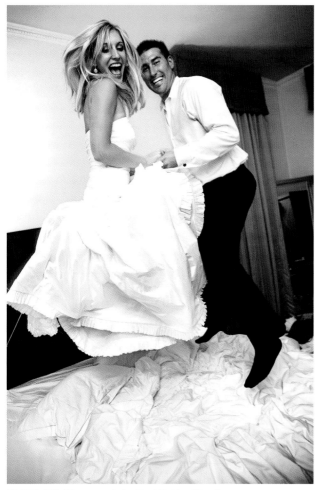

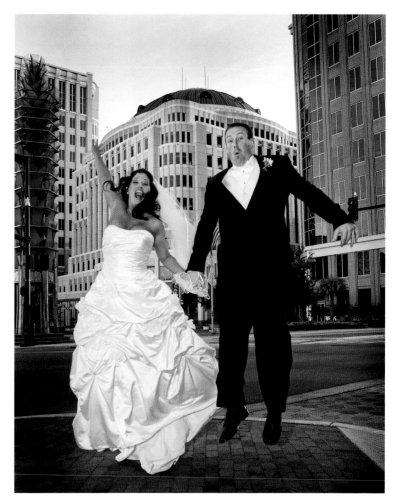

PLATE 458. Photograph by Paul D. Van Hoy II.

PLATE 459. Photograph by Jeff Hawkins.

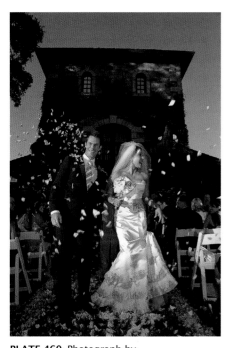

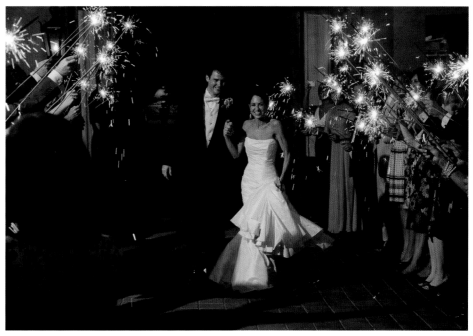

PLATE 460. Photograph by
Cherie Steinberg Coté.

PLATE 461. Photograph by Jeff Hawkins.

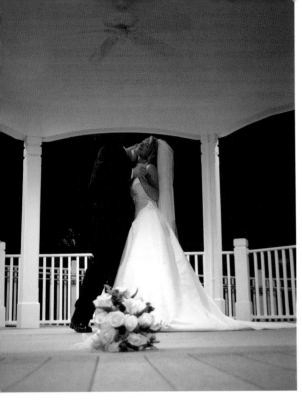

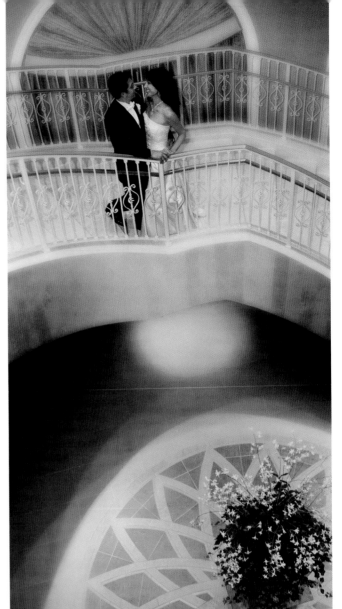

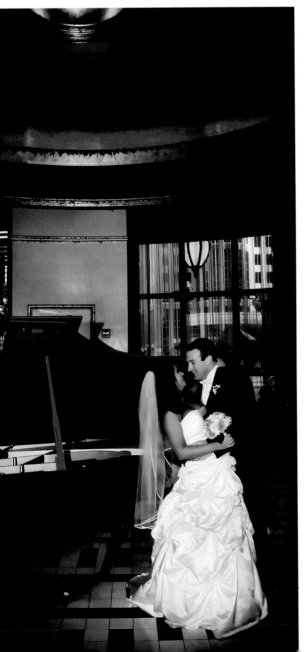

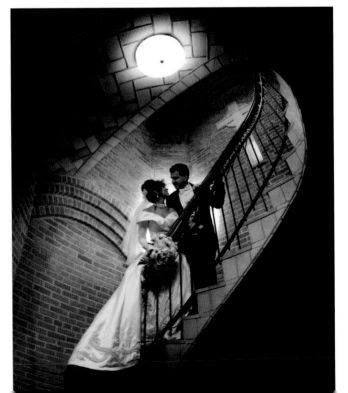

**PLATE 462
(TOP LEFT).**
Photograph by
Jeff Hawkins.

**PLATE 463
(TOP RIGHT).**
Photograph by
Jeff Hawkins.

**PLATE 464
(BOTTOM LEFT).**
Photograph by
Jeff Hawkins.

**PLATE 465
(BOTTOM
RIGHT).**
Photograph by
Jeff Hawkins.

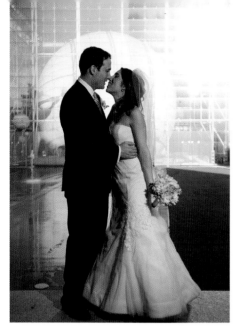

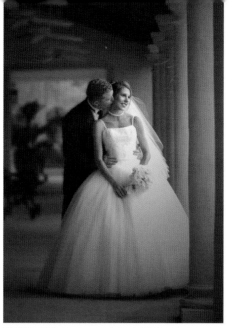

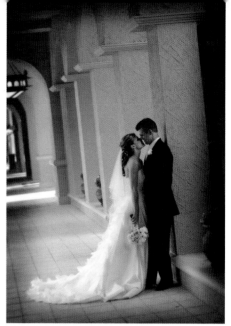

PLATE 466. Photograph by Neil van Niekerk.

PLATE 467. Photograph by Jeff Hawkins.

PLATE 468. Photograph by Damon Tucci.

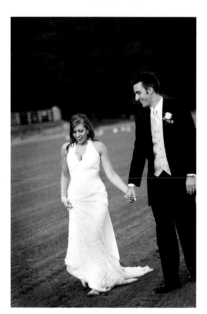

PLATE 469 (ABOVE).
Photograph by Tracy Dorr.

PLATE 470 (RIGHT).
Photograph by Jeff Hawkins.

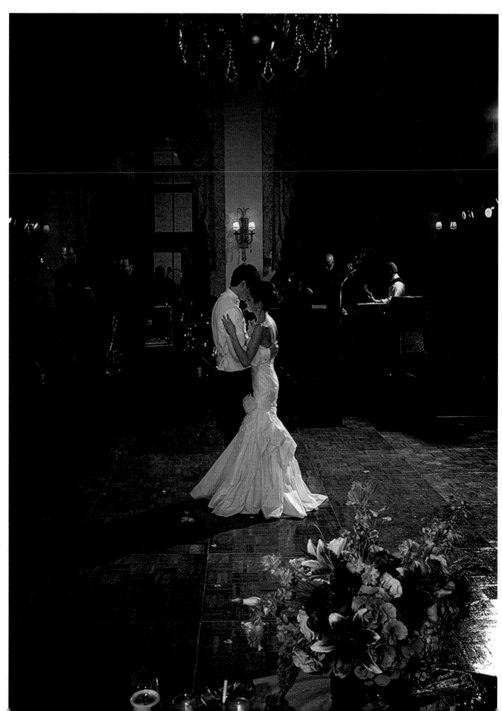

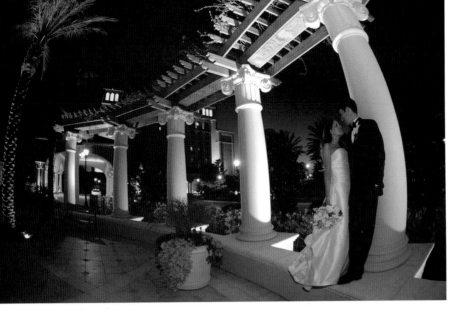

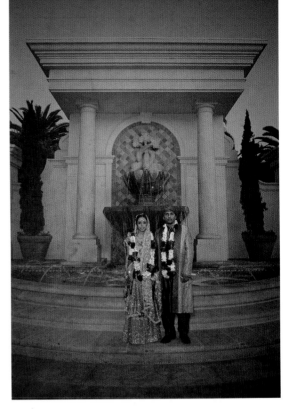

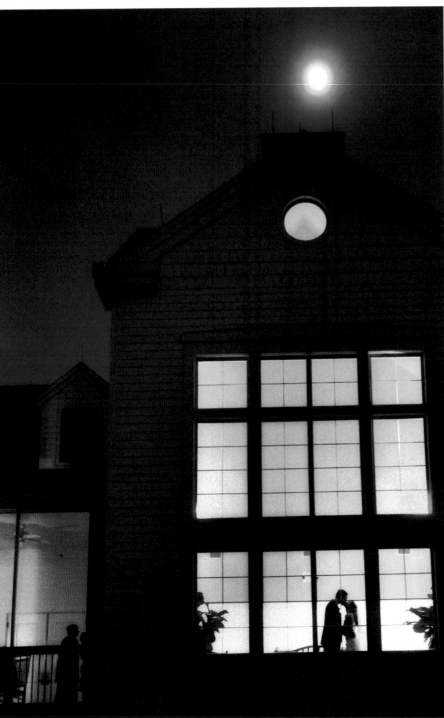

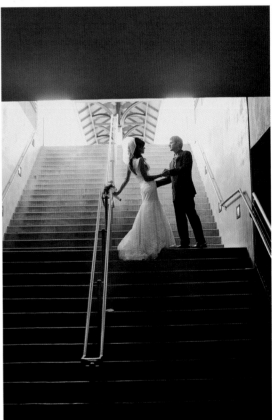

PLATE 471 (TOP LEFT).
Photograph by Damon Tucci.

PLATE 472 (TOP RIGHT).
Photograph by Cherie Steinberg Coté.

PLATE 473 (BOTTOM LEFT).
Photograph by Damon Tucci.

PLATE 474 (BOTTOM RIGHT).
Photograph by Cherie Steinberg Coté.

PLATE 475 (TOP LEFT). Photograph by Damon Tucci.

PLATE 476 (TOP RIGHT).
Photograph by Cherie Steinberg Coté.

PLATE 477 (BOTTOM LEFT). Photograph by Damon Tucci.

PLATE 478 (BOTTOM RIGHT).
Photograph by Cherie Steinberg Coté.

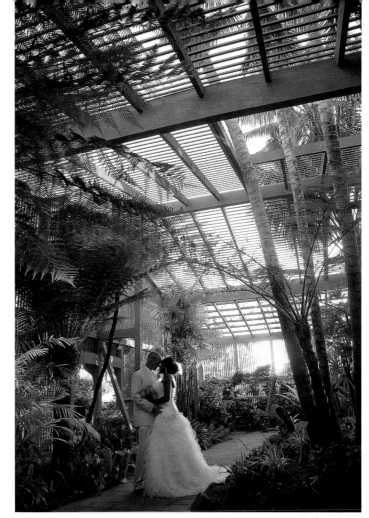

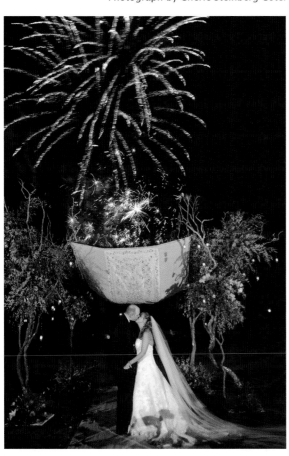

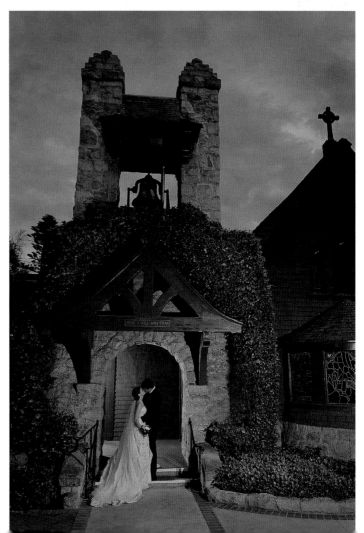

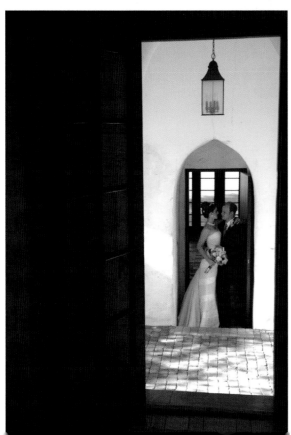

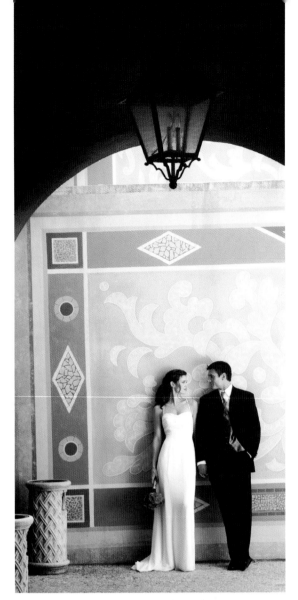

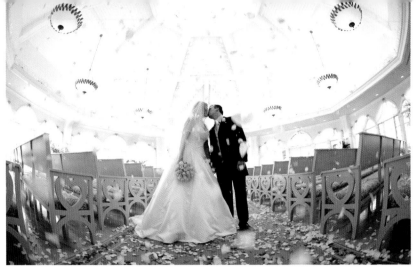

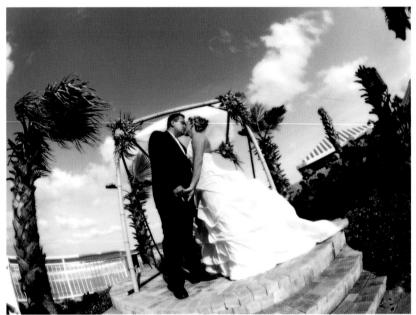

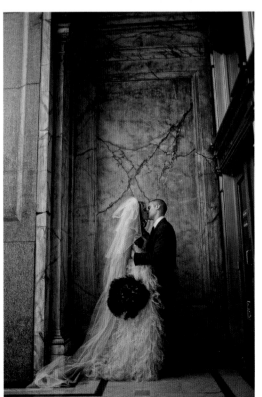

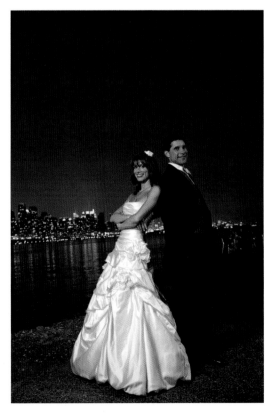

PLATE 479 (TOP LEFT).
Photograph by Damon Tucci.

PLATE 480 (TOP RIGHT).
Photograph by Damon Tucci.

PLATE 481 (ABOVE RIGHT).
Photograph by Damon Tucci.

PLATE 482 (BOTTOM LEFT).
Photograph by
Cherie Steinberg Coté.

PLATE 483 (BOTTOM RIGHT).
Photograph by Neil van Niekerk.

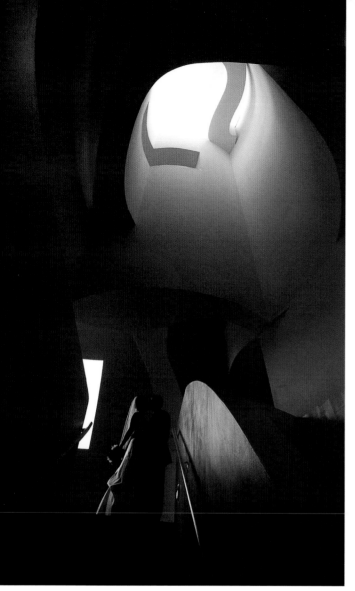

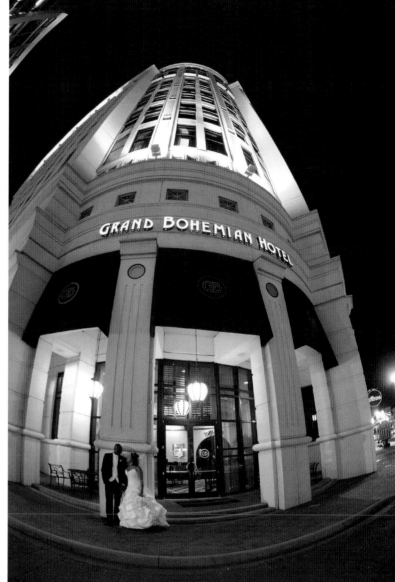

PLATE 484. Photograph by Cherie Steinberg Coté.

PLATE 485. Photograph by Damon Tucci.

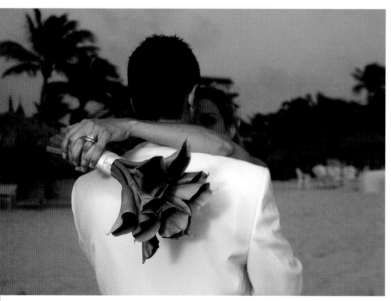

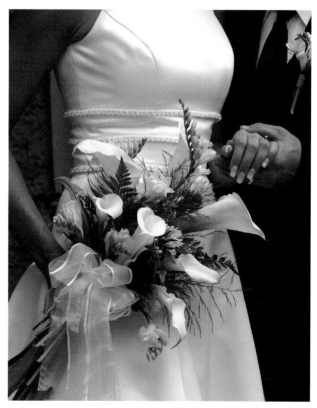

PLATE (ABOVE) 486. Photograph by Neil van Niekerk.

PLATE (RIGHT) 487. Photograph by Jeff Hawkins.

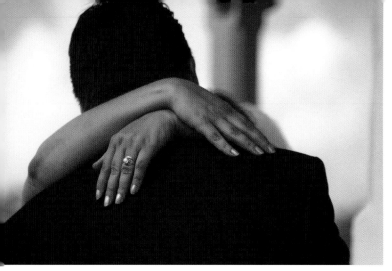

PLATE 488. Photograph by Jeff Hawkins.

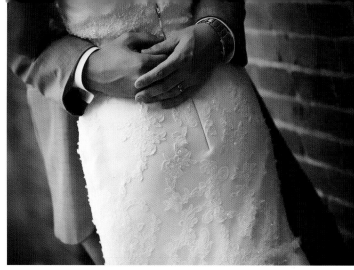

PLATE 489 Photograph by Salvatore Cincotta.

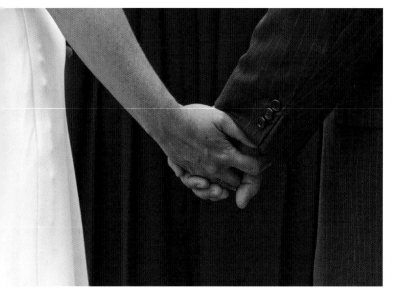

PLATE 490. Photograph by Michelle Perkins.

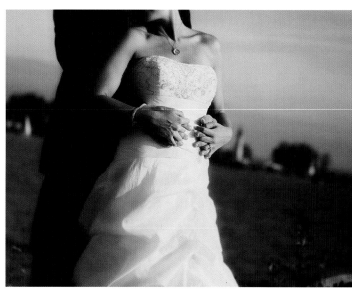

PLATE 491. Photograph by Tracy Dorr.

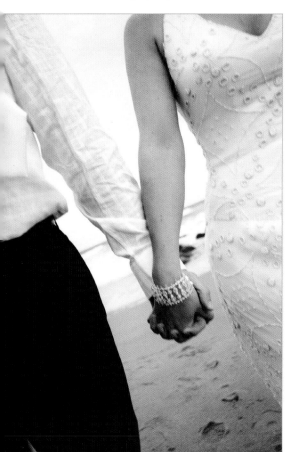

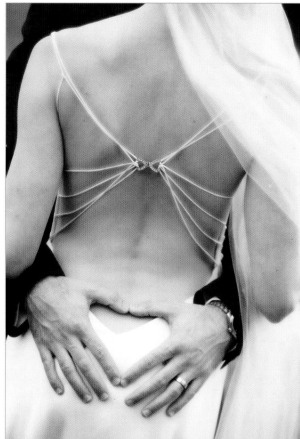

PLATE 492. Photograph by Brett Florens.

PLATE 493. Photograph by Kevin Kubota.

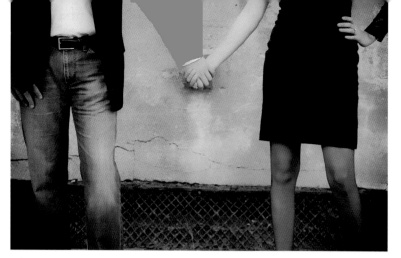

RIGHT COLUMN, TOP TO BOTTOM:

PLATE 494. Photograph by Salvatore Cincotta.

PLATE 495. Photograph by Regeti's Photography.

PLATE 496. Photograph by Cal Landau.

PLATE 497. Photograph by Cal Landau.

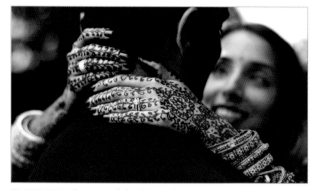

PLATE 498. Photograph by Tracy Dorr.

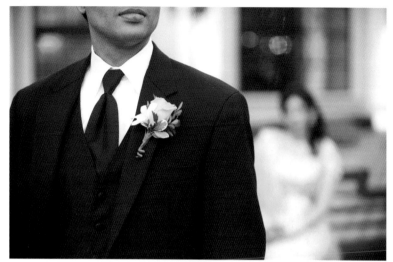

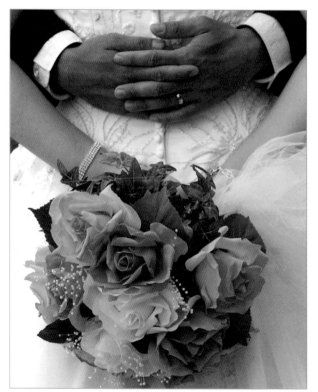

PLATE 499. Photograph by Jeff Hawkins.

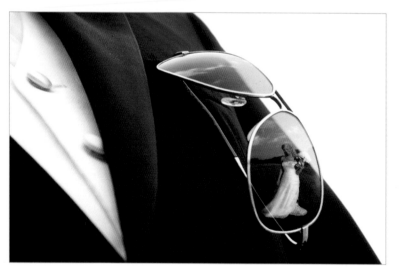

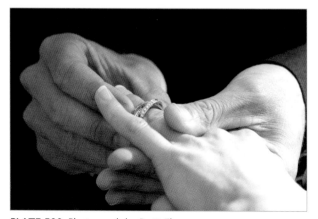

PLATE 500. Photograph by Brett Florens.

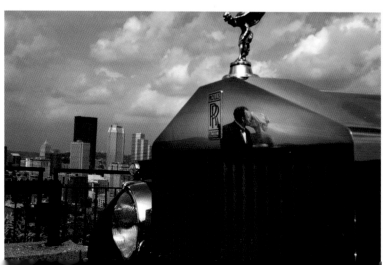

Posing Fundamentals

This section covers the fundamental rules of traditional posing—techniques that are illustrated in many of the images in this book. While these rules are often intentionally broken by contemporary photographers, most are cornerstones for presenting the human form in a flattering way.

TYPES

The four basic types of poses are defined by how much of the couple's bodies are included in the image. When including less than the full body in the frame, it is recommended that you avoid cropping at joints (such as knees or elbows); this creates an amputated look. Instead, crop between joints.

Head-and-Shoulders Portraits (or Headshots). Head-and-shoulders portraits show, as the term implies, the subjects' head and shoulders. If the hands are lifted to a position near the faces, these may also be included.

Waist-Up Portraits. These portraits include the subjects' head and shoulders along with at least some of the torso. In portraits of couples, these images are often cropped just above the waist. Waist-up portraits are sometimes considered a type of headshot.

Three-Quarter-Length Portraits. Three-quarter-length portraits show the subjects' from the head down to the mid-thigh or mid-calf. In some cases, one foot may be visible.

Full-Length Portraits. Full-length portraits show the subjects from the heads down to the feet (or at least the ankles). In some cases, only one foot may be visible.

FACIAL VIEWS

There are four primary facial views. In portraits of couples, you may see one facial view used for both subjects or the individuals may be posed to show differing views.

Full Face View. In a full-face view, the subject's nose is pointed directly at the camera for a very symmetrical look.

Seven-Eighths View. For this view, the subject's face is turned slightly off camera, but both ears are visible.

Three-Quarters or Two-Thirds View. In these portraits, the subject's face is angled enough that the far ear is hidden

Two facial views (full face and near profile) are combined in this image by Christopher Grey.

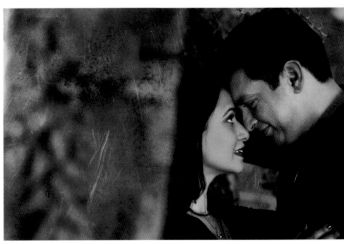

Mirrored profile views create a sense of intimacy in this image by Regeti's Photography.

from the camera's view. In this pose, the far eye may appear slightly smaller because it is farther away from the camera than the other eye. The head should not be turned so far that the tip of the nose extends past the line of the cheek or the bridge of the nose obscures the far eye.

Profile View. To create a profile, the subject's head is turned 90 degrees to the camera so that only one eye is visible.

THE SHOULDERS

For women, the subject's shoulders are almost always turned at an angle to the camera for a slimmer look. This is a common practice in portraits of men, as well. However, men may also be successfully posed with their shoulders square to the camera—especially when it is desirable to emphasize the broadness of the subject's shoulders. For a natural-looking pose, have the subject shift his or her weight onto one leg. This causes one shoulder to drop slightly, introducing a sense of ease and an appealing diagonal line into the composition.

THE HEAD

Tilting the Head. Tilting the head slightly produces diagonal lines that can help a pose feel more dynamic. In portraits of couples, the subjects heads are usually tilted at least slightly toward each other to create a sense of intimacy.

Eyes. In most portraits, the eyes are the most important part of the face. Typically, eyes look best when the eyelids border the iris. Turning the subjects' faces slightly away from the camera and directing their eyes back toward the camera reveals more of the whites of the eyes, making the eyes look larger.

In portraits of couples, a good starting point for posing the faces is to place the eyes of one subject at the level of the

Placing the subjects' faces at different heights creates attractive diagonals in this image by Neil van Niekerk.

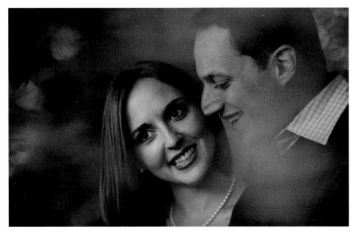

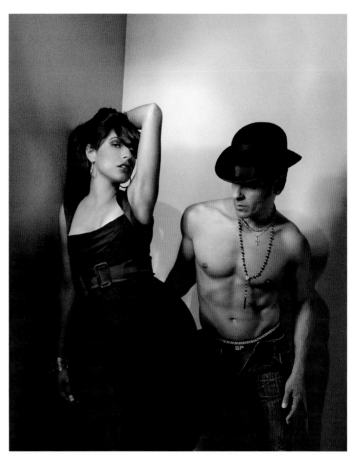

Separating the arms from the body creates a slim view of the subjects' torsos in this image by Hernan Rodriguez.

lips of the other subject. This creates a pleasant diagonal line between the subjects' eyes in the frame.

ARMS

The arms should be separated at least slightly from the waist. This creates a space that slims the appearance of the upper body. It also creates a triangular base for the composition, leading the viewer's eye up to the subject's face.

The subjects' arms should be articulated and not allowed to simply hang at their sides. (*Note:* This rule is sometimes broken in editorial-style images.) In portraits of couples, the arms can be posed by asking the couple to hold hands or put their arms around each other. Alternately, elements of the scene or props can give the hands something to do, which also poses the arms.

HANDS

For both men and women, keeping the hands at an angle to the lens help to avoid distorting their size and shape. Photographing the outer edge of the hand produces a more appealing look than showing the back of the hand or the

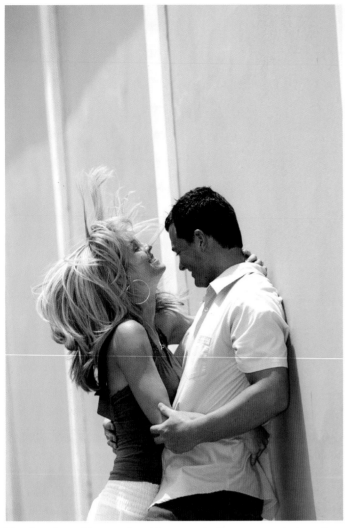

Turning the subject to the side presents the narrowest view of the body, as seen in this image by Neil van Niekerk.

palm, which may look unnaturally large (especially when close to the face). Additionally, it is usually advised that the hands should be at different heights in the image. This creates a diagonal line that makes the pose more dynamic.

Hands are often easiest to pose when they have something to do—either a prop to hold or something to rest upon. Placing the hands in the pockets or resting them on the hips is a simple solution that will feel comfortable to almost everyone. Having couples hold hands or rest their hands on their partner's shoulder, waist, or knee creates a natural look and lends images a sense of intimacy.

WAIST AND STOMACH

Separating the arms from the torso will help to slim your subjects' waists—something that is particularly important to women. Turning the torso so that it is at an angle to the camera will also have a slimming effect. (*Note:* This is not

the case, however, for men with larger "beer bellies"; turning these subjects can place the protruding stomach area in profile, accentuating it. Instead, choose a more straight-on pose to flatten the look of this area.)

In seated poses, an upright posture will help to flatten the stomach area, as will selecting a standing pose rather than a seated one. It is also generally recommended that the body be angled away from the main light. This allows the far side of the body to fall into shadow for a slimming effect.

LEGS

Whether the subjects are standing or seated, the legs of each individual should be posed independently rather than identically. Typically, one leg is straighter and used to support the body (or in a seated pose, to connect the subject to the floor). The other leg can then be bent to create a more interesting line in the composition.

According to traditional posing rules, the subject should put his weight on his back foot, shifting the body slightly away from the camera. This creates a more flattering appearance than having the weight distributed evenly on both feet. For women in bridal gowns (the subject of many portraits of couples), this also allows the front of the dress to fall naturally.

FEET

Feet often look distorted when the toes are pointed directly at the camera. It is best to show the feet from an angle. In seated poses with the legs crossed, avoid showing the soles of the shoes—especially if they are worn or dirty.

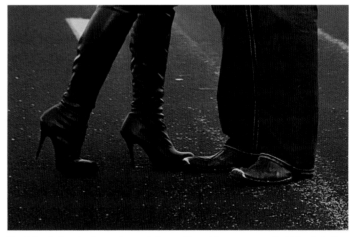

Feet look best when viewed from the side, as seen in this detail from an image by Salvatore Cincotta. (To see the complete image, check out plate 342).

The Photographers

Doug Box (www.texasphotographicworkshops.com). In addition to being an excellent photographer, Doug Box is a dynamic and entertaining speaker who has appeared in a wide variety of seminars around the world. He was also chosen to teach at the International Wedding Institute by Hasselblad University. He is the owner of Texas Photographic Workshops, a year-round educational facility, and the author of numerous books, including *Professional Secrets of Wedding Photography, Professional Secrets of Natural Light Portrait Photography, Doug Box's Guide to Posing for Portrait Photographers,* and *Doug Box's Flash Photography,* all from Amherst Media.

Mark Chen (www.markchenphotography.com). Mark is a pro photographer, Adobe Certified Photoshop Expert/Instructor, Photoshop trainer, and owner of Mark Chen Photography in Houston, Texas. In addition to his studio operations, Chen teaches Photoshop at Houston Baptist University and Houston Community College and is touring the nation giving Photoshop training sessions. Mark is the author of *Creative Wedding Album Design Techniques with Adobe Photoshop, Unleashing the RAW Power of Adobe Camera Raw,* and *Flash and Ambient Lighting for Digital Wedding Photography* from Amherst Media.

Salvatore Cincotta (www.behindtheshutter.com). Salvatore is the owner and principal photographer of Salvatore Cincotta Photography and Studio C based in O'Fallon, Illinois. After receiving his business degree from Binghamton University in New York, Sal worked for Fortune Top 50 companies like Microsoft and Procter & Gamble, honing his skills with some of the most brilliant business and technical minds in the world. After turning pro in 2007, Sal and his wife Taylor quickly established themselves as a major studio covering events in New York, Chicago, Saint Louis, and Internationally. Today, Salvatore Cincotta Photography shoots over fifty weddings a year, 120+ seniors, and a multitude of families and babies. Studio C shoots over two hundred seniors and also services

family clients. In addition to being an active photographer, Sal is a contributing writer for *Rangefinder* magazine and has created BehindTheShutter.com as a training resource for professional photographers. He is also the author of *Behind the Shutter: The Digital Wedding Photographer's Guide to Financial Success* from Amherst Media.

Tracy Dorr (www.tracydorrphotography.com). Tracy Dorr holds a BA in English/Photography from the State University of New York at Buffalo and has been shooting weddings in a professional capacity since 2003. She is the owner of Tracy Dorr Photography, and in 2009 won two Awards of Excellence from WPPI (Wedding and Portrait Photographers International). She is the author of *Advanced Wedding Photojournalism: Professional Techniques for Digital Photographers* and *Engagement Portraiture: Master Techniques for Digital Photographers* (both from Amherst Media).

Allison Earnest (www.allisonearnestphotography.com). Allison Earnest is a Pro Contributor for Lexar Media and holds a BS in Business Management from the University of Maryland. She is essentially a self-taught photographer and credits her success to countless mentors who have, throughout the years, graciously shared their knowledge and talent. She believes in continuing education and is currently teaching photography, lighting, and postproduction work-flow classes to aspiring photographers. Allison has written numerous educational articles for *Studio Photography* magazine. One such article, "Sculpting People with Light," was the inspiration for her first book, *Sculpting with Light®: Techniques for Portrait Photographers* (from Amherst Media). This was quickly followed by her second book, *The Digital Photographer's Guide to Light Modifiers: Techniques for Sculpting with Light®,* also from Amherst Media.

Rick Ferro (www.rickferro.com). Rick Ferro and Deborah Lynn Ferro operate Signature Studio, a full-service studio that provides complete photography services for families, portraits,

children, high-school seniors, and weddings. In addition to the acclaim they have received for their images, Rick and Deborah are also popular photography instructors who tour nationally, presenting workshops to standing-room-only audiences (for more on this, visit www.ferrophotographyschool.com). Rick and Deborah have also authored numerous books, including *Wedding Photography: Creative Techniques for Lighting, Posing, and Marketing* and *Artistic Techniques with Adobe Photoshop and Corel Painter,* both from Amherst Media.

Brett Florens (www.brettflorens.com). Brett Florens launched his career in 1992 while fulfilling his national service obligations. Within the police riot unit, a photographic unit was formed to document political changes, crimes, and township violence during a volatile time in South Africa. Brett jumped at the chance to join. With no photographic experience prior to that, Brett thrived on the opportunity, quickly mastering the technical requirements. He soon found himself in the thick of newsworthy events, creating images that found a ready market in newspapers and other media. Since then, Brett's devotion to photography has taken him from photojournalism to a highly successful career in wedding, commercial, and fashion photography. He has received numerous accolades along the way, the most recent of which was Nikon recognizing him as one of the world's most influential photographers. Brett frequently travels from South Africa to Europe, Australia, and the U.S. to photograph the weddings of his discerning, high-end clients. He is the author of *Brett Florens' Guide to Photographing Weddings* from Amherst Media.

Christopher Grey (www.christophergrey.com). For over thirty years, Christopher has dedicated himself to being a generalist photographer, giving him the opportunity to photograph an amazing variety of people, products, and services. "My work has been, and continues to be, a rich, visual exploration of people and culture, of psychology and motivation, of line and form and love of life," says Christopher. "Good fortune and hard work have seen a number of national and international awards come my way—the ownership of which has opened even more doors for me." He has achieved additional recognition as an educator and is the author of several popular books, including *Master Lighting Guide for Portrait Photography, Christopher Grey's Studio Lighting Techniques for Photography, Christopher Grey's Advanced Lighting Techniques,* and *Christopher Grey's Lighting Techniques for Beauty and Glamour Photography,* all from Amherst Media.

Jeff Hawkins (www.jeffhawkins.com). For the past twenty years, Jeff and Kathleen Hawkins have operated an award-winning wedding and portrait studio in Orlando, Florida. Industry sponsored, they are both very active in the photography

lecture circuit and take pride in their impact in the industry and in the community. Jeff holds the Master of Photography, Certified Professional Photographer (CPP) and Photographic Craftsman degrees. Kathleen is also an award-winning photographer and takes pride in the connection she establishes with her clients. Together, Jeff and Kathleen have authored nine books on photography, including *Professional Techniques for Digital Wedding Photography* from Amherst Media.

Kevin Kubota (www.kubotaimagetools.com). Kevin is a professional wedding photographer and, with his wife Clare Kubota, owner of Kubota PhotoDesign. In 2007, American Photo named him one of the top ten wedding photographers in the world. Kevin is the founder of Kubota ImageTools.com—an award-winning company he created to produce training DVDs, album-creation software, and Photoshop action sets—and a popular speaker at major photographic conventions. He is also the author of *Digital Photography Boot Camp* (now in its second edition from Amherst Media), a book based on his popular workshop series.

Cal Landau (www.callandau.com). Cal's creative life began very early. His mother was a painter of landscapes, while his father and uncle were photography aficionados. After years of drawing, painting, and photography schooling at Kent State, Cal continued his passion for photography by shooting and writing for automobile and bicycle racing magazines. One day, a friend asked him to shoot his wedding. After much resistance, he acquiesced—and discovered a passion that eclipsed all he had done before. Fifteen years and over five-hundred weddings later, the thrill is still there and he continues to strive to be one of the best in the business. In 2004, the first time he entered, Cal won "Best Bride and Groom" and the "Grand Award" for the best of the competition in WPPI's International Print Competition. His work has also been featured in numerous magazines and books, including Bill Hurter's *The Best of Wedding Photography* and *The Best of Wedding Photojournalism* (both from Amherst Media).

Srinu and Amy Regeti (www.regetisphotography.com). The Regetis are internationally recognized for their skill in telling stories through photography. As a talented husband and wife team, they are also well known in the photography industry as motivational speakers. Their images have been featured in such magazines as *Grace Ormonde, Engaged!,* and *Virginia Bride,* as well as on ABC's Nightline. The Regetis operate a full-service studio located in the quaint historic town of Warrenton, Virginia, in the rolling hills outside of Washington, DC.

Hernan Rodriguez (www.hernanphotography.com). The recipient of over twenty international photography awards in the

past three years alone, Hernan Rodriguez operates a successful studio in the heart of Los Angeles' San Fernando Valley. There, he juggles a steady roster of commercial, product, and celebrity photography, along with portraiture for families, children, and graduates. He has art directed and photographed advertising campaigns for Guess Clothing, Tanline CA, Comfort Zone, and Corona (to name just a few). He has also been featured in *Rangefinder, Studio Photography,* and *Photoshop User* magazines.

Cherie Steinberg Coté (www.cheriefoto.com). Cherie Steinberg Coté began her photography career as a photojournalist at the *Toronto Sun,* where she had the distinction of being the first female freelance photographer. She currently lives in Los Angeles and has been published in *Grace Ormonde, Los Angeles Magazine,* and *Town & Country.* She is also a Getty Image stock photographer and an acclaimed instructor who has presented seminars to professional photographers from around the country.

Damon Tucci (www.damontucci.com). Damon Tucci has been a professional photographer in the Orlando area for more than fifteen years and has photographed over 2500 weddings. Damon began his career as an underwater cinematographer and later worked as a photographer for Disney Photographic Services. It was at Disney that he carefully crafted his unique approach to wedding photography, which features a mix of documentary-style photography and stylized fashion shots. Damon is the author of *Step-by-Step Wedding Photography: Techniques for Professional Photographers* and, with Rosena Usmani, the co-author of *Tucci and Usmani's The Business of Photography* (both from Amherst Media).

Paul D. Van Hoy II (www.fotoimpressions.com). Paul D. Van Hoy II holds an MFA in Fine Art Photography from the Rochester Institute of Technology. His award-winning wedding photojournalism has been featured in popular magazines such as *Brides and Bridal, Wedding Style, In Style Wedding, Modern Bride,* and *Martha Stewart Weddings.* Some of his former and current clients include *Forbes, Health and Wellness, Men's Health, Food & Wine, Better Homes and Gardens, Country Living,* Adidas, Barilla, DKNY, Jones New York, and Fossil Inc. Presently residing in Rochester, NY, he documents approximately thirty to forty weddings annually, and shoots editorial, documentary, stock, and travel photography during his off-season. AGE Fotostock in Barcelona, Spain, represents Van Hoy's work. He is the author of *Wedding Photojournalism: The Business of Aesthetics* from Amherst Media.

Neil van Niekerk (www.neilvn.com). Neil van Niekerk, originally from Johannesburg, South Africa, is a wedding and portrait photographer based in northern New Jersey. He graduated with a college degree in electronic engineering and worked as a television broadcast engineer in South Africa (while pursuing photography as a parallel career) before deciding to settle in the United States in 2000. Says Neil, "I love photography for a variety of reasons. The stimulation and excitement of responding to new situations satisfies both my analytical and creative sides, and I also truly love working with people. I get real pleasure from sharing the happiness with the people that I photograph and knowing that I'm creating images that will evoke wonderful memories for a lifetime." His "Planet Neil" web site (www.planetneil.com) has become a popular destination for photographers seeking information on the latest equipment and techniques. He is also the author of two popular books: *On-Camera Flash Techniques for Digital Wedding and Portrait Photographers* and *Off-Camera Flash Techniques for Digital Photographers* (both from Amherst Media).

Bibliographical References

1. Tucci, Damon. *Step-by-Step Wedding Photography.* Amherst Media, 2009. Page 96.

2. Florens, Brett. *Brett Florens' Guide to Photographing Weddings.* Amherst Media, 2011. Page 102.

3. Dorr, Tracy. *Engagement Portraiture: Master Techniques for Digital Photographers.* Amherst Media, 2012. Page 34.

4. Dorr, Tracy. *Engagement Portraiture: Master Techniques for Digital Photographers.* Amherst Media, 2012. Page 56.

5. Van Hoy, Paul D. *Wedding Photojournalism: The Business of Aesthetics.* Amherst Media, 2011. Page 77.

6. Van Hoy, Paul D. *Wedding Photojournalism: The Business of Aesthetics.* Amherst Media, 2011. Page 77.

7. Box, Doug. *Doug Box's Guide to Posing for Portrait Photographers.* Amherst Media, 2009. Pages 47–48.

8. Box, Doug. *Doug Box's Guide to Posing for Portrait Photographers.* Amherst Media, 2009. Page 48.

MORE BOOKS IN THE 500 POSES SERIES

500 Poses
for Photographing Men

Overcome the challenges of posing male subjects with this visual sourcebook, showcasing an array of head-and-shoulders, three-quarter, full-length, and seated and standing poses. *$34.95 list, 8.5x11, 128p, 500 color images, index, order no. 1934.*

500 Poses
for Photographing Brides

Filled with images by some of the world's best wedding photographers, this book can provide the inspiration you need to spice up your posing or refine your techniques. *$34.95 list, 8.5x11, 128p, 500 color images, index, order no. 1909.*

500 Poses
for Photographing Women

A vast assortment of inspiring images, from head-and-shoulders to full-length portraits, and classic to contemporary styles—perfect for when you need a little shot of inspiration to create a new pose. *$34.95 list, 8.5x11, 128p, 500 color images, order no. 1879.*

Flash and Ambient Lighting
for Digital Wedding Photography

Mark Chen

Meet every lighting challenge with these tips for shooting with flash, ambient light, or flash and ambient light together. *$34.95 list, 8.5x11, 128p, 200 color photos and diagrams, index, order no. 1942.*

Off-Camera Flash

TECHNIQUES FOR DIGITAL PHOTOGRAPHERS

Neil van Niekerk

Learn how to set your camera, which flash settings to employ, and where to position your flash for exceptional results. *$34.95 list, 8.5x11, 128p, 235 color images, index, order no. 1935.*

Wedding Photojournalism

THE BUSINESS OF AESTHETICS

Paul D. Van Hoy II

Learn how to create strong images and implement the powerful business and marketing practices you need to reach your financial goals. *$34.95 list, 8.5x11, 128p, 230 color images, index, order no. 1939.*

JEFF SMITH'S
Studio Flash Photography

This common-sense approach to strobe lighting shows working photographers how to master solid techniques and tailor their lighting setups to individual subjects. *$34.95 list, 8.5x11, 128p, 150 color images, index, order no. 1928.*

Just One Flash

A PRACTICAL APPROACH TO LIGHTING FOR DIGITAL PHOTOGRAPHY

Rod and Robin Deutschmann

Get down to the basics and create striking images with just one flash. *$34.95 list, 8.5x11, 128p, 180 color images, 30 diagrams, index, order no. 1929.*

WES KRONINGER'S
Lighting Design Techniques

FOR DIGITAL PHOTOGRAPHERS

Design portrait lighting setups that blur the lines between fashion, editorial, and traditional portrait styles. *$34.95 list, 8.5x11, 128p, 80 color images, 60 diagrams, index, order no. 1930.*

DOUG BOX'S
Off-Camera Flash

TECHNIQUES FOR DIGITAL PHOTOGRAPHERS

Master off-camera flash, alone or with light modifiers. Box teaches you how to create perfect portrait, wedding, and event shots, indoors and out. *$34.95 list, 8.5x11, 128p, 345 color images, index, order no. 1931.*

Wedding Photographer's Handbook, 2nd Ed.

Bill Hurter

Learn to exceed your clients' expectations before, during, and after the wedding. *$34.95 list, 8.5x11, 128p, 150 color images, index, order no. 1932.*

CHRISTOPHER GREY'S
Lighting Techniques
for Beauty and Glamour Photography
Create evocative, detailed shots that emphasize your subject's beauty. Grey presents twenty-six varied approaches to classic, elegant, and edgy lighting. *$34.95 list, 8.5x11, 128p, 170 color images, 30 diagrams, index, order no. 1924.*

UNLEASHING THE RAW POWER OF
Adobe® Camera Raw®
Mark Chen

Digital guru Mark Chen teaches you how to perfect your files for unprecedented results. *$34.95 list, 8.5x11, 128p, 100 color images, 100 screen shots, index, order no. 1925.*

Advanced Wedding Photojournalism
Tracy Dorr

Tracy Dorr charts a path to a new creative mind-set, showing you how to get better tuned in to a wedding's events and participants so you're poised to capture outstanding, emotional images. *$34.95 list, 8.5x11, 128p, 200 color images, index, order no. 1915.*

CHRISTOPHER GREY'S
Advanced Lighting Techniques
Learn how to create twenty-five unique portrait lighting effects that other studios can't touch. Grey's popular, stylized effects are easy to replicate with this witty and highly informative guide. *$34.95 list, 8.5x11, 128p, 200 color photos.*

Wedding Photography
ADVANCED TECHNIQUES FOR WEDDING PHOTOGRAPHERS
Bill Hurter

The advanced techniques and award-winning images in this book will show you how to achieve photographic genius that will help you win clients for life. *$34.95 list, 8.5x11, 128p, 150 color images, index, order no. 1912.*

Off-Camera Flash
CREATIVE TECHNIQUES FOR DIGITAL PHOTOGRAPHY
Rod and Robin Deutschmann

Break free from the shackles of natural light and push the limits of design with these off-camera flash techniques. Covers portraits, nature photography, and more. *$34.95 list, 8.5x11, 128p, 269 color images, 41 diagrams, index, order no. 1913.*

The Art of Posing
TECHNIQUES FOR DIGITAL PORTRAIT PHOTOGRAPHERS
Lou Jacobs Jr.

Create compelling poses for individuals, couples, and families. Jacobs culls strategies and insights from ten photographers whose styles range from traditional to modern. *$34.95 list, 8.5x11, 128p, 180 color images, index, order no. 2007.*

The Best of Wedding Photojournalism, 2nd Ed.
Bill Hurter

From the pre-wedding preparations to the ceremony and reception, you'll see how professionals identify fleeting moments and capture them in an instant. *$34.95 list, 8.5x11, 128p, 150 color images, index, order no. 1910.*

Creative Wedding Album Design
WITH ADOBE® PHOTOSHOP®
Mark Chen

Master the skills you need to design wedding albums that will elevate your studio above the competition. *$34.95 list, 8.5x11, 128p, 225 color images, index, order no. 1891.*

CHRISTOPHER GREY'S
Studio Lighting Techniques for Photography
With these strategies—and some practice—you'll approach your sessions with confidence! *$34.95 list, 8.5x11, 128p, 320 color images, index, order no. 1892.*

On-Camera Flash
TECHNIQUES FOR DIGITAL WEDDING AND PORTRAIT PHOTOGRAPHY
Neil van Niekerk

Use on-camera flash to create lighting that flatters your subjects—and doesn't slow you down on location shoots. *$34.95 list, 8.5x11, 128p, 190 color images, index, order no. 1888.*

JEFF SMITH'S GUIDE TO
Head and Shoulders Portrait Photography
Make head and shoulders portraits a more creative and lucrative part of your business—whether in the studio or on location. *$34.95 list, 8.5x11, 128p, 200 color images, index, order no. 1886.*

Minimalist Lighting
PROFESSIONAL TECHNIQUES FOR STUDIO PHOTOGRAPHY
Kirk Tuck

Learn how technological advances have made it easy and inexpensive to set up your own studio. *$34.95 list, 8.5x11, 128p, 190 color images and diagrams, index, order no. 1880.*

Master Posing Guide for Wedding Photographers
Bill Hurter

Learn to create images that make your clients look their very best while still reflecting the spontaneity and joy of the event. *$34.95 list, 8.5x11, 128p, 180 color images and diagrams, index, order no. 1881.*